VISUALIZING THE
BEATLES

VISUALIZING THE
BEATLES

A COMPLETE GRAPHIC HISTORY
OF THE WORLD'S FAVORITE BAND

JOHN PRING AND ROB THOMAS

FOREWORD BY ROB SHEFFIELD

DEY ST.
An Imprint of WILLIAM MORROW

HarperCollins books may be purchased for educational, business, or
sales promotional use. For information, please email the Special Markets
Department at SPsales@harpercollins.com.

Originally published as *Visualising the Beatles* in the UK in 2016 by
Orphans Publishing.

First Dey Street hardcover published 2018.

FIRST EDITION

Library of Congress Cataloging-in-Publication Data has been applied for.

ISBN 978-0-06-279098-9

18 19 20 21 22 QVE 10 9 8 7 6 5 4 3 2 1

*John and Rob would like to dedicate this book
to their friends, family, and everyone who
supported them and now knows more about
The Beatles than they ever wanted to . . .*

CONTENTS

FOREWORD

There's no story anywhere like John, Paul, George, and Ringo. The Beatles remain the world's favorite dream, nearly fifty years after the band broke up. These four nowhere boys from Liverpool were never expected to amount to anything in their lives—much less turn into artists. Yet they found each other and made their most outrageous dreams come true, inventing a sound that changed the world. Their music gets more beloved, more popular, and more influential every year—even though most of today's Beatles fans weren't born when the lads played that legendary rooftop farewell gig.

Visualizing the Beatles tells the story in a whole new way—a feast for the eyes as well as the ears. This book offers fresh and irresistible ways to look at this music and the lads who made it. All four Beatles had a lifelong passion for visual art, from John's art-school scribbles to Ringo's film cameras. They always kept their eyes open to the world around them as well as to the worlds inside their minds, so they prized the visual dimensions of their music. As they once sang, they wanted us all to listen to the color of our dreams. And they wanted to capture those colors in their songs.

Visualizing the Beatles is a book full of images that tell the Fab Four's story—mapping the landscape of the Liverpool where they grew up, decoding the album cover designs that got burned into generations of fans' brains, charting their astonishing musical progression as they grew from scruffy rock 'n' roll kids to innovative experimental artists. It has live setlists, instrumental breakdowns, and historical timelines. *Visualizing the Beatles* also follows the band's tours around the globe as they steadily conquered the world.

When Beatlemania blew up in the early 1960s, all the experts predicted the bubble would burst and all this "yeah, yeah, yeah" business the kids were into would turn out to be a fad. It didn't work out that way. John Pring and Rob Thomas make *Visualizing the Beatles* a unique celebration of how the Beatles happened and why their music keeps shining on. As the lads once sang to a girl named Prudence, "Look around." There's a lot to see.

Rob Sheffield

Rolling Stone *columnist and author of* Dreaming the Beatles

A NOTE FROM THE AUTHORS

Even now, nearly fifty years since The Beatles released their final album and performed one last time on the rooftop of the Apple Corps building, the world's love for this, perhaps ultimate, band shows no signs of cooling. Each generation jubilantly passes the Fab Four's music on to the next, hoping to inspire a budding songwriter or groundbreaking guitarist, or simply to share the magic of the first notes of "All You Need Is Love."

The Beatles have become ingrained in modern popular culture, as much shaped by it as they were instrumental in shaping it. The pair of us—two friends who played, wrote songs, sketched, and photographed through our youth in noughties Brighton (not quite the incredible live music scene of postwar Liverpool The Beatles thrived in but as near as our generation will ever get)—grew up enthralled by their creativity, experimentation, and originality.

As designers, we wondered what it would look like to visualize The Beatles and chart their story—the evolution of their music, style, and characters—through a series of graphics. What might presenting the information in a totally different way, never done before on this scale, tell us that we hadn't noticed or appreciated previously? With the help of an incredible bunch of Beatles and infographic fans on Kickstarter, we began to find out. This book is a product of their generosity and encouragement, and was made possible by one of the biggest sources of our generation's creativity: the internet.

The book is organized by album (in order of the dates the albums were released rather than recorded). It is by no means a definitive history of The Beatles. Instead, it is an attempt to create something beautiful, vibrant, and original from the data their music left behind. It is an attempt to present the facts in a way you haven't seen them before, so you can spot, in an instant, the patterns, anomalies, and changes. And finally, it is an attempt to capture the spirit of The Beatles and the sixties, a decade we're almost as unwilling to let go of as the band themselves, visually.

John Pring & Rob Thomas

INTRODUCTION
1960–1962

Meet The Beatles

Known in their formative years as Blackjacks, The Quarrymen, Johnny and the Moondogs, Beatals, Silver Beetles, Silver Beatles, and finally The Beatles, John Lennon, Paul McCartney, and George Harrison were joined by Richard Starkey in 1962 to form the group we know and love today.

The Beatles' first-ever "professional" performance was on Friday, May 20th, 1960, in Scotland, as Johnny Gentle's backing group. Their first break came not long afterward, when their manager Allan Williams secured a deal for the group to go and play at Indra bar in Hamburg, Germany, for two months, famously driving them and a host of other acts all the way there in his van.

Once there, The Beatles performed for a staggering 205 hours over seven weeks and it transformed them. It was also where they first got to know Ringo Starr, playing with his band the Hurricanes at *Tanzpalast der Jugend*, "dance palace of the youth." By the time The Beatles got back to Liverpool, their new audiences were transfixed by them. The effect was explosive . . .

John Winston (later Ono) Lennon

Parents:
Alfred Lennon
Julia Stanley

Favorite childhood book:
Alice in Wonderland

Date of Birth
October 9, 1940

James Paul McCartney

Parents:
James McCartney
Mary Mohin

Alternative career:
Paul's mother wanted him to
become a doctor

Date of Birth
June 18, 1942

George Harrison

Parents:
Harold Harrison
Louise French

School: Liverpool Institute
(with Paul) on the same
street as John's art college

Date of Birth
February 25, 1943

Richard Starkey (professional name Ringo Starr)

Parents:
Richard Starkey
Elsie Gleave

Pre-Beatles: "Ritchie" was an
apprentice at manufacturing
company H. Hunt & Son

Date of Birth
July 7, 1940

Beatles Landmarks

Although the band spent many of their later years in London or abroad, Liverpool is the spiritual home of the Fab Four. All four band members were born here, met here, and honed their talents here before hitting the big time.

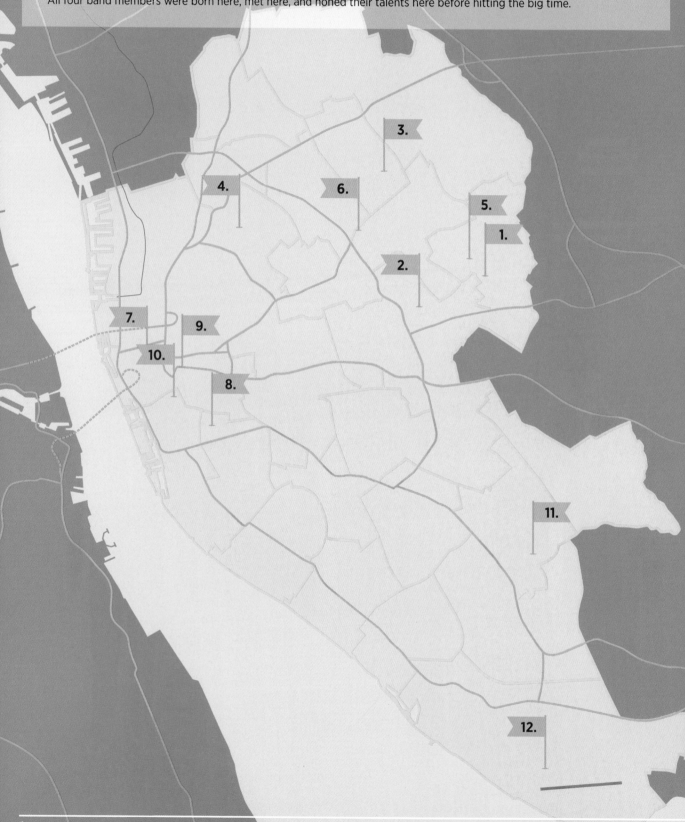

1. **Mendips, 251 Menlove Avenue, Liverpool, L25 7SA**

The childhood home of John Lennon. Lennon moved to this address after his mother was persuaded that his aunt Mimi and uncle George were better suited to looking after him. He lived at this address until he was 22.

2. **20 Forthlin Road, Allerton, Liverpool, L18 9TN**
The childhood home of Paul McCartney. Known by many as "the birthplace of The Beatles," it's not only where the McCartney family lived and Paul was born, it's also where The Beatles wrote and recorded some of their earliest songs.

3. **12 Arnold Grove, Liverpool, L15 8HP**
The childhood home of George Harrison. Harrison was born in this tiny house, and lived here for six years with his mother, father, and three older siblings—Louise, Harry, and Peter.

4. **10 Admiral Grove, Dingle, Liverpool, L8 8BH**
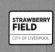
The childhood home of Ringo Starr. Ringo was born close by at 9 Madryn Street, but his parents separated when he was three, and he and his mother moved to Admiral Grove. Starr lived there for 20 years until 1963 when he became famous.

5. **Strawberry Field, Beaconsfield Road, Liverpool, L25 6DA**

A former Salvation Army children's home near to where John Lennon grew up, it became famous as the title of one of The Beatles' best-known hits. As a child, Lennon would look forward to the summer garden party held there each year.

6. **Penny Lane, Liverpool, L18 1DE**

A street near to where John Lennon was born, and believed to have been named after an affluent slave trader in the 18th century, James Penny. Lennon and McCartney would often meet here to catch a bus into the center of Liverpool.

7. **The Cavern Club, 10 Mathew Street, Liverpool, L2 6RE**

Originally opened in 1957 as a jazz club, the Cavern Club later became the center of the rock-and-roll scene in Liverpool. From 1961 to 1963, The Beatles performed 292 times at the club, and this helped to spark the "Beatlemania" frenzy.

8. **Liverpool Institute (now LIPA), Mount Street, Liverpool L1 9HF**

Mount Street is where Paul McCartney was educated between 1953 and 1960, as well as George Harrison from 1954. It was closed in 1985 until in 1989 Paul announced his plans to redevelop the building as the Liverpool Institute for Performing Arts.

9. **The Empire Theatre, Lime Street, Liverpool, L1 1JE**

The boys auditioned here (unsuccessfully) for Carroll Levis's "Search for the Stars" talent show: once in '57 as The Quarrymen and again in '59 as Johnny and the Moondogs. They also gave their last-ever Liverpool performance here in December 1964.

10. **The Jacaranda, 21–23 Slater Street, Liverpool, L1 4BW**

John, George, and Paul hung out here as students, and it was also where The Silver Beetles played a dozen times in 1960 before their first trip to Hamburg.

11. **St. Peter's Church, 26 Church Road, Liverpool, L25 5JF**
This church is where Paul first met John. It's also where Eleanor Rigby appears to be buried.

12. **John Lennon Airport, Speke Hall Avenue, Speke, Liverpool, L24 1YD**

Renamed from Liverpool Airport in 2001 to honor the life of one of Liverpool's most famous sons.

Beatles in London

London in the swinging sixties was a mecca for all things cool and hip, including the Fab Four. Here are some of The Beatles' haunts in the UK capital.

57 Wimpole Street. It was here that the Asher family lived, and Paul would use this house as his London base until late 1965. Paul worked on many of his songs here, including "**Yesterday**," "**And I Love Her**," "**Every Little Thing**," "**I've Just Seen A Face**," "**You Won't See Me**," and "**I'm Looking Through You**." Paul and John also worked on collaborations here, including "**I Want to Hold Your Hand**."

Abbey Road, St. John's Wood. This famous studio is where most of The Beatles' music was recorded from June 1962 to January 1970.

Trident House, 17 St. Anne's Court. Here is Trident Studios, where The Beatles recorded "**Honey Pie**," "**Dear Prudence**," "**Savoy Truffle**," and "**Martha My Dear**." John's "**Cold Turkey**" and George's "**My Sweet Lord**" were also recorded here.

Number 34 Montagu Square was Ringo's late-1964 address. Paul set up an experimental recording studio here, and Jimi Hendrix even stayed here (although Ringo had to redecorate it after Hendrix trashed it during an acid trip). John and Yoko also lived there and were busted for marijuana possession in 1968, after which Ringo sold the lease.

13 Emperor's Gate, West Kensington. This top-floor maisonette flat was the first London-based family home for the Lennons.

2 Lower Regent Street, W1. This was the address of the BBC Paris Theatre, where The Beatles recorded sessions for their *Saturday Club* and other radio appearances between 1963 and 1965. The cover of the *Live at the BBC* album was photographed outside this venue.

Soho Square is the location of MPL (McCartney Productions Ltd), the home of Paul's publishing empire. In the basement of the building is a replica of Studio Two from Abbey Road, The Beatles' favorite studio.

Apartment L, number 57, Green Street. This was The Beatles' first London apartment from the summer of 1963, after Brian Epstein rented it for them.

3 Savile Row. This used to be the home of The Beatles' company Apple Corps. Their final live performance, shown at the close of *Let It Be*, took place on the roof of this building on January 30, 1969.

The Indica, number 6 Mason's Yard. This is where John Lennon met Yoko Ono in November 1966.

24 Chapel Street, Belgravia. This was the home of Brian Epstein from 1964, and it was the place he died on August 27, 1967.

Before The Beatles

Before becoming The Beatles we all know and love, John, Paul, George, and Ringo were in a number of bands and lineups from the mid-1950s right through to the very early 60s. Let's have a look at some of the bands they were in before The Beatles.

THE QUARRYMEN 1956–1957	**THE REBELS** 1957

THE McCARTNEY BROTHERS 1957	**THE QUARRYMEN** 1957–1958

THE QUARRYMEN 1958–1960	**THE VIKINGS** 1958

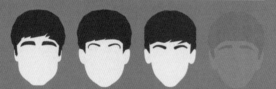

JOHNNY & THE MOONDOGS 1958	**JAPAGE 3** 1959

DARKTOWN 1959	**THE RAVING TEXANS** 1959

ROY STORM & THE HURRICANES
1959–1962

LU WALTERS
1960

THE BEATLES
1960

THE NERK TWINS
1960

LONG JOHN & THE SILVER BEATLES
1960

JOHNNY GENTLE & HIS GROUP
1960

THE BEATLES
1960–1962

TONY SHERIDAN & BEAT BROTHERS
1961

TOP TEN CLUB HOUSE BAND
1961–1962

THE BEATMAKERS
1961

 THE BEATLES
1962–1970

The Beatles' First-Ever Tour

After arriving back in Liverpool from Hamburg in December 1960, The Beatles embarked on their first (unofficial) tour*, playing 25 dates in their home city between January 5 and February 9, 1961.

The last date of this tour was the start of a new era: their first-ever performance at the now legendary Cavern Club. Reportedly, they were paid £5 for their appearance and George Harrison was nearly denied admission because he was wearing jeans! Their nearly 300 performances at the club between then and 1963 would be instrumental in amassing their fan base—and "Beatlemania."

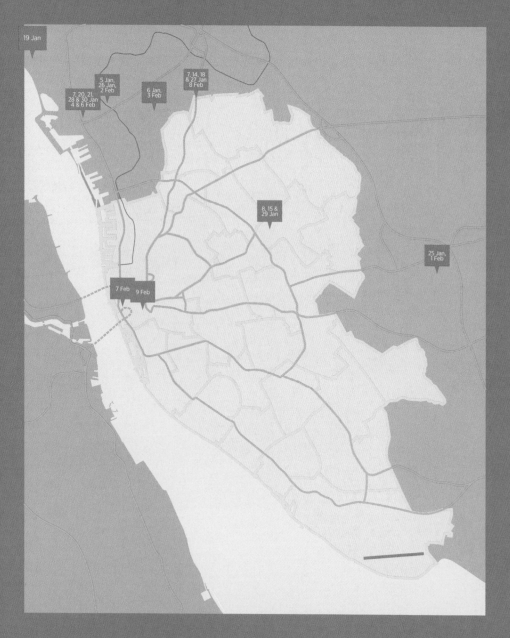

January 5, 1961.
Litherland—Town Hall
January 6, 1961
Bootle—St. John's Hall
January 7, 1961
Aintree—Aintree Institute
Seaforth—Lathom Hall
January 8, 1961
Liverpool—The Casbah Coffee Club
January 14, 1961
Aintree—Aintree Institute
January 15, 1961
Liverpool—The Casbah Coffee Club
January 18, 1961
Aintree—Aintree Institute
January 19, 1961
Crosby—Alexandra Hall
January 20 & 21, 1961
Seaforth—Lathom Hall
January 25, 1961
Huyton—Hambleton Hall
January 26, 1961
Litherland—Town Hall
January 27, 1961
Aintree—Aintree Institute
January 28, 1961
Seaforth—Lathom Hall
January 29, 1961
Liverpool—The Casbah Coffee Club
January 30, 1961
Seaforth—Lathom Hall
February 1, 1961
Huyton—Hambleton Hall
February 2, 1961
Litherland—Town Hall
February 3, 1961
Bootle—St. John's Hall
February 4, 1961
Seaforth—Lathom Hall
February 5, 1961
Walton—Blair Hall
February 6, 1961
Seaforth—Lathom Hall
February 7, 1961
Liverpool—Merseyside Civil Service Cl
February 8, 1961
Aintree—Aintree Institute
February 9, 1961
Liverpool—The Cavern Club

*All with Pete Best as drummer instead of Ringo Starr

Hamburg—The Top Ten Club

The Beatles returned to Hamburg in March 1961. This time, they were performing at the Top Ten Club. They played even longer hours here than they had at the Indra: seven nights a week, till 4:00 a.m. on weekends, for three months. Their confidence leaped again and it was during this stint that Germany's best-known producer, Bert Kaempfert, spotted them. The band did their first-ever recording session for him and it was this single that would, eventually, on November 9, 1961, lead Brian Epstein to watch one of their performances at the Cavern Club. On January 24, 1962, the band (with Pete Best as drummer) would sign a management contract with Epstein. It wouldn't be long before they'd be signing a recording contract with EMI . . .

ALBUM OVERVIEW

Released: March 22, 1963
Producers: George Martin, Ron Richards
Engineers: Norman Smith, Stuart Eltham

The Beatles' very first single, "Love Me Do," was recorded
over three days in June and September 1962 at Abbey Road
studios, shortly after the band signed with EMI. It was released
in the UK on October 5, reaching number 17. But it was the band's
second single, "Please Please Me," that attracted the attention
of the record industry when it was released in January 1963.
It reached number 2 and left the people clamoring for more.
To ride on this success, the band needed to produce an album
sharpish, so *Please Please Me* was released just two months
later, on March 22.

The norm for British 12″ vinyl pop albums in 1963 was to
have seven songs on each side. These would include the four
sides of the two singles "Love Me Do"/"P.S. I Love You" and
"Please Please Me"/"Ask Me Why." But this still left The Beatles'
producer George Martin with ten tracks to fill. George asked
the band what they could record quickly and the answer was
their stage act. So the album is essentially a straightforward
performance of their live repertoire at the time.

PLEASE PLEASE ME
MARCH 1963

March 21, 1963
The Alcatraz Federal Penitentiary on Alcatraz Island in San Francisco Bay closes.

May 1, 1963
The Coca-Cola Company introduces its first diet drink.

July 1, 1963
ZIP codes are introduced by the US Postal Service.

March 28, 1963
Alfred Hitchcock's film *The Birds* is released in the United States.

June 3, 1963
Pope John XXIII dies.

March 22, 1963
Please Please Me album is released.

May 8, 1963
Dr. No, the first James Bond film, is shown in US theaters.

March 5, 1963
Country music superstar Patsy Cline is killed in a plane crash.

April 8, 1963
Julian Lennon is born in Liverpool to John and Cynthia Lennon.

June 16, 1963
Vostok 6 carries the first woman into space, Soviet cosmonaut Valentina Tereshkova.

September 16, 1963
Malaysia is formed through the merging of the
Federation of Malaya and the British crown
colony of Singapore, North Borneo, and Sarawak.

July 26, 1963
NASA launches *Syncom 2*, the world's
first geostationary satellite.

October 16, 1963
The thousandth day of
John F. Kennedy's presidency.

August 8, 1963
The Great Train Robbery
takes place in
Buckinghamshire, England.

September 16, 1963
"She Loves You"
is released.

July 12, 1963
"Twist and Shout"
is released.

August 28, 1963
Martin Luther King Jr. delivers
his "I Have a Dream" speech.

August 8, 1963
Kyoko Chan Cox is born in Japan
to Yoko Ono and Anthony Cox.

October 13, 1963
The Beatles' performance on ITV's weekly
musical variety show, *Val Parnell's Sunday Night
at the London Palladium*, launches Beatlemania.

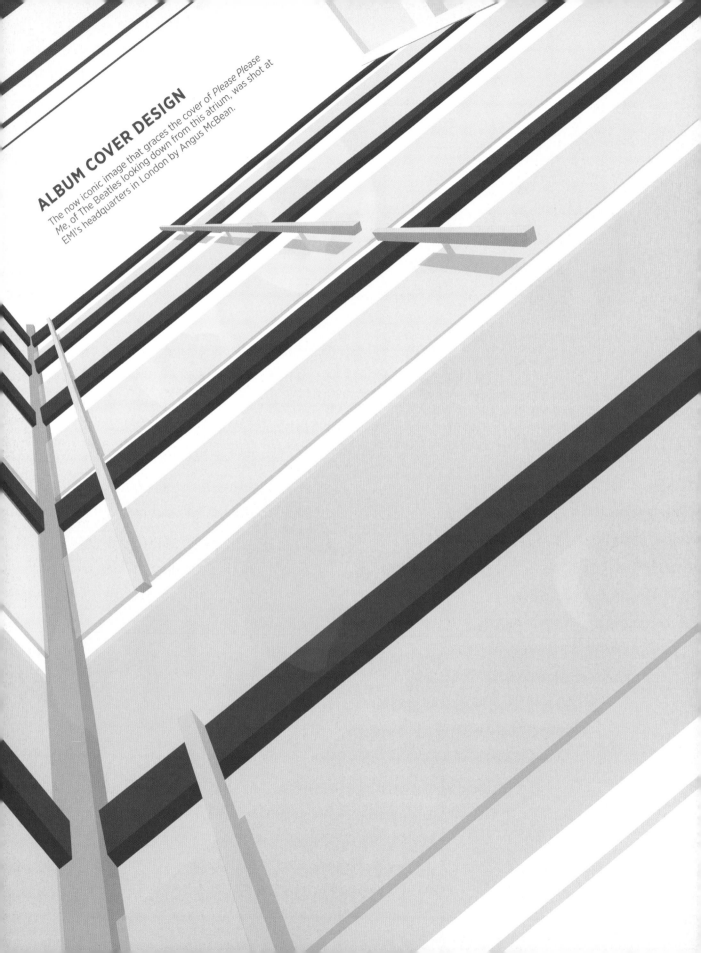

ALBUM COVER DESIGN

The now iconic image that graces the cover of *Please Please Me*, of The Beatles looking down from this atrium, was shot at EMI's headquarters in London by Angus McBean.

"

IT WAS A DAY THAT LASTED THREE WEEKS... WE DID 11 SONGS IN 11 HOURS!

"

— GEORGE MARTIN —

(PRODUCER) ON RECORDING PLEASE PLEASE ME

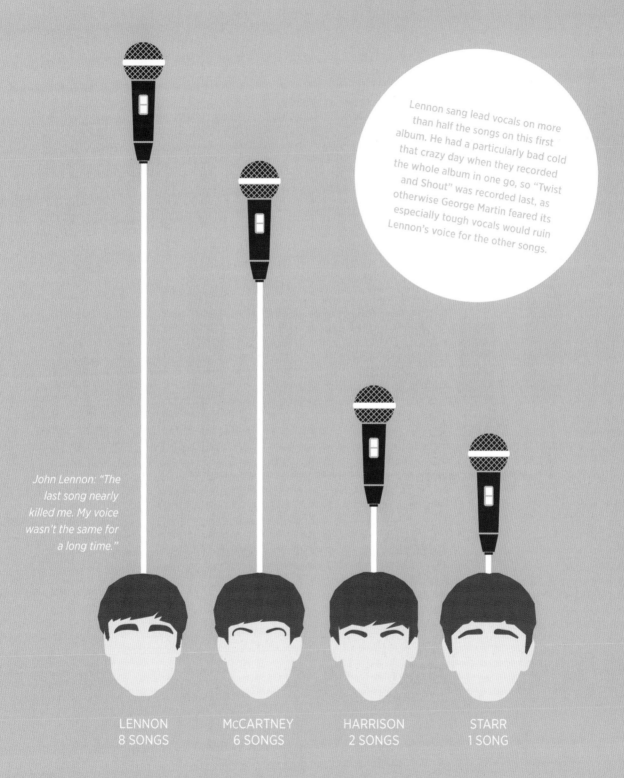

Lennon sang lead vocals on more than half the songs on this first album. He had a particularly bad cold that crazy day when they recorded the whole album in one go, so "Twist and Shout" was recorded last, as otherwise George Martin feared its especially tough vocals would ruin Lennon's voice for the other songs.

John Lennon: "The last song nearly killed me. My voice wasn't the same for a long time."

LENNON
8 SONGS

McCARTNEY
6 SONGS

HARRISON
2 SONGS

STARR
1 SONG

When band members shared lead vocals, both are listed. As a result, the total may add up to more than the number of tracks on the album.

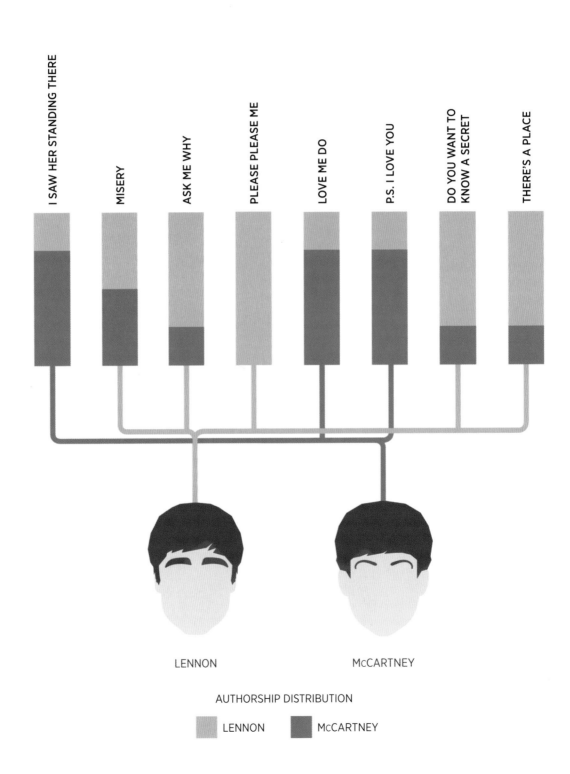

LENNON

McCARTNEY

AUTHORSHIP DISTRIBUTION

LENNON McCARTNEY

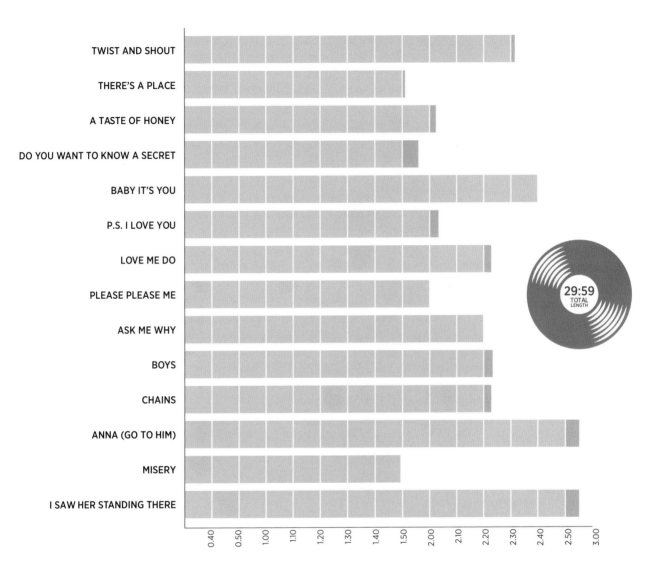

TWIST AND SHOUT
THERE'S A PLACE
A TASTE OF HONEY
DO YOU WANT TO KNOW A SECRET
BABY IT'S YOU
P.S. I LOVE YOU
LOVE ME DO
PLEASE PLEASE ME
ASK ME WHY
BOYS
CHAINS
ANNA (GO TO HIM)
MISERY
I SAW HER STANDING THERE

29:59
TOTAL LENGTH

0.40 · 0.50 · 1.00 · 1.10 · 1.20 · 1.30 · 1.40 · 1.50 · 2.00 · 2.10 · 2.20 · 2.30 · 2.40 · 2.50 · 3.00

6 COVERS

VS

8 ORIGINALS

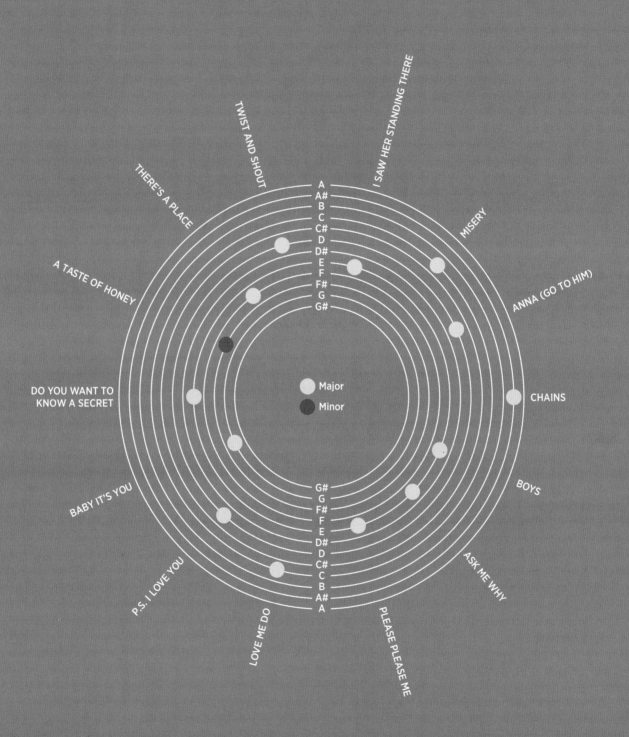

UK SINGLE RELEASES

I SAW HER STANDING THERE
MISERY
ANNA (GO TO HIM)
CHAINS
BOYS
ASK ME WHY
PLEASE PLEASE ME
LOVE ME DO
P.S. I LOVE YOU
BABY IT'S YOU
DO YOU WANT TO KNOW A SECRET
A TASTE OF HONEY
THERE'S A PLACE
TWIST AND SHOUT

17 17

2 2

"Love Me Do" was the first single The Beatles ever released (with "P.S. I Love You" as the B-side), closely followed by "Please Please Me" (B-side: "Ask Me Why"), which was much more successful, reaching number 2 in the main Record Retailer chart, but number 1 in the NME charts. For the US edition, several songs were cut and it was retitled "Introducing the Beatles."

Non-album singles that reached number 1 around this time include "From Me To You"/"Thank You Girl" (4/11/63), "She Loves You"/"I'll Get You" (8/23/63), and "I Want to Hold Your Hand"/ "This Boy" (11/29/63).

- NOT RELEASED
- TOP 20
- TOP 10

ALBUM CHART POSITIONS

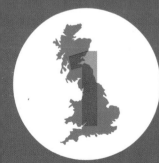

UNITED KINGDOM
Number One

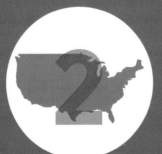

UNITED STATES
Number Two

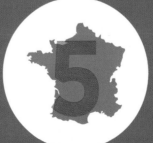

FRANCE
Number Five

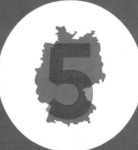

GERMANY
Number Five

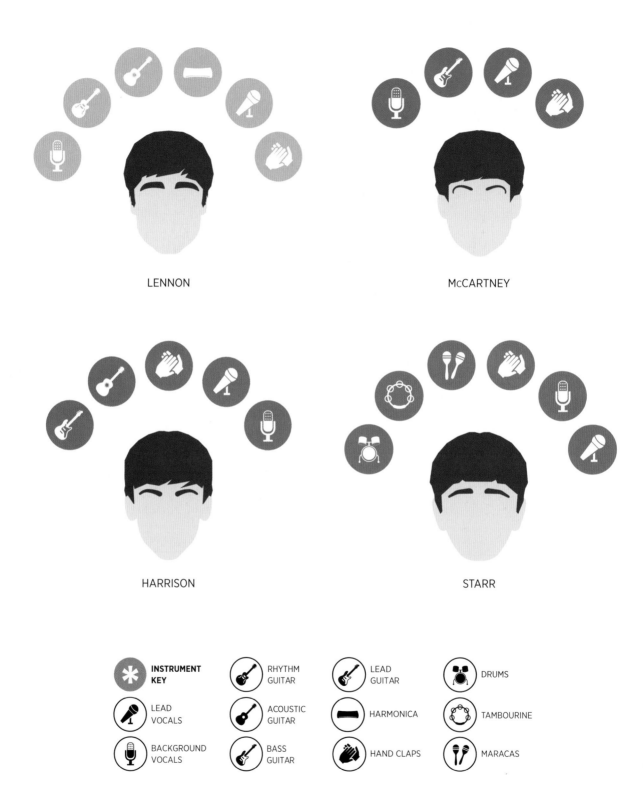

LENNON

McCARTNEY

HARRISON

STARR

INSTRUMENT KEY

LEAD VOCALS

BACKGROUND VOCALS

RHYTHM GUITAR

ACOUSTIC GUITAR

BASS GUITAR

LEAD GUITAR

HARMONICA

HAND CLAPS

DRUMS

TAMBOURINE

MARACAS

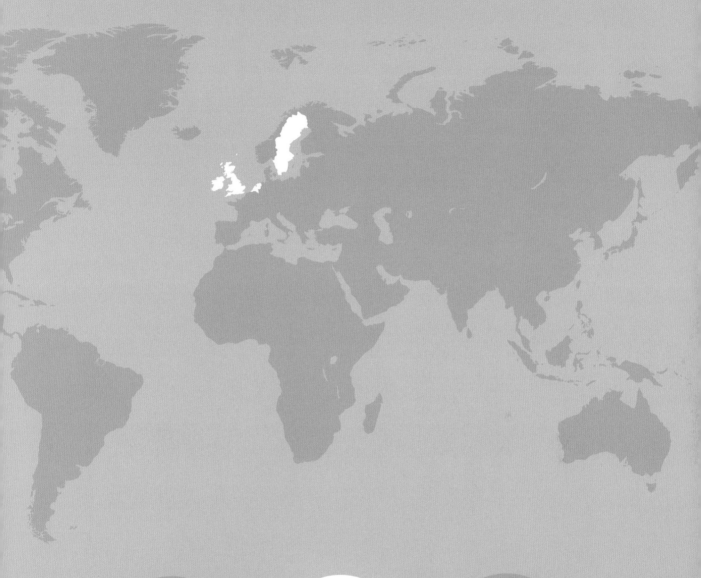

3

COUNTRIES

7

TOURS

259

LIVE SHOWS

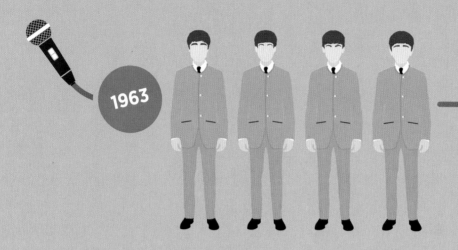

1963

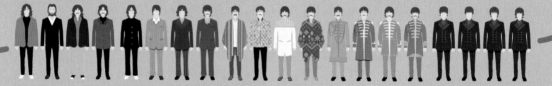

late 1963 mid-1964 late 1964 mid-1965 late 1965

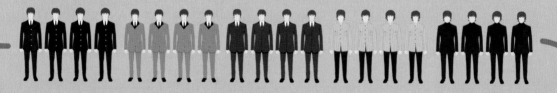

early 1969 late 1968 late 1967 mid-1967 mid-1966

1969 1970

1970

The classic collarless suits of The Beatles' early years were an immediate hit. While many people credit the design to Pierre Cardin, they were designed by The Beatles' stylist, Douglas Millings. They differ slightly from the Cardin design, but it is likely that Millings took his inspiration from the slim, sleek, and revolutionary cut of his suits.

Birth of Rock and Roll

A major influence on The Beatles' early sound, Carl Perkins was a rock-and-roll pioneer and inspired the young Beatles to perform this style of music. Like Chuck Berry, The Beatles and The Quarrymen often played Perkins's songs in their live shows, with covers of at least 11 of his songs making their way into the set lists. The Beatles would record and release three Perkins covers, "Honey Don't," "Everybody's Trying to be My Baby," and "Matchbox," all in 1964. Other covers such as "Glad All Over" and "Sure to Fall (In Love with You)" appeared on the *Live at the BBC* albums, with "Blue Suede Shoes," "Your True Love," and "Tennessee" played on the 1969 *Get Back* sessions but never recorded.

If there were no Carl Perkins there would be no Beatles.

Paul McCartney

ALBUM OVERVIEW

Released: November 22, 1963
Producer: George Martin
Engineer: Norman Smith

With the Beatles was recorded in just seven
(nonconsecutive) days. Released exactly eight months
after *Please Please Me*, it was an immediate hit and
cemented the band's newfound stardom. In fact, the
album's release had to be delayed because of the
sensational success of *Please Please Me*, which was
still at the top of the UK album chart.

It took the release of The Beatles' second album to
topple it to number 2. *With the Beatles* was at
number 1 for 21 weeks, giving the band a spectacular
continuous run of 51 weeks in the top spot.

WITH THE BEATLES
NOVEMBER 1963

November 22, 1963
US president John F. Kennedy is assassinated by Lee Harvey Oswald.

November 23, 1963
The first episode of the BBC television series *Doctor Who* is broadcast.

January 18, 1964
Plans to build the New York City World Trade Center are announced.

March 9, 1964
The first Ford Mustang rolls off the assembly line at Ford Motor Company.

February 25, 1964
Muhammad Ali beats Sonny Liston in Miami Beach, Florida.

November 22, 1963
With the Beatles is released.

February 9, 1964
The Beatles appear on *The Ed Sullivan Show*, their first live performance on American television.

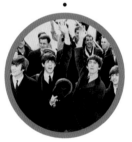

November 18, 1963
The first push-button telephone is made available to AT&T customers.

December 12, 1963
Kenya gains independence from the United Kingdom.

March 6, 1964
Malcolm X says in New York City that he is forming a black nationalist party.

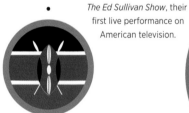

April 16, 1964
The Rolling Stones release their
debut album, *The Rolling Stones.*

May 12, 1964
Twelve young men in New York City publicly
burn their draft cards to protest the Vietnam War,
the first such act of war resistance.

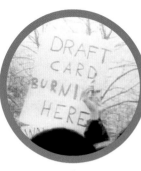

April 26, 1964
Tanganyika and Zanzibar
merge to form Tanzania.

June 12, 1964
Nelson Mandela and seven others are
sentenced to life imprisonment on
Robben Island, South Africa.

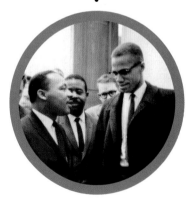

April 7, 1964
IBM announces
the System/360.

May 1, 1964
John George Kemeny and
Thomas Eugene Kurtz
run the first computer
program written in BASIC.

April 20, 1964
Nelson Mandela makes his "I Am Prepared to Die" speech at the
opening of the Rivonia Trial, a key event for the anti-apartheid movement.

July 2, 1964
President Lyndon Johnson signs the Civil
Rights Act of 1964 into law, officially abolishing
racial segregation in the United States.

ALBUM COVER DESIGN

The photograph for *With the Beatles*' cover was taken by Robert Freeman in a corridor of the Palace Court Hotel in Bournemouth, UK. The Beatles wanted a treatment similar to the iconic images of Astrid Kirchherr, which they had shown to Freeman. Kirchherr was a friend of the band whom, along with Klaus Voormann, they had met in Hamburg in their early days. Ringo (as he was the shortest) was placed in the bottom right corner, rather than in a line with the others, in order to fit the square format of the cover.

EMI were reluctant to use the photo at first because it was black and white, but George Martin and Brian Epstein convinced them.

"

WE LIKE DOING STAGE SHOWS, BUT THE THING WE LIKE BEST IS GOING INTO THE RECORDING STUDIO TO MAKE NEW RECORDS.

"

—— PAUL McCARTNEY ——

1963, AROUND WITH THE BEATLES

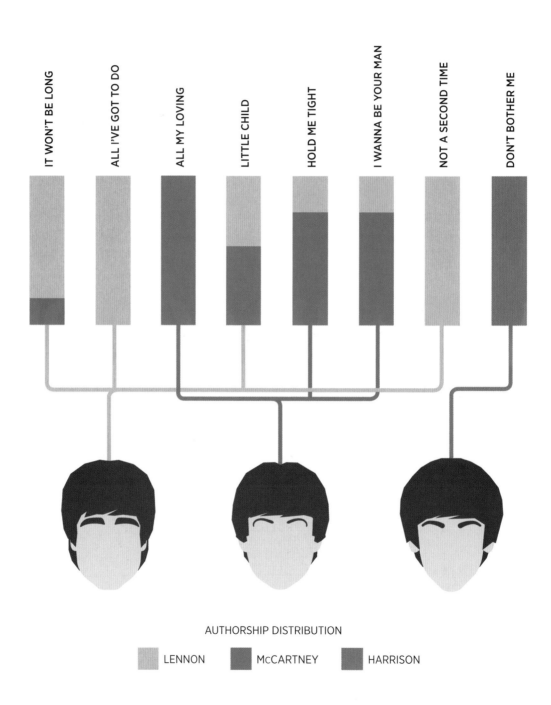

IT WON'T BE LONG

ALL I'VE GOT TO DO

ALL MY LOVING

LITTLE CHILD

HOLD ME TIGHT

I WANNA BE YOUR MAN

NOT A SECOND TIME

DON'T BOTHER ME

AUTHORSHIP DISTRIBUTION

LENNON McCARTNEY HARRISON

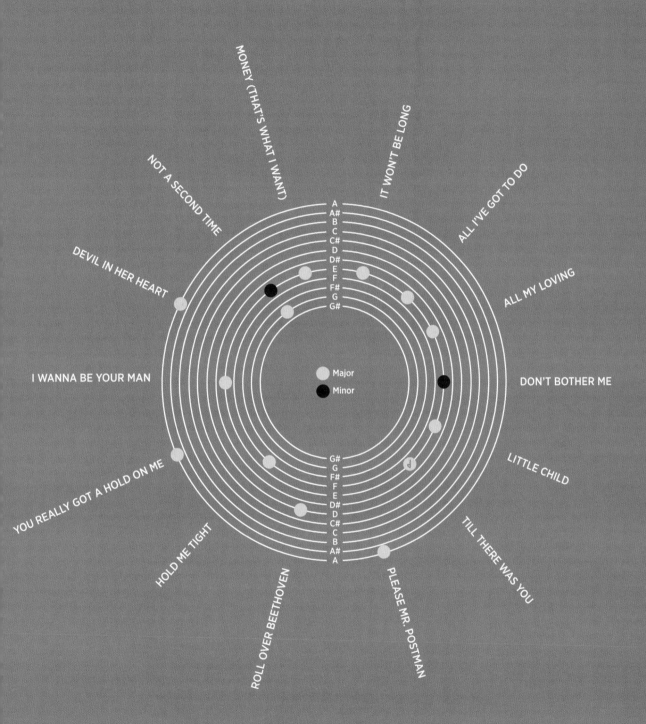

MONEY (THAT'S WHAT I WANT)

IT WON'T BE LONG

NOT A SECOND TIME

ALL I'VE GOT TO DO

DEVIL IN HER HEART

ALL MY LOVING

A
A#
B
C
C#
D
D#
E
F
F#
G
G#

I WANNA BE YOUR MAN

Major
Minor

DON'T BOTHER ME

G#
G
F#
F
E
D#
D
C#
C
B
A#
A

LITTLE CHILD

YOU REALLY GOT A HOLD ON ME

TILL THERE WAS YOU

HOLD ME TIGHT

ROLL OVER BEETHOVEN

PLEASE MR. POSTMAN

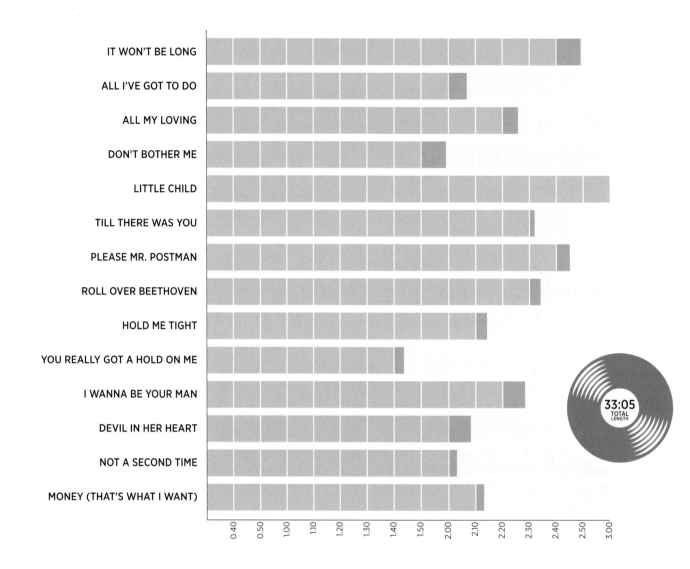

| | 0.40 | 0.50 | 1.00 | 1.10 | 1.20 | 1.30 | 1.40 | 1.50 | 2.00 | 2.10 | 2.20 | 2.30 | 2.40 | 2.50 | 3.00 |

IT WON'T BE LONG

ALL I'VE GOT TO DO

ALL MY LOVING

DON'T BOTHER ME

LITTLE CHILD

TILL THERE WAS YOU

PLEASE MR. POSTMAN

ROLL OVER BEETHOVEN

HOLD ME TIGHT

YOU REALLY GOT A HOLD ON ME

I WANNA BE YOUR MAN

DEVIL IN HER HEART

NOT A SECOND TIME

MONEY (THAT'S WHAT I WANT)

33:05
TOTAL
LENGTH

6 COVERS

VS

8 ORIGINALS

38

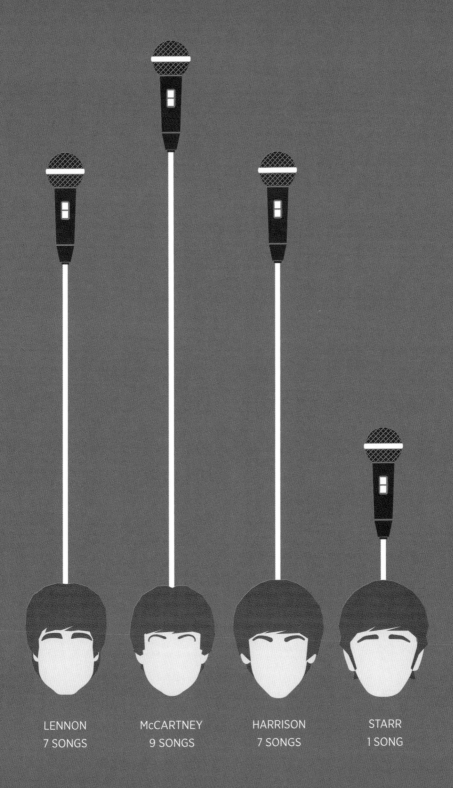

LENNON
7 SONGS

McCARTNEY
9 SONGS

HARRISON
7 SONGS

STARR
1 SONG

When band members shared lead vocals, both are listed. As a result, the total may add up to more than the number of tracks on the album.

UK SINGLE RELEASES

IT WON'T BE LONG
ALL I'VE GOT TO DO
ALL MY LOVING
DON'T BOTHER ME
LITTLE CHILD
TILL THERE WAS YOU
PLEASE MR. POSTMAN
ROLL OVER BEETHOVEN
HOLD ME TIGHT
YOU REALLY GOT A HOLD ON ME
I WANNA BE YOUR MAN
DEVIL IN HER HEART
NOT A SECOND TIME
MONEY (THAT'S WHAT I WANT)

No songs from *With the Beatles* were released as singles, but in the interim between *Please Please Me* and this album, the single "She Loves You" was released and went to number 1 in both the UK and the US. Then, one week after *With the Beatles* came out, the band had another runaway hit with "I Want to Hold Your Hand."

NOT RELEASED
TOP 20
TOP 10

ALBUM CHART POSITIONS

UNITED KINGDOM
Number One

GERMANY
Number One

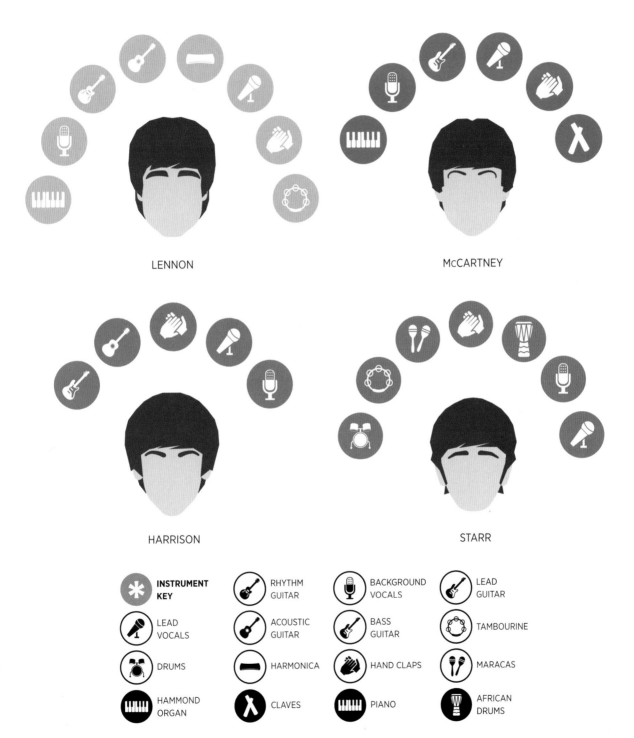

LENNON

McCARTNEY

HARRISON

STARR

	INSTRUMENT KEY		RHYTHM GUITAR		BACKGROUND VOCALS		LEAD GUITAR
	LEAD VOCALS		ACOUSTIC GUITAR		BASS GUITAR		TAMBOURINE
	DRUMS		HARMONICA		HAND CLAPS		MARACAS
	HAMMOND ORGAN		CLAVES		PIANO		AFRICAN DRUMS

Black circle indicates instruments used for the first time in a Beatles' album.

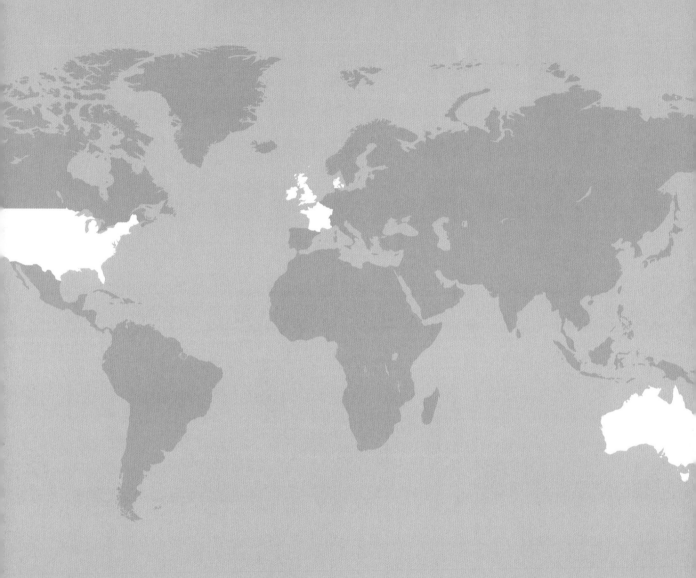

8

COUNTRIES

6

TOURS

157

LIVE SHOWS

Press Conference Humor

The Beatles' dry sense of humor led to some classic press conference retorts showcasing true British wit.

How do you feel about teenagers imitating you with Beatles wigs?

They're not imitating us because we don't wear Beatles wigs!

How did you find America?

Turned left at Greenland.*

Do you speak French?

Non.

Does it bother you that you can't hear what you sing during concerts?

No, we don't mind. We've got the records at home.

What would you do if the fans got past the police lines?

We'd die laughing!

What do you do when you're cooped up in a hotel room between shows?

We ice skate.

Are you a mod or a rocker?

I'm a mocker.

What do you call that hairstyle?

Arthur.*

Were you worried about the oversized roughnecks who tried to infiltrate the airport crowd on your arrival?

That was us . . .

* Quotes taken from the script of *A Hard Day's Night*.

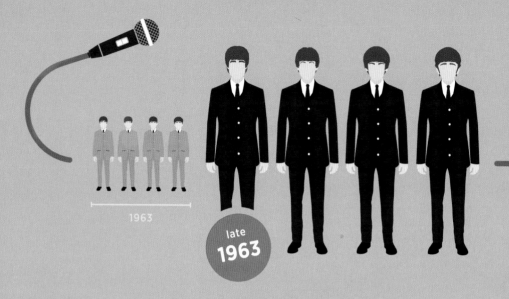

1963

late
1963

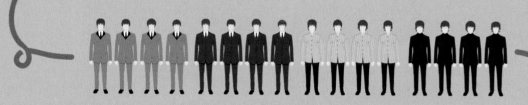

mid-1964 late 1964 mid-1965 late 1965

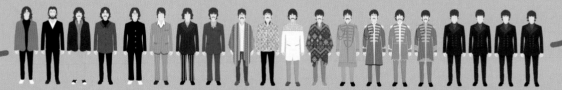

early 1969 late 1968 late 1967 mid-1967 mid-1966

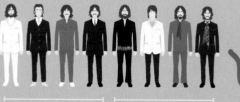

1969 1970

1970

The classic English Chesterfield suit was another favorite of The Beatles during their early years. Characterized by the velvet lapels and high buttoning, they are also known as "Sullivan suits," as they were the ones worn by the band for their historic first appearance on *The Ed Sullivan Show.*

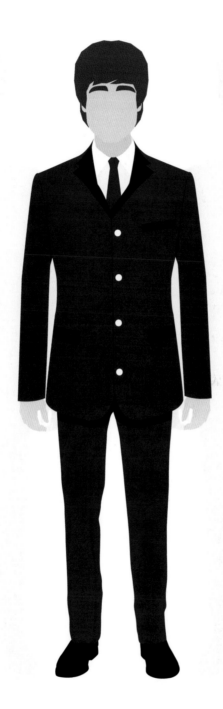

British Invasion

The Beatles left the United Kingdom on February 7, 1964, heading for the United States. When they left Heathrow Airport on Pan Am Flight 101, an estimated 4,000 fans were present to see them off. The Beatles were accompanied by an entourage of journalists, photographers, and producer Phil Spector. Their arrival in the US marked the beginning of what would be termed the "British Invasion," and a change in the direction of popular music in America.

Arriving in New York's John F. Kennedy Airport, the band were again greeted by a large crowd of fans and journalists. The airport had never seen such a substantial gathering, and reports suggest a few members of the crowd were injured due to the number of people packed into a small space.

After a press conference, the band were driven to New York City in individual limousines. On the way, McCartney reportedly listened to a running commentary of their journey on the radio. Upon arriving at the Plaza Hotel in New York, the band were again mobbed by fans and reporters.

The US Top Five

For the week of April 4, 1964, The Beatles achieved a feat that's unlikely ever to be repeated: occupying the top five positions of the *Billboard* Hot 100 chart.

Not only did the band hold the top five positions, but they also had a further seven records in the top 100, giving them 12 places in total on the US chart. Let's have a look at that chart in full . . .

1 Can't Buy Me Love
The Beatles

2 Twist and Shout
The Beatles

3 She Loves You
The Beatles

4 I Want to Hold Your Hand
The Beatles

5 Please Please Me
The Beatles

6 Suspicion
Terry Stafford

7 Hello, Dolly!
Louis Armstrong and The All Stars

8 The Shoop Shoop Song (It's in His Kiss)
Betty Everett

9 My Heart Belongs to Only You
Bobby Vinton

10 Glad All Over
The Dave Clark Five

11 Dawn (Go Away)
The 4 Seasons

12 The Way You Do the Things You Do
The Temptations

13 Fun, Fun, Fun
The Beach Boys

14 Don't Let the Rain Come Down (Crooked Little Man)
The Serendipity Singers

15 Needles and Pins
The Searchers

16 Stay
The 4 Seasons

17 Kissin' Cousins
Elvis Presley with The Jordanaires

18 You're a Wonderful One
Marvin Gaye

19 Java
Al (He's the King) Hirt

20 Hi-Heel Sneakers
Tommy Tucker

21 Ain't Nothing You Can Do
Bobby Bland

22 Money
The Kingsmen

23 I Love You More and More Every Day
Al Martino

24 Hippy Hippy Shake
The Swinging Blue Jeans

25 Dead Man's Curve
Jan & Dean

26 Think
Brenda Lee

27 Navy Blue
Diane Renay

28 Blue Winter
Connie Francis

29 It Hurts Me
Elvis Presley with The Jordanaires

30 Nadine (Is It You?)
Chuck Berry

31 I Saw Her Standing There
The Beatles

32 Hey Jean, Hey Dean
Dean and Jean

33 Tell It on the Mountain
Peter, Paul & Mary

34 White on White
Danny Williams

35 Hey, Bobba Needle
Chubby Checker

36 Rip Van Winkle
The Devotions

37 See the Funny Little Clown
Bobby Goldsboro

38 My Heart Cries for You
Ray Charles

39 That's the Way Boys Are
Lesley Gore

40 The New Girl in School
Jan & Dean

41 From Me to You
The Beatles

42 We Love You Beatles
The Carefrees

43 Understand Your Man
Johnny Cash

44 Forever
Pete Drake and His Talking Steel Guitar

45 Penetration
The Pyramids

46 Do You Want to Know a Secret
The Beatles

47 Ebb Tide
Lenny Welch

48 Bits and Pieces
The Dave Clark Five

The Ed Sullivan Show

On February 9, 1964, The Beatles gave their first live US television performance on *The Ed Sullivan Show*. The show aired at 8:00 that evening, and was viewed by 73 million people—approximately two-fifths of the total population of the United States. The Nielsen ratings audience measurement system ranks the show as having the largest number of viewers ever recorded for a US television show.

Interestingly, the day before the show, George Harrison had a fever of 102°F (39°C) and was told to stay in bed, so he was replaced on guitar for the rehearsal by Neil Aspinall, the band's personal assistant.

On Sunday, February 16, after successful concerts in Washington, D.C., and New York, the band gave their second performance on *The Ed Sullivan Show,* this time broadcast live from the Deauville Hotel in Miami Beach. The live show was watched by around 70 million people.

Between 1964 and 1970, the band would appear on the show nine times in total, including prerecorded segments, live performances, and via video. Their first performance, however, is the one that has gone down in history, and is considered by many one of the most important moments in rock-and-roll history.

Working for the Man

Roy Orbison was a close friend of The Beatles and a major influence on them, particularly George Harrison and John Lennon. In 1963 The Beatles supported Roy Orbison on tour, but they had taken his place as headliner by the time the tour ended. Still, the reception for Orbison was so great that The Beatles often worried they wouldn't get to perform their set, jokingly yelling out "Yankee, go home!" from the side of the stage.

Roy Orbison was the only
act that The Beatles didn't
want to follow.

Ringo Starr

ALBUM OVERVIEW

Released: July 10, 1964
Producer: George Martin
Engineer: Norman Smith

1964 was the year Beatlemania began to spread from the UK and infect the rest of the world. A US record deal was signed late in 1963, shortly before the band appeared on American TV's *The Ed Sullivan Show*, which was broadcast to more than 70 million people. A world tour followed, along with the band's debut feature film and innumerable interviews and recordings.

The title of the album was born out of a comment Ringo Starr made about working hard in the studio. It took nine days to record the 14 songs, which were solely written by Lennon and McCartney (the first album on which this is the case), and it was the first album to feature all original tunes. By now the band had advanced to four-track recording and the memorable chord that opens the album remains one of the most iconic moments in the band's music. Many years later, George Martin revealed that the chord was Fadd9, played on a 12-string guitar.

A HARD DAY'S NIGHT
JULY 1964

July 31, 1964
Ranger 7 sends back the first close-up photographs of the Moon.

September 21, 1964
The island of Malta obtains independence from the United Kingdom.

November 28, 1964
NASA launches the *Mariner 4* space probe from Cape Kennedy toward Mars.

August 27, 1964
Walt Disney's *Mary Poppins* has its world premier in Los Angeles.

October 14, 1964
Martin Luther King Jr. becomes the youngest recipient of the Nobel Peace Prize.

August 13, 1964
Gwynne Evans and Peter Allen become the last people to be executed in the United Kingdom.

October 2, 1964
The Kinks release their first album, *Kinks*.

September 18, 1964
King Constantine II of Greece marries Princess Anne-Marie of Denmark, who becomes Europe's youngest queen at age 18 years, 19 days.

November 9, 1964
The House of Commons of the United Kingdom votes to abolish the death penalty for murder in Britain.

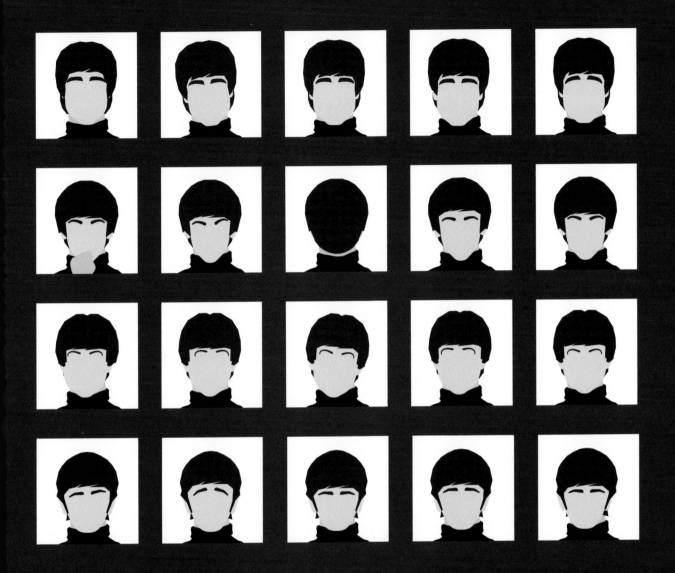

ALBUM COVER DESIGN

The original album cover was again designed and
photographed by Robert Freeman. Just as with *With the
Beatles*, Freeman used black-and-white photography of the
band, this time featuring multiple images of each member.
The concept is similar to that of a photography contact
sheet, which was used by photographers at the time to
allow them to view a mini-preview of a roll of film.

The idea was totally unique in its day, but in the years since
has become iconic and often imitated.

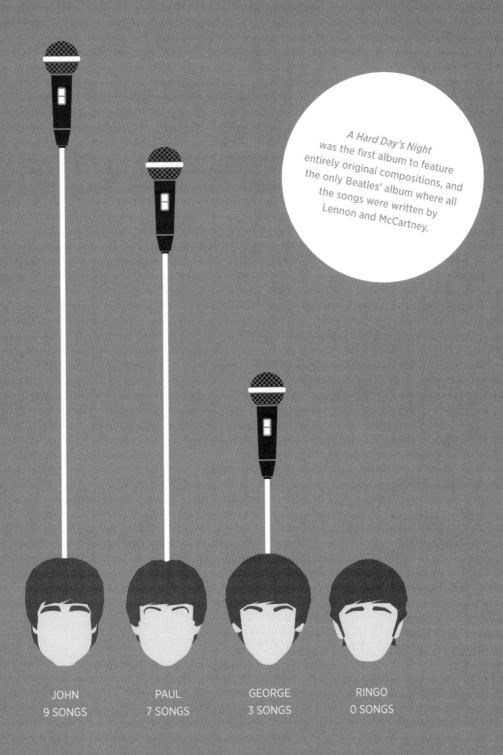

A Hard Day's Night was the first album to feature entirely original compositions, and the only Beatles' album where all the songs were written by Lennon and McCartney.

JOHN
9 SONGS

PAUL
7 SONGS

GEORGE
3 SONGS

RINGO
0 SONGS

When band members shared lead vocals, both are listed. As a result, the total may add up to more than the number of tracks on the album.

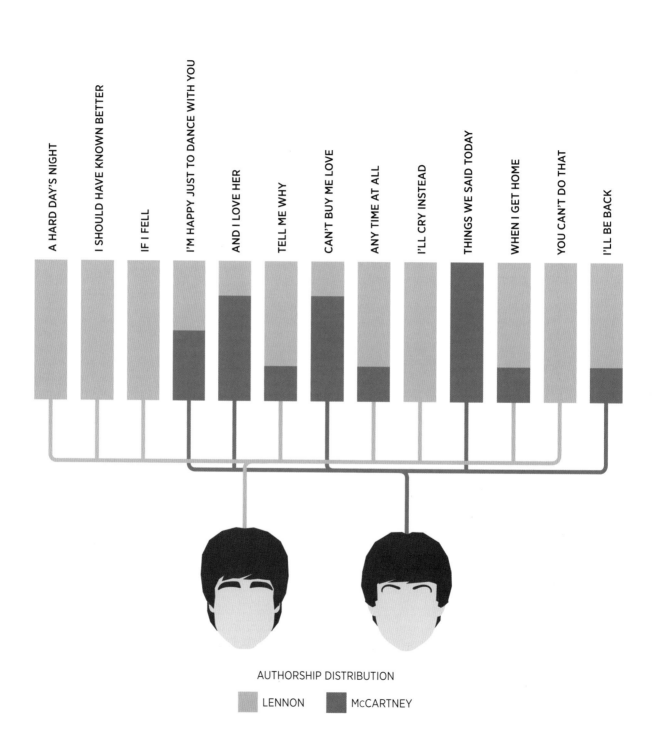

AUTHORSHIP DISTRIBUTION

LENNON McCARTNEY

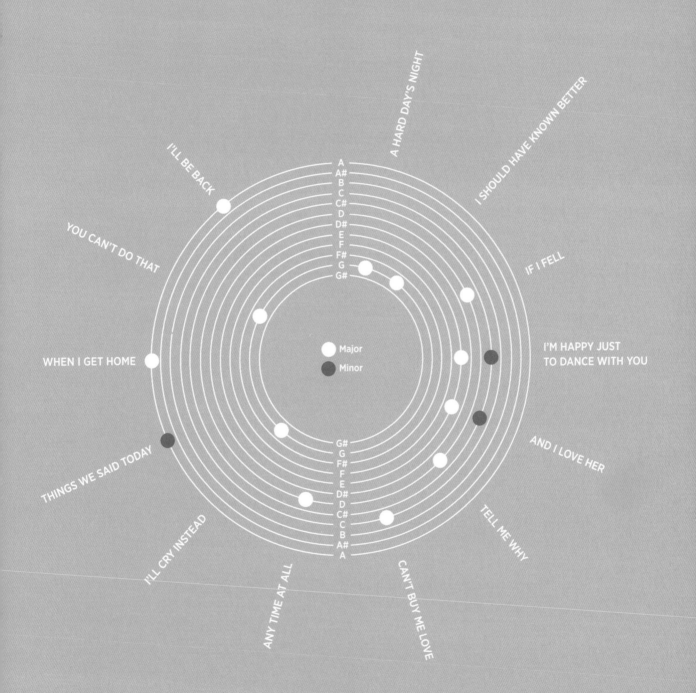

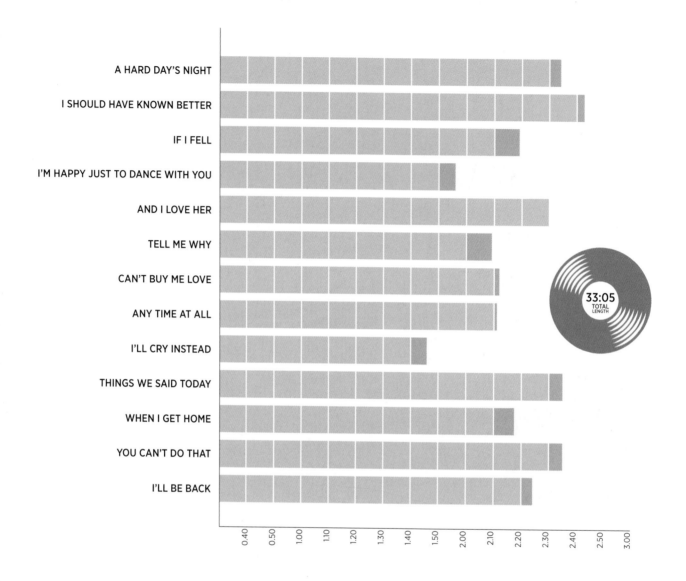

	0.40	0.50	1.00	1.10	1.20	1.30	1.40	1.50	2.00	2.10	2.20	2.30	2.40	2.50	3.00
A HARD DAY'S NIGHT															
I SHOULD HAVE KNOWN BETTER															
IF I FELL															
I'M HAPPY JUST TO DANCE WITH YOU															
AND I LOVE HER															
TELL ME WHY															
CAN'T BUY ME LOVE															
ANY TIME AT ALL															
I'LL CRY INSTEAD															
THINGS WE SAID TODAY															
WHEN I GET HOME															
YOU CAN'T DO THAT															
I'LL BE BACK															

33:05 TOTAL LENGTH

0 COVERS

VS

13 ORIGINALS

UK SINGLE RELEASES

A HARD DAY'S NIGHT
I SHOULD HAVE KNOWN BETTER
IF I FELL
I'M HAPPY JUST TO DANCE WITH YOU
AND I LOVE HER
TELL ME WHY
CAN'T BUY ME LOVE
ANY TIME AT ALL
I'LL CRY INSTEAD
THINGS WE SAID TODAY
WHEN I GET HOME
YOU CAN'T DO THAT
I'LL BE BACK

By the end of 1964, *A Hard Day's Night* had sold 600,000 copies and spent 21 consecutive weeks at the top of the UK album chart. The US version of the album sold over a million advance copies, and then another million within three months of its release, topping the US Billboard album chart for 14 weeks. It remains one of the fastest-selling albums of all time.

1 1

▬ NOT RELEASED
▬ TOP 20
▬ TOP 10

ALBUM CHART POSITIONS

UNITED KINGDOM
Number One

GERMANY
Number One

AUSTRALIA
Number Five

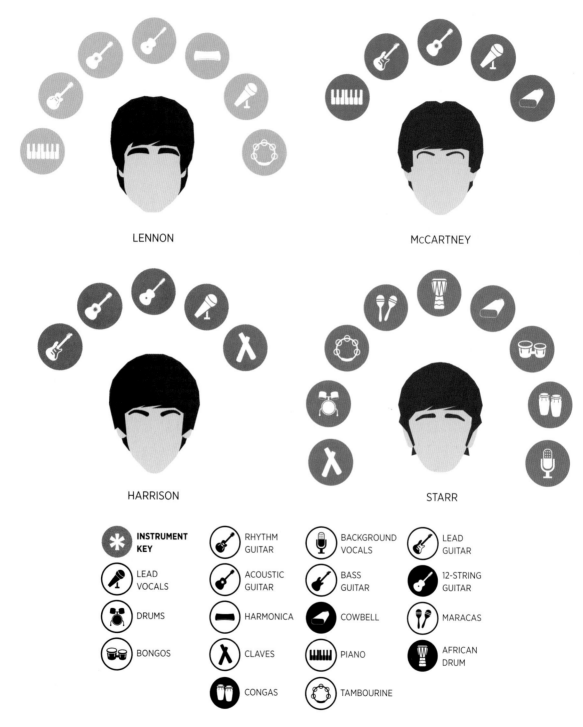

LENNON

McCARTNEY

HARRISON

STARR

INSTRUMENT KEY

LEAD VOCALS

DRUMS

BONGOS

RHYTHM GUITAR

ACOUSTIC GUITAR

HARMONICA

CLAVES

CONGAS

BACKGROUND VOCALS

BASS GUITAR

COWBELL

PIANO

TAMBOURINE

LEAD GUITAR

12-STRING GUITAR

MARACAS

AFRICAN DRUM

Black circle indicates instruments used for the first time in a Beatles' album.

4

COUNTRIES

3

TOURS

101

LIVE SHOWS

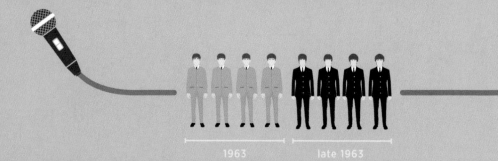

1963 late 1963

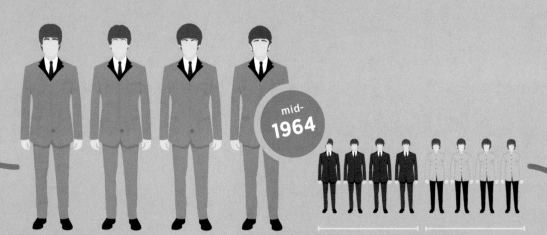

mid-1964

late 1964 mid-1965

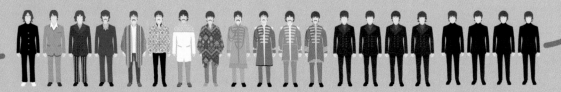

late 1968 late 1967 mid-1967 mid-1966 late 1965

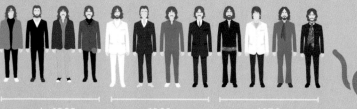

early 1969 1969 1970

1970

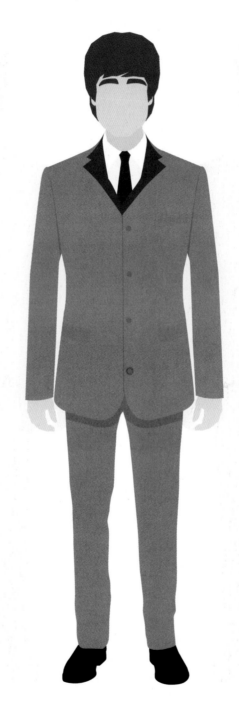

Similar in style to the classic
English Chesterfield suits worn
throughout 1963, this newer
model still has the black lapels
but is now a Harrier gray.

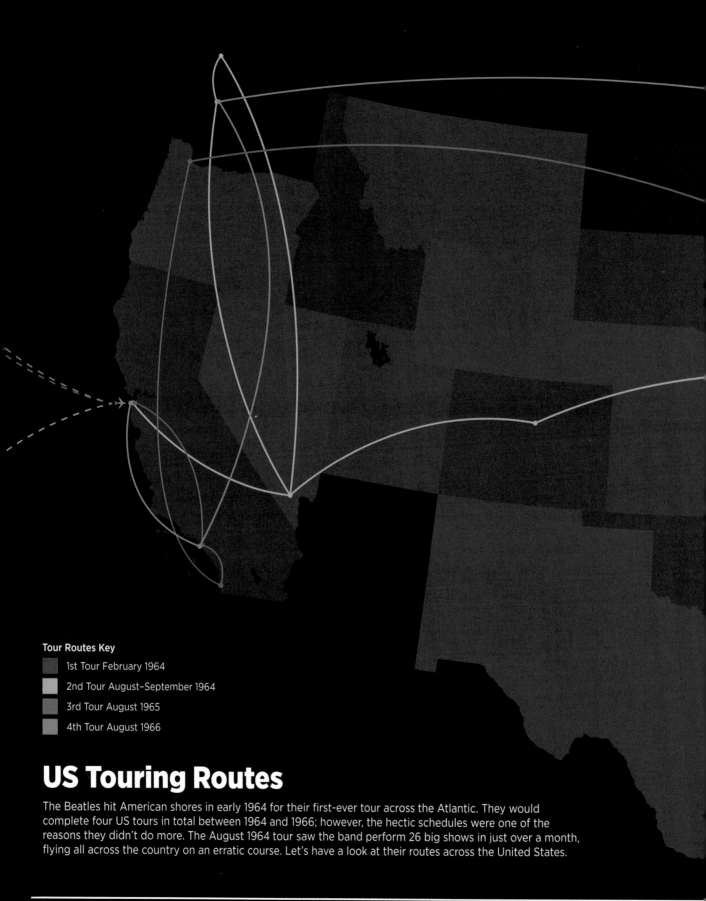

Tour Routes Key

■ 1st Tour February 1964

■ 2nd Tour August–September 1964

■ 3rd Tour August 1965

■ 4th Tour August 1966

US Touring Routes

The Beatles hit American shores in early 1964 for their first-ever tour across the Atlantic. They would complete four US tours in total between 1964 and 1966; however, the hectic schedules were one of the reasons they didn't do more. The August 1964 tour saw the band perform 26 big shows in just over a month, flying all across the country on an erratic course. Let's have a look at their routes across the United States.

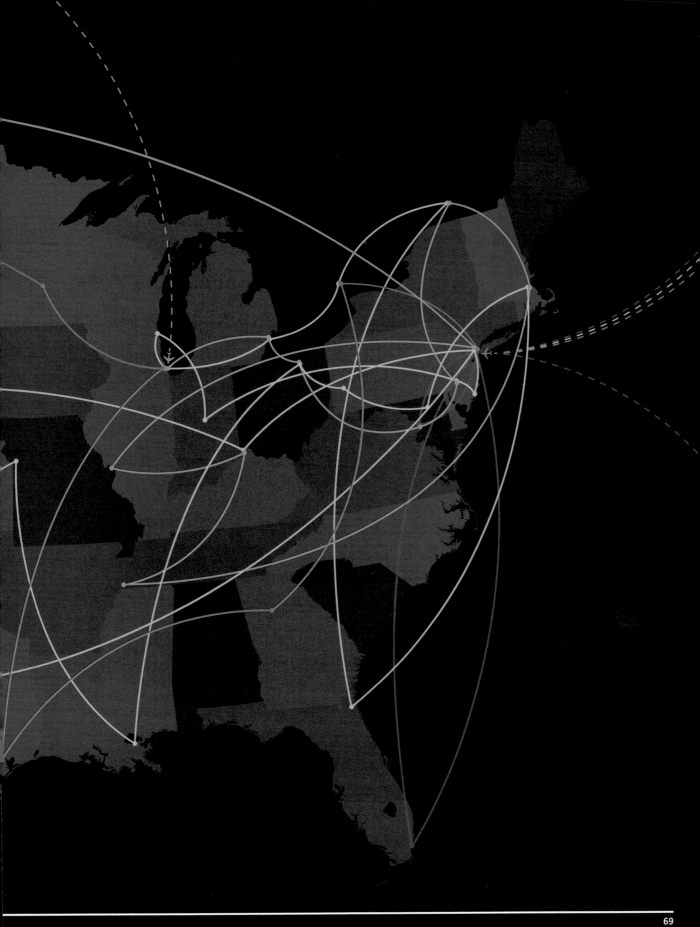

That'll Be the Day

Buddy Holly was a major influence on The Beatles, in particular John and Paul, who took great inspiration from him in their early years. The name "The Beatles" came from their admiration of Buddy, and they chose it after being inspired by Holly's band "The Crickets." The fact that Buddy Holly played and wrote his own songs was also a big part of his appeal, encouraging them to write too. Despite this, their admiration for him meant they covered several of his songs, including "Words of Love" and "Crying, Waiting, Hoping."

John and I started to write
because of Buddy Holly. It
was like wow—he writes and
is a musician.

Paul McCartney

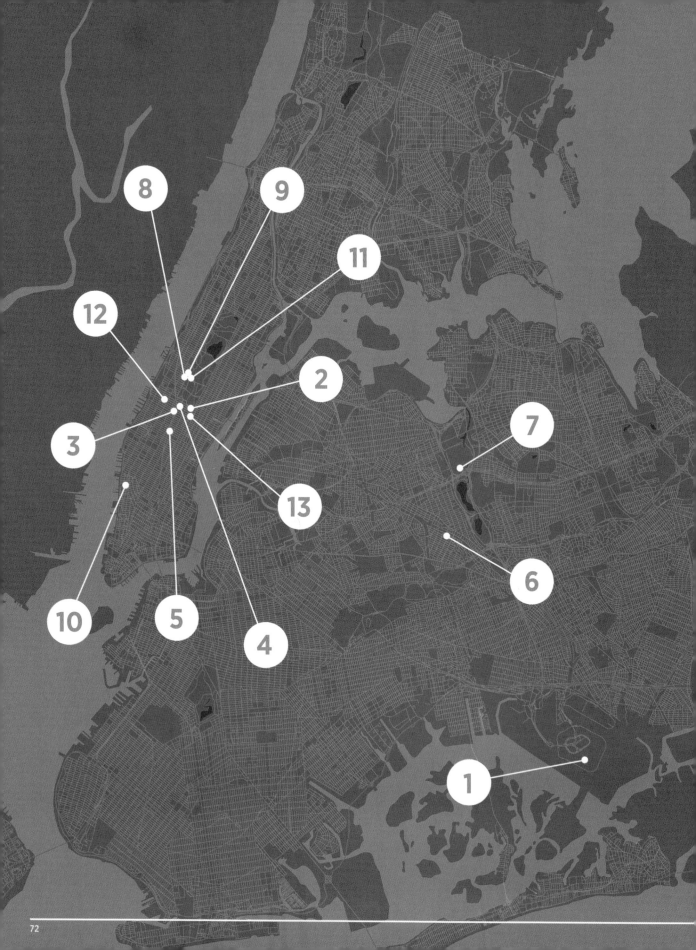

The Beatles in New York City

New York would become a hugely important place in the life and career of The Beatles, and there are many important areas of the city for Beatles fans. Let's have a look at some of the most notable locations:

1 JFK Airport, Queens, NY 11430
The Beatles arrived at JFK airport on February 7, 1964, on Pan Am "Yankee Clipper" flight 101, and with them came Beatlemania.

2 Plaza Hotel, 768 5th Avenue, New York, NY 10019
After the press conference given by the four, they were quickly taken to the Plaza Hotel, where they were staying, and thousands of screaming fans followed, blocking the road outside!

3 Ed Sullivan Theater, 1695 Broadway, New York, NY 10019
On February 9, The Beatles played their first US television appearance on *The Ed Sullivan Show*, a broadcast that was watched by more than 73 million people!

4 Carnegie Hall, 881 7th Avenue, New York, NY 10019
On February 12, The Beatles played two shows at Carnegie Hall, the first live concerts (barring the appearances on *The Ed Sullivan Show*). Each were seen by 2,900 lucky fans.

5 Paramount Theatre, 1501 Broadway, New York, NY 10036
The Beatles played a charity gig here on September 20, which marked the last date of their first US tour. Around 3,600 people were inside, and nearly 100,000 outside!

6 Forest Hills Stadium, 1 Tennis Place, Forest Hills, NY 11375
The Beatles played two dates here on August 28 and 29, 1964, to 16,000 people each night, as part of the Forest Hills Music Festival, which took place all summer.

7 Shea Stadium, 123-01 Roosevelt Avenue, Flushing, Queens, New York 11368
The band played two dates here in August 1965 and 1966. The first was one of the most famous Beatles appearances in the US in front of a crowd of more than 55,000 screaming fans.

8 The Dakota, 1 West 72nd Street, New York, NY 10023
One of Manhattan's most prestigious buildings, originally designed and built for the head of Singer sewing machines, and John's residence with Yoko from 1973 until his murder in 1980.

9 Cafe La Fortuna, 69 West 71st Street, New York, NY 10023
Just around the corner from the Dakota building, an old café that was a favorite hangout of John and Yoko when they lived in New York.

10 105 Bank Street, New York, NY 10014
A two-bed, top-floor apartment in the trendy Greenwich Village area of New York, John and Yoko moved here from the St. Regis hotel in 1971 and stayed until they moved to the Dakota.

11 Strawberry Fields, West 72nd Street, New York, NY 10019
The 2.5-acre memorial section in Central Park, near the Dakota, dedicated to the memory of John, and featuring the "Imagine" mosaic as its centerpiece.

12 The Hit Factory, 421 West 54th Street, New York, NY 10019
The recording studio where John produced his last work, days before his death. It is not known exactly what he was working on, but many people think he was mixing tracks for Yoko.

13 St. Regis Hotel, 2 East 55th Street, New York, NY 10022
John's first residence outside of the UK, a suite on the seventh floor of the iconic St. Regis, where he stayed for two months before renting the Bank Street apartment.

ALBUM OVERVIEW

Release: December 4, 1964
Producer: George Martin
Engineer: Norman Smith

Beatlemania was at its height when *Beatles For Sale* was made. Recording sessions had to be fit in around the band's hectic schedule and it has been documented that they were absolutely exhausted. As a result, George Martin has said the album isn't particularly memorable.

Indeed, the band lacked some of the creative drive showcased in the previous album, demonstrated by the band's use of old cover versions and early Lennon-McCartney compositions, along with only a few new songs. It has also been suggested that the more downbeat tone of the album in comparison to *A Hard Day's Night* is a further reflection of their depleted energy levels. The growing influence of Bob Dylan on the band, particularly on John Lennon, was also becoming evident.

"Eight Days a Week" was the first pop music recording to feature a fade-in introduction and "Every Little Thing" was one of the first recorded songs to feature multitracked bass guitar.

BEATLES FOR SALE
DECEMBER 1964

January 20, 1965
Lyndon B. Johnson is sworn in as
US president for his second term.

March 8, 1965
US Marines arrive in Da Nang, South Vietnam, becoming
the first American ground combat troops in Vietnam.

July 29, 1965
The Beatles' second
movie *Help!* premieres.

February 15, 1965
A new red-and-white
maple leaf design is
inaugurated as the flag of Canada.

January 30, 1965
The state funeral of Sir Winston
Churchill takes place in London.

March 18, 1965
Cosmonaut Alexey Leonov,
leaving his spacecraft *Voskhod 2*
for 12 minutes, becomes the
first person to walk in space.

July 14, 1965
US spacecraft *Mariner 4* flies by Mars,
becoming the first spacecraft to return
images from the Red Planet.

February 21, 1965
African American Muslim minister
and human rights activist Malcolm X
is assassinated in New York City.

"

JOHN AND I WOULD SIT DOWN
AND BY THEN IT MIGHT BE ONE OR TWO O'CLOCK,
BY FOUR OR FIVE O'CLOCK
WE'D BE DONE.

"

— PAUL McCARTNEY —
ON WRITING BEATLES FOR SALE

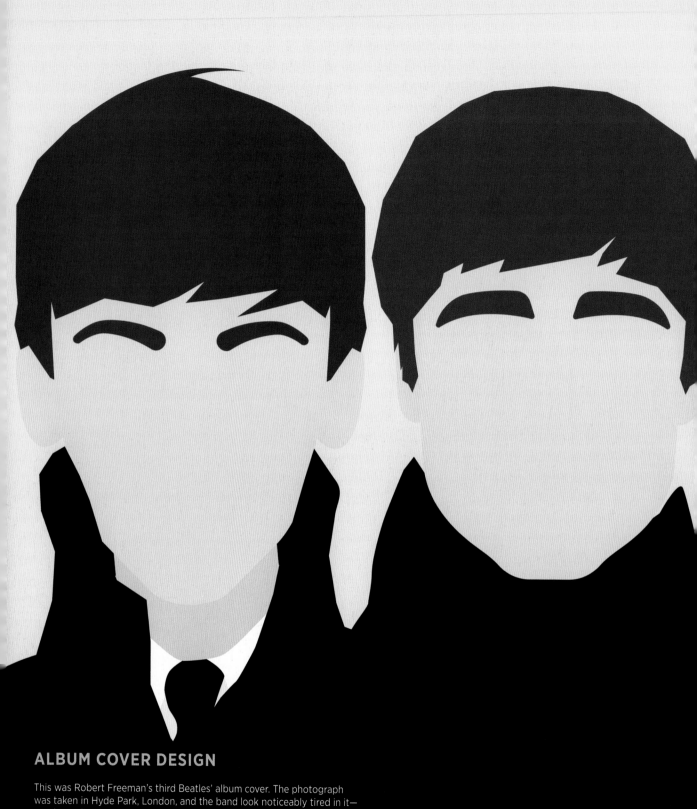

ALBUM COVER DESIGN

This was Robert Freeman's third Beatles' album cover. The photograph
was taken in Hyde Park, London, and the band look noticeably tired in it—
another reflection of their intense schedule at the time. The album was
packaged in a gatefold sleeve, which was a first for The Beatles.

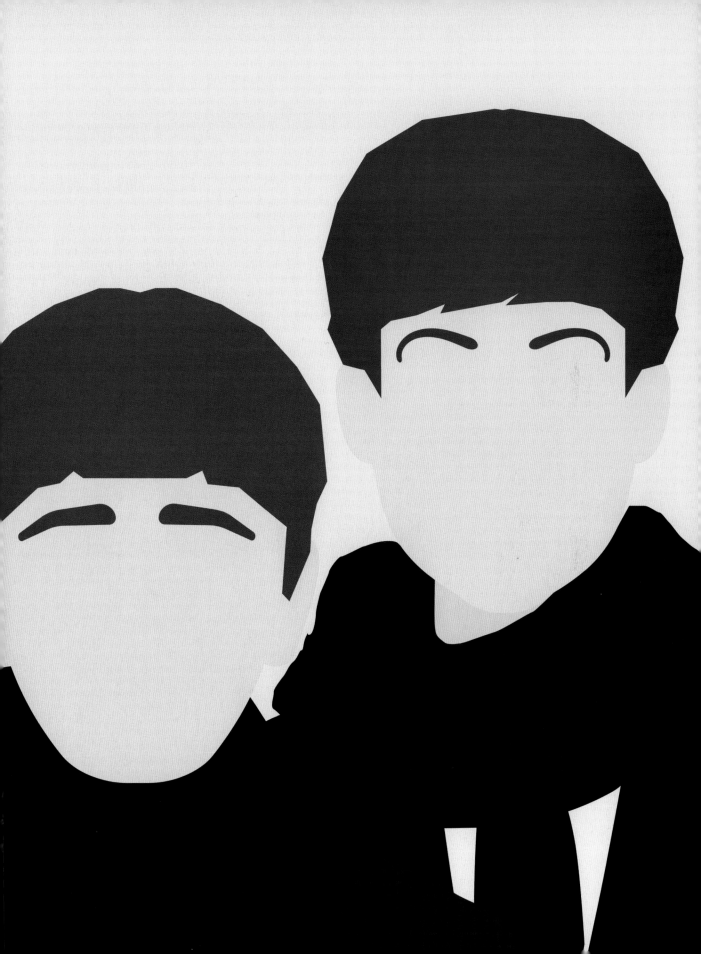

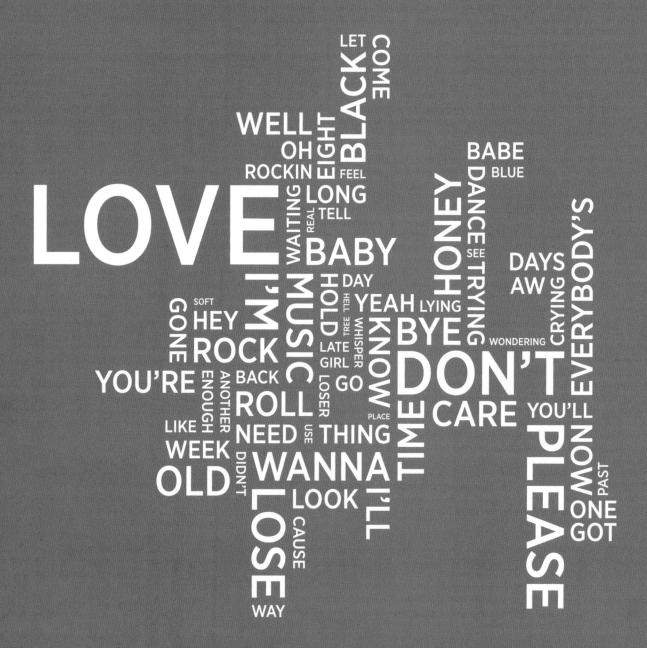

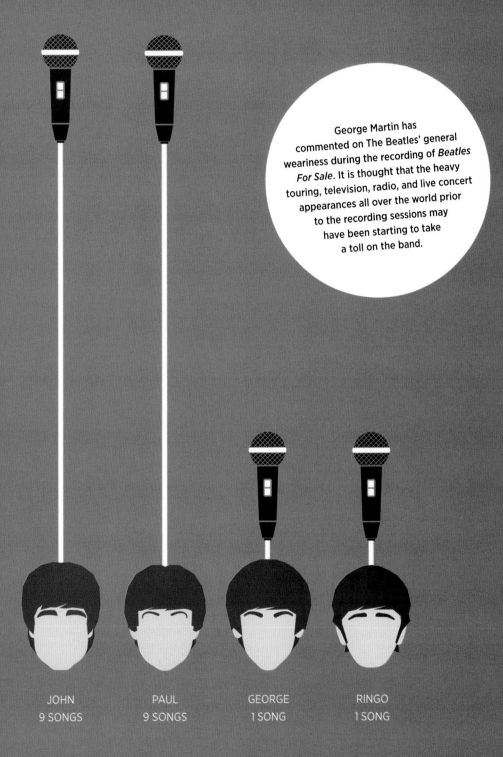

George Martin has commented on The Beatles' general weariness during the recording of *Beatles For Sale*. It is thought that the heavy touring, television, radio, and live concert appearances all over the world prior to the recording sessions may have been starting to take a toll on the band.

JOHN
9 SONGS

PAUL
9 SONGS

GEORGE
1 SONG

RINGO
1 SONG

When band members shared lead vocals, both are listed. As a result, the total may add up to more than the number of tracks on the album.

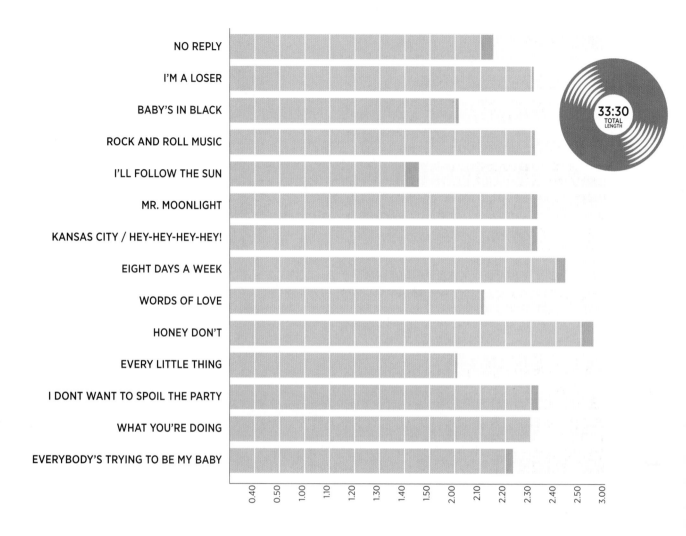

NO REPLY
I'M A LOSER
BABY'S IN BLACK
ROCK AND ROLL MUSIC
I'LL FOLLOW THE SUN
MR. MOONLIGHT
KANSAS CITY / HEY-HEY-HEY-HEY!
EIGHT DAYS A WEEK
WORDS OF LOVE
HONEY DON'T
EVERY LITTLE THING
I DONT WANT TO SPOIL THE PARTY
WHAT YOU'RE DOING
EVERYBODY'S TRYING TO BE MY BABY

0.40 0.50 1.00 1.10 1.20 1.30 1.40 1.50 2.00 2.10 2.20 2.30 2.40 2.50 3.00

33:30 TOTAL LENGTH

6 COVERS

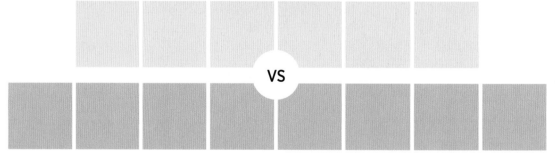

VS

8 ORIGINALS

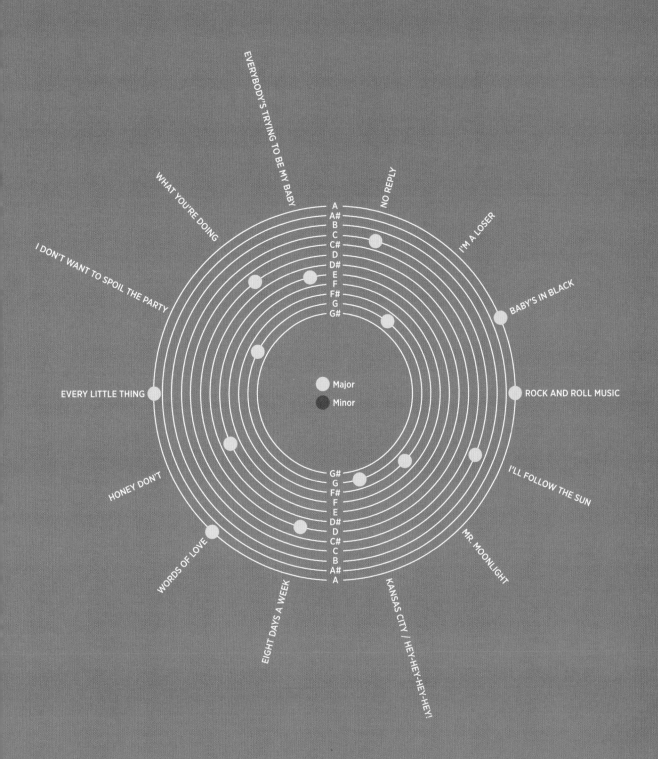

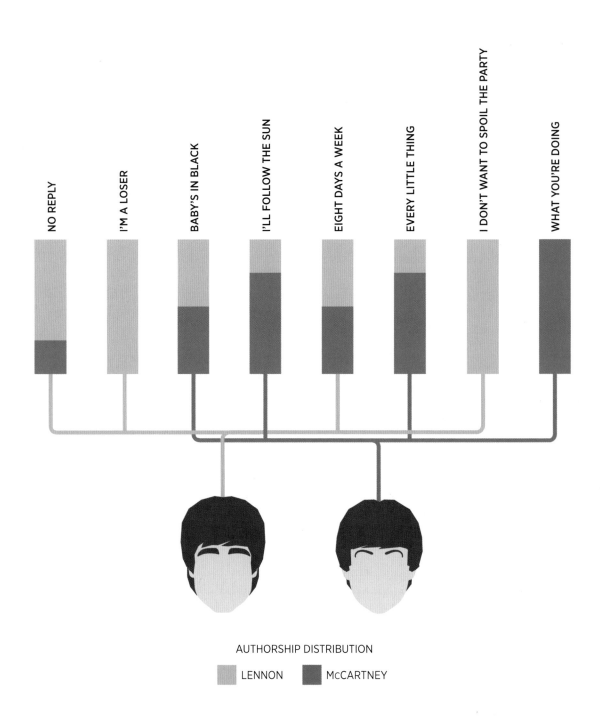

AUTHORSHIP DISTRIBUTION

LENNON McCARTNEY

UK SINGLE RELEASES

NO REPLY
I'M A LOSER
BABY'S IN BLACK
ROCK AND ROLL MUSIC
I'LL FOLLOW THE SUN
MR. MOONLIGHT
KANSAS CITY / HEY-HEY-HEY-HEY!
EIGHT DAYS A WEEK
WORDS OF LOVE
HONEY DON'T
EVERY LITTLE THING
I DON'T WANT TO SPOIL THE PARTY
WHAT YOU'RE DOING
EVERYBODY'S TRYING TO BE MY BABY

Beatles For Sale topped the UK album charts as soon as it was released, knocking *A Hard Day's Night* off the top spot. The album spent seven consecutive weeks at number 1. None of the songs from this album were released as singles.

NOT RELEASED
TOP 20
TOP 10

ALBUM CHART POSITIONS

UNITED KINGDOM
Number One

GERMANY
Number One

AUSTRALIA
Number Five

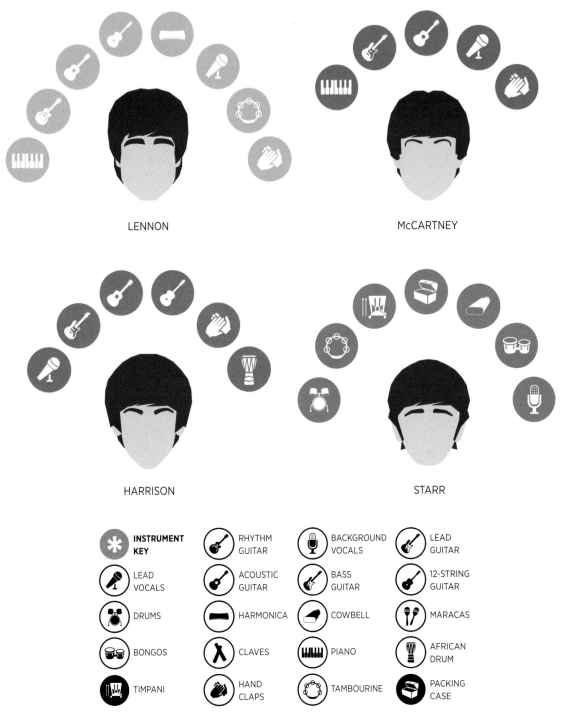

LENNON

McCARTNEY

HARRISON

STARR

INSTRUMENT KEY

LEAD VOCALS

DRUMS

BONGOS

TIMPANI

RHYTHM GUITAR

ACOUSTIC GUITAR

HARMONICA

CLAVES

HAND CLAPS

BACKGROUND VOCALS

BASS GUITAR

COWBELL

PIANO

TAMBOURINE

LEAD GUITAR

12-STRING GUITAR

MARACAS

AFRICAN DRUM

PACKING CASE

Black circle indicates instruments used for the first time in a Beatles' album.

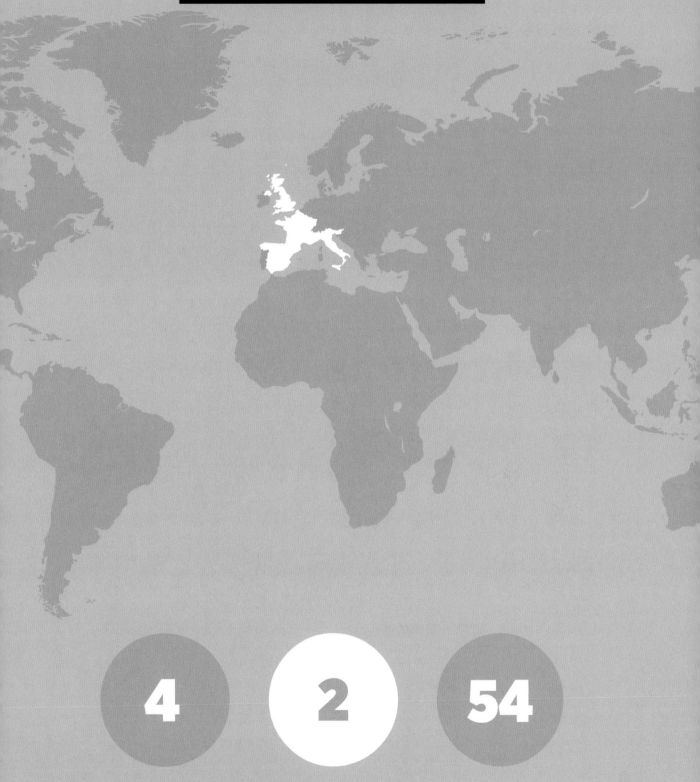

4

COUNTRIES

2

TOURS

54

LIVE SHOWS

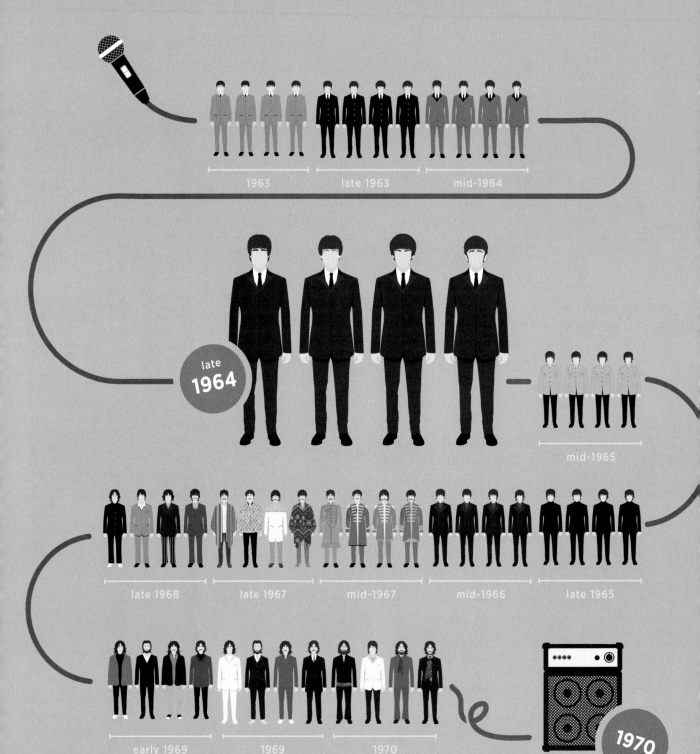

1963 late 1963 mid-1964

late **1964**

mid-1965

late 1968 late 1967 mid-1967 mid-1966 late 1965

early 1969 1969 1970

1970

Again, similar in style to the outfits worn over the past few years, the classic sharp black suit, white shirt, black tie, and, of course, "Beatle boots" were a favorite.

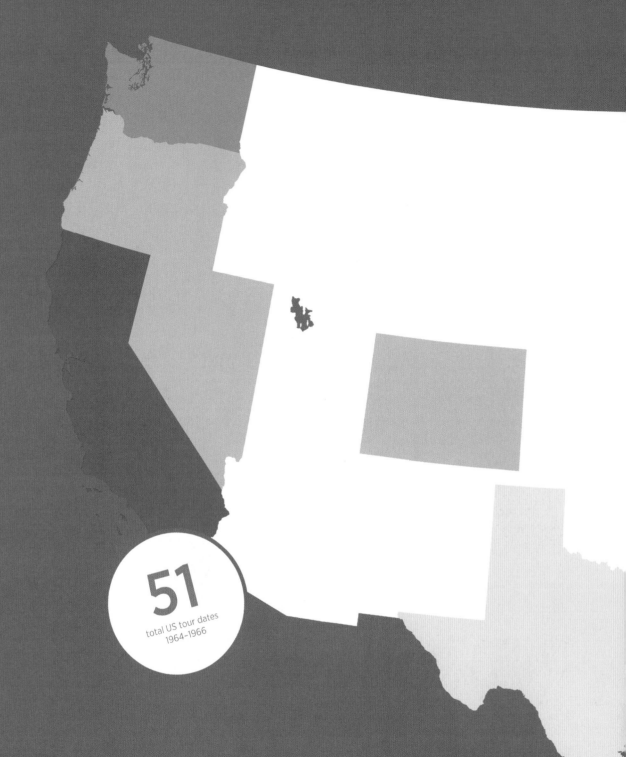

US Touring Heat Map, 1964–1966

The Beatles played throughout the United States in the period between 1964 and 1966, particularly shows in California and New York. Starting with their first US gig in 1964, this map shows how many live dates they played in each of the US states.

51
total US tour dates
1964–1966

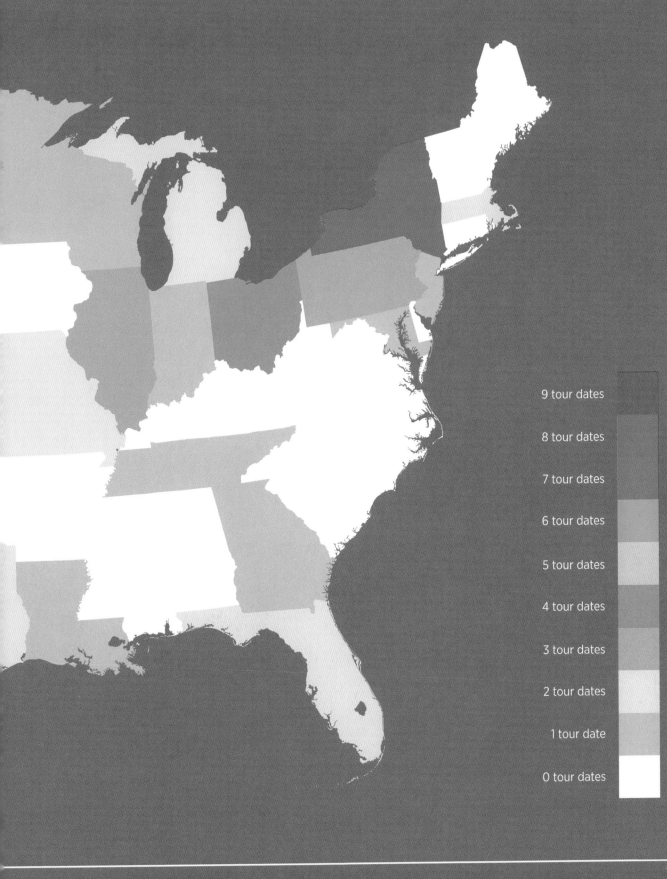

9 tour dates

8 tour dates

7 tour dates

6 tour dates

5 tour dates

4 tour dates

3 tour dates

2 tour dates

1 tour date

0 tour dates

Good Vibrations

Whereas many of the influencers we cover in these sections are early influences, The Beach Boys were a much later influence on The Beatles, and particularly on Paul McCartney, although The Beatles were in turn an influence on The Beach Boys. It's been said that *Rubber Soul* inspired *Pet Sounds*, and *Pet Sounds* inspired *Sgt. Pepper's Lonely Hearts Club Band*. The friendly rivalry between Brian Wilson and Lennon / McCartney led to two of the greatest albums in history.

It was Pet Sounds that really
blew me out of the water.
First of all, it was Brian's writing.
I love that album so much ...
I figure no one is educated in
music until they've heard that album.

Paul McCartney

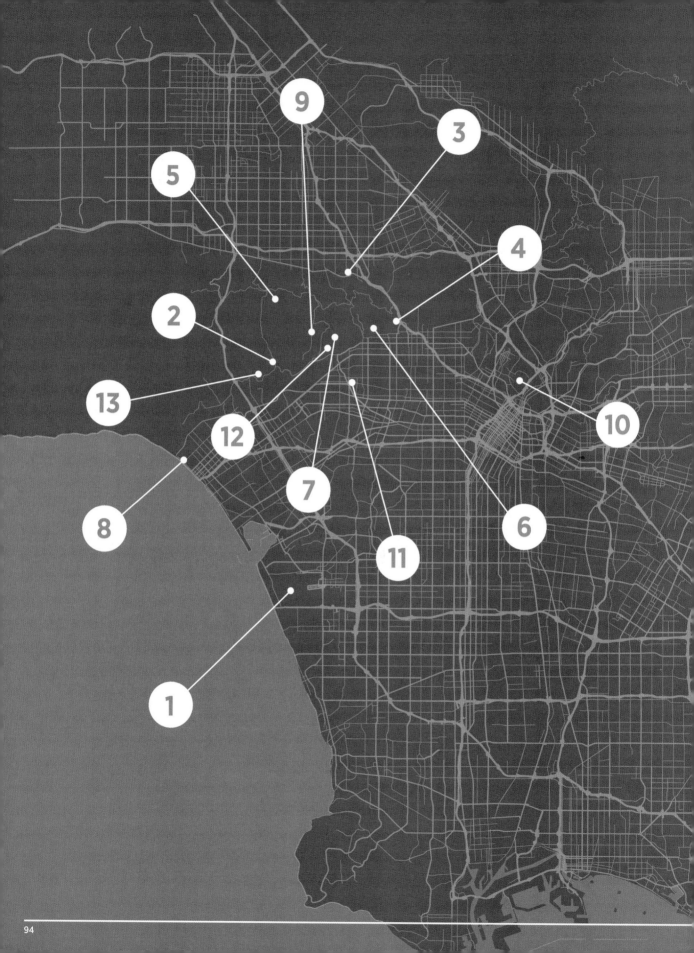

The Beatles in Los Angeles

L.A. would become significant to The Beatles, both personally and professionally. Here we'll look at the most iconic Beatles locations in the City of Angels.

1 Los Angeles International Airport, 1 World Way, Los Angeles, CA 90045
The first destination on their second visit to the US, but their first proper tour, was LAX on August 18, 1964, where they gave a press conference before heading off to San Francisco.

2 356 Saint Pierre Road, Los Angeles, CA 90077
After various hotels canceled their bookings for fear of hoards of fans turning up, actor Reginald Owen offered the boys his house in Bel Air to rent.

3 11345 Ventura Boulevard, Studio City, CA 91604
The location for the press conference prior to the Hollywood Bowl show, a nightclub nearby and one of a chain called "Cinnamon Cinder."

4 Hollywood Bowl, 2301 N. Highland Avenue, Los Angeles, CA 90068
The first of three live shows at the iconic Hollywood Bowl, watched by nearly 19,000 people. All the tickets had sold out more than four months in advance.

5 2850 Benedict Canyon Drive, Beverly Hills, CA 90210
While touring in 1965, The Beatles rented this house from Zsa Zsa Gabor, and it was the first place John, George, and Ringo took LSD together. Peter Fonda, midtrip, inspired John to later write "She Said, She Said" about the night when he said "I know what it's like to be dead."

6 7655 Curson Terrace, Los Angeles, CA 90046
The house the four stayed in during their last US tour in August 1966, rented for them by Brian Epstein.

7 1567 Blue Jay Way, Los Angeles, CA 90069
The house George rented in 1967, and whilst waiting for publicist Derek Taylor, who was lost in fog, wrote the song "Blue Jay Way."

8 625 Palisades Beach Road, Santa Monica, CA 90402
The house that John, Ringo, Harry Nilsson, and Keith Moon moved into in 1974 as part of the "Lost Weekend" and John's time away from Yoko. Paul and Linda visited John here, and it is where the last known photos of the two were taken.

9 9555 Heather Road, Beverly Hills, CA 90210
Supposedly the house where George died and Paul stays sometimes, it was originally built for Bert Lahr, the lion in *The Wizard of Oz*. Other former residents have included the Osbournes and Courtney Love.

10 Dodger Stadium, 1000 Vin Scully Avenue, Los Angeles, CA 90012
The penultimate gig on the late 1966 tour, the band performed for 45,000 people, although this wasn't a sellout partly due to John's controversial comments about being "more popular than Jesus."

11 Record Plant Studios, 1032 N. Sycamore Avenue, Los Angeles, CA 90038
The site for the only known recording of John and Paul together after the breakup of The Beatles, released as a bootleg album called *A Toot and a Snore in '74.*

12 918 North Hillcrest Road, Beverly Hills, CA 90210
Part of the exclusive Trousdale Estates, Ringo has owned a house here since the 1990s, alongside many famous neighbors such as Jennifer Aniston and Jane Fonda.

13 565 Perugia Way, Bel Air, Los Angeles, CA 90077
In August 1965, Brian Epstein and Col. Tom Parker finally agreed to a meeting place, and The Beatles met Elvis at his home in Bel Air. They chatted, joked, and had a jam session.

ALBUM OVERVIEW

Released: August 6, 1965
Producer: George Martin
Engineer: Norman Smith

Originally set to be called *Beatles II*, and then *Eight Arms to Hold You*, *Help!* was The Beatles' fifth UK album release and the soundtrack to their second feature film. It is considered to be one of the band's most diverse albums, featuring elements of folk, rock, country and western, classical, and bluegrass. Bob Dylan also played a part in it, not least through the inspiration The Beatles took from his music but also through his introducing the band to marijuana the previous year. The drug greatly influenced *Help!*

John Lennon wrote the title track during a period of inward reflection. He suggested that he was dissatisfied with himself and was subconsciously crying for help. Technology-wise, from this point onward reduction mixes played a crucial role in their albums (until the introduction of eight-track recording in 1968).

HELP!

AUGUST 1965

TIMELINE: AUGUST–NOVEMBER 1965

October 26, 1965
Moors murderers Ian Brady and Myra Hindley
appear in court charged with three murders,
later to be memorialized on the first Smiths
record in 1984.

November 16, 1965
The Soviet Union launches
the *Venera 3* space probe from
Baikonur, Kazakhstan, toward Venus.

August 1, 1965
Cigarette advertising is
banned on British television.

September 9, 1965
Hurricane Betsy roars ashore
near New Orleans with winds of
145 mph, causing 76 deaths and
$1.42 billion in damage.

August 15, 1965
The Beatles perform the first
stadium concert in the history of music,
playing before 55,600 people at
Shea Stadium in New York City.

September 25, 1965
The *Tom & Jerry* cartoon
series makes its world broadcast
premier on CBS.

November 15, 1965
US racer Craig Breedlove
sets a new land speed record
of 600.601 mph (966.574 km/h).

ALBUM COVER DESIGN

You guessed it, the cover photograph was yet another Robert Freeman original. This time it features the band members standing in their ski outfits from the film *Help!*, spelling out letters in semaphore.

Originally, they intended to spell the word "HELP," but Freeman decided the arrangement of their arms didn't look good that way. In the end they settled on the letters NUJV, as it worked better visually. For the US version, the order was amended and they spelled NVUJ.

NEVER
FALLING
DIZZY
TRY
NOW
WITHOUT
BIG
TRUE
YOU'RE
CHANGE
ONE
PA
TICKET
GIRL
GONE
LIKE
CAUSE
GO
HEY
LOOK
LOSE
EYES
WELL
SEE
KNOW
RIDE
GONNA
NEW
MEAN
LET
LOSE
TELL
DON'T
RUN
SING
TREAT
CRY
I'M
MM
COME
AIN'T
NOBODY
DA
AWAY
PIE
ACT
OOO
LOVE
OH
GIRLS
WANT
BACK
AH
MAKE
PART
GET
NEED
MON
I'VE
STAR
HELP
RIGHT
KIND
FEEL
I'LL
TAKE
SHE'S
JUST
CARE
WRONG
YES
FOOL
WAY
MAN
NEAR

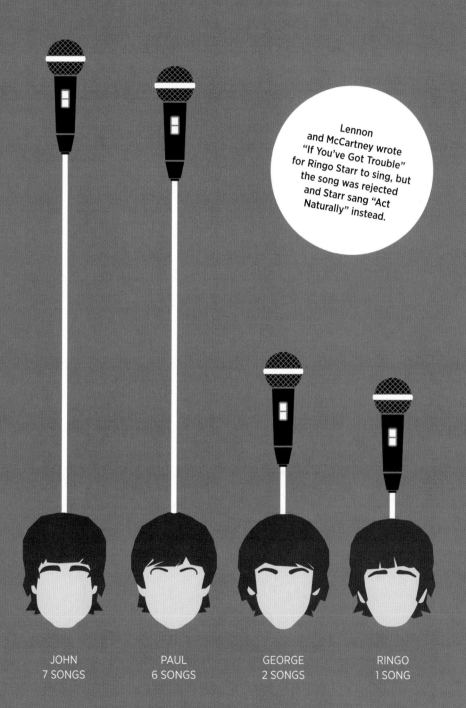

Lennon and McCartney wrote "If You've Got Trouble" for Ringo Starr to sing, but the song was rejected and Starr sang "Act Naturally" instead.

JOHN
7 SONGS

PAUL
6 SONGS

GEORGE
2 SONGS

RINGO
1 SONG

When band members shared lead vocals, both are listed. As a result, the total may add up to more than the number of tracks on the album.

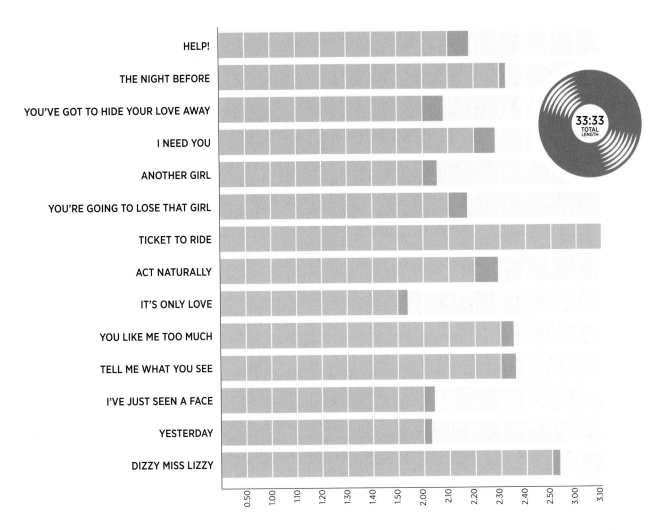

HELP!

THE NIGHT BEFORE

YOU'VE GOT TO HIDE YOUR LOVE AWAY

I NEED YOU

ANOTHER GIRL

YOU'RE GOING TO LOSE THAT GIRL

TICKET TO RIDE

ACT NATURALLY

IT'S ONLY LOVE

YOU LIKE ME TOO MUCH

TELL ME WHAT YOU SEE

I'VE JUST SEEN A FACE

YESTERDAY

DIZZY MISS LIZZY

0.50 1.00 1.10 1.20 1.30 1.40 1.50 2.00 2.10 2.20 2.30 2.40 2.50 3.00 3.10

33:33 TOTAL LENGTH

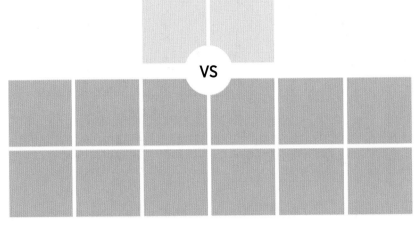

2 COVERS

VS

12 ORIGINALS

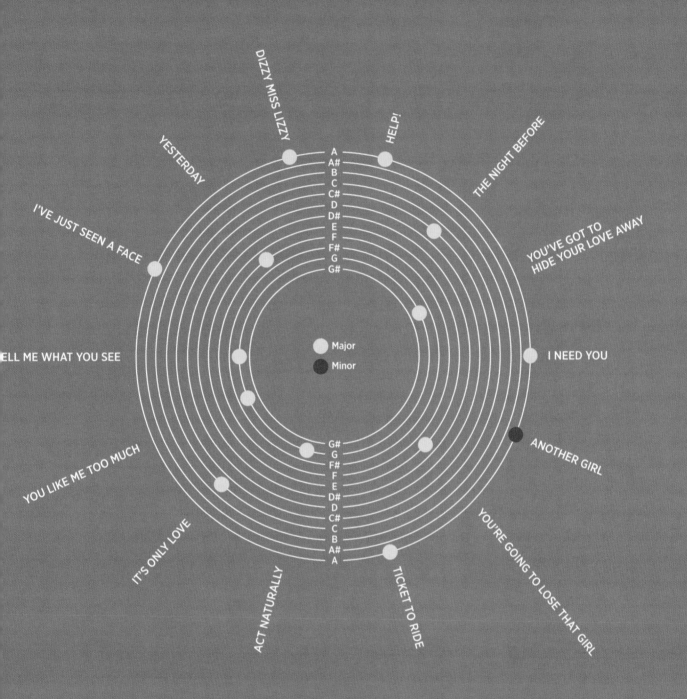

DIZZY MISS LIZZY

YESTERDAY

HELP!

THE NIGHT BEFORE

I'VE JUST SEEN A FACE

YOU'VE GOT TO
HIDE YOUR LOVE AWAY

ELL ME WHAT YOU SEE

A
A#
B
C
C#
D
D#
E
F
F#
G
G#

Major
Minor

I NEED YOU

ANOTHER GIRL

YOU LIKE ME TOO MUCH

G#
G
F#
F
E
D#
D
C#
C
B
A#
A

IT'S ONLY LOVE

ACT NATURALLY

TICKET TO RIDE

YOU'RE GOING TO LOSE THAT GIRL

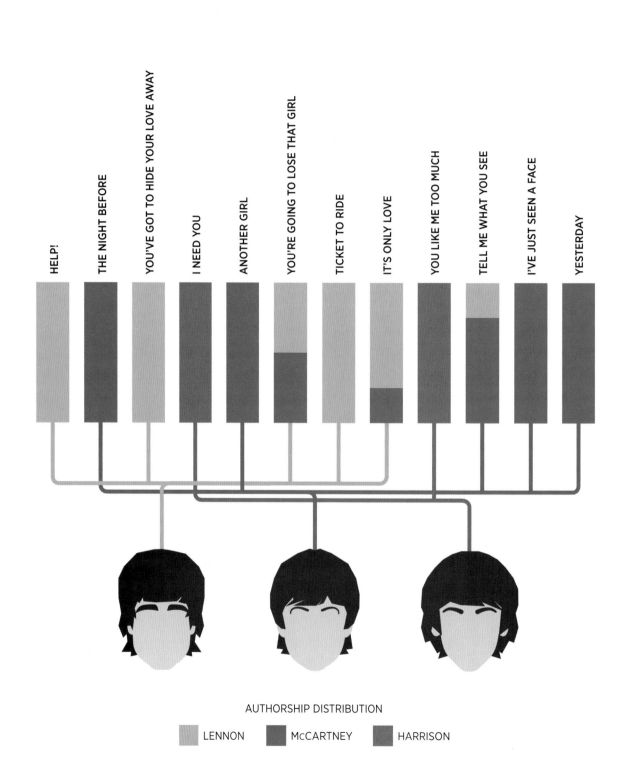

HELP!

THE NIGHT BEFORE

YOU'VE GOT TO HIDE YOUR LOVE AWAY

I NEED YOU

ANOTHER GIRL

YOU'RE GOING TO LOSE THAT GIRL

TICKET TO RIDE

IT'S ONLY LOVE

YOU LIKE ME TOO MUCH

TELL ME WHAT YOU SEE

I'VE JUST SEEN A FACE

YESTERDAY

AUTHORSHIP DISTRIBUTION

LENNON McCARTNEY HARRISON

UK SINGLE RELEASES

HELP!
THE NIGHT BEFORE
YOU'VE GOT TO HIDE YOUR LOVE AWAY
I NEED YOU
ANOTHER GIRL
YOU'RE GOING TO LOSE THAT GIRL
TICKET TO RIDE
ACT NATURALLY
IT'S ONLY LOVE
YOU LIKE ME TOO MUCH
TELL ME WHAT YOU SEE
I'VE JUST SEEN A FACE
YESTERDAY
DIZZY MISS LIZZY

1 1 8

McCartney wrote his most famous song, "Yesterday," for this album. It wasn't released as a single at the time because McCartney performed it on his own (this was the first Beatles song to feature just one member of the group) but it later charted in the UK on the 1976 rerelease. It would go on to be recorded by more than 3,000 different artists, making it the most-covered pop song in history. It was performed approximately 7 million times in the 20th century. Non-album singles to reach number 1 during this period were "We Can Work It Out"/"Day Tripper" (12/3/65) and "Paperback Writer"/"Rain" (6/10/66).

- ■ NOT RELEASED
- ■ TOP 20
- □ TOP 10

ALBUM CHART POSITIONS

UNITED KINGDOM
Number One

GERMANY
Number One

UNITED STATES
Number One

AUSTRALIA
Number Five

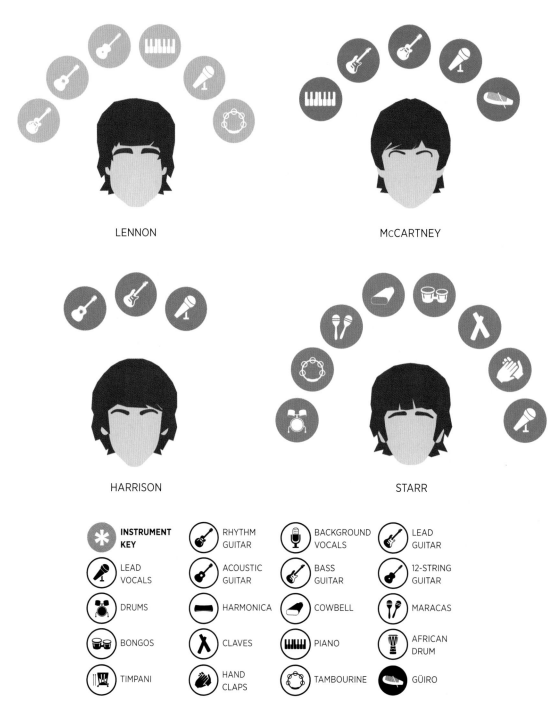

LENNON

McCARTNEY

HARRISON

STARR

	INSTRUMENT KEY		RHYTHM GUITAR		BACKGROUND VOCALS		LEAD GUITAR
	LEAD VOCALS		ACOUSTIC GUITAR		BASS GUITAR		12-STRING GUITAR
	DRUMS		HARMONICA		COWBELL		MARACAS
	BONGOS		CLAVES		PIANO		AFRICAN DRUM
	TIMPANI		HAND CLAPS		TAMBOURINE		GÜIRO

Black circle indicates instruments used for the first time in a Beatles' album.

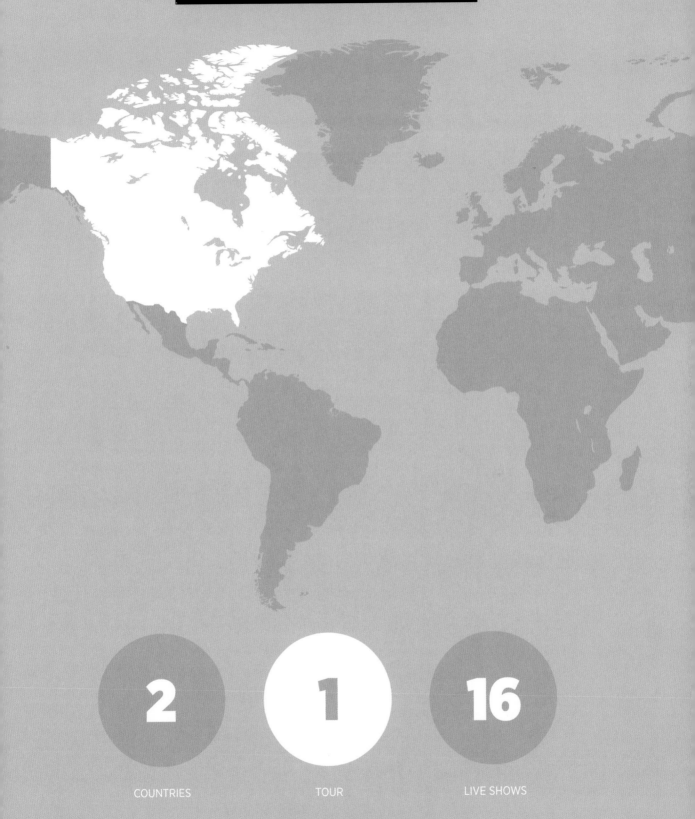

2

COUNTRIES

1

TOUR

16

LIVE SHOWS

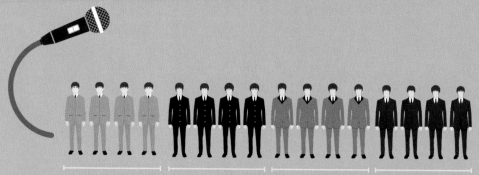

1963 late 1963 mid-1964 late 1964

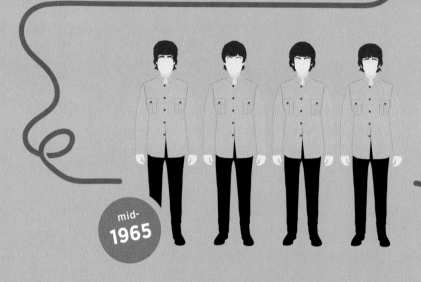

mid-**1965**

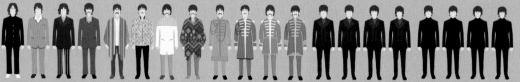

late 1968 late 1967 mid-1967 mid-1966 late 1965

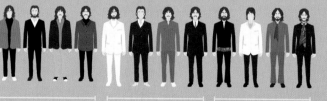

early 1969 1969 1970

1970

Known as the "Shea Stadium" suits after the famous gig where they were worn, the tan, military-style jackets were paired with drainpipe trousers and Wells Fargo security officer badges from the security company that escorted the band into the venue.

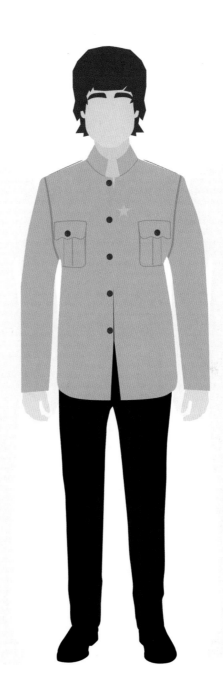

US Albums

The albums released in the United States were in many cases dramatically different from those in the UK market. As a result, the experience of the band's music was an alternative one for US audiences. Here are the albums delivered to American listeners...

Introducing the Beatles (January 10, 1964)

Meet the Beatles! (January 20, 1964)

The Beatles' Second Album (April 10, 1964)

A Hard Day's Night—OST (June 26, 1964)

Something New (July 20, 1964)

The Beatles' Story (November 23, 1964)

Beatles '65 (December 15, 1964)

The Early Beatles (March 22, 1965)

Beatles VI (June 14, 1965)

OST = Official Sound Track

Help!—OST (August 13, 1965)

Rubber Soul (December 6, 1965)

Yesterday . . . And Today (June 20, 1966)

Revolver (August 8, 1966)

Sgt. Pepper's Lonely Hearts
Club Band (June 2, 1967)

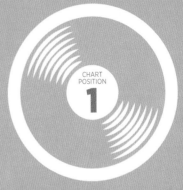

Magical Mystery Tour (November 27, 1967)

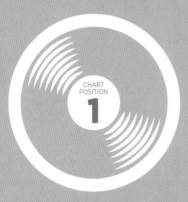

The Beatles (November 25, 1968)

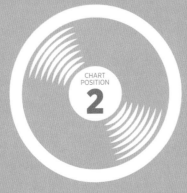

Yellow Submarine—OST (January 13, 1969)

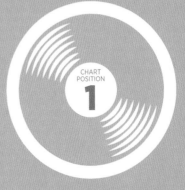

Abbey Road (October 1, 1969)

Hey Jude/The Beatles Again (February 26, 1970)

Let It Be—OST (May 18, 1970)

NB: From *Sgt. Pepper* onward,
the US albums finally matched
the UK releases.

Down at the End of Lonely Street

All of The Beatles were influenced by Elvis Presley, but John Lennon in particular. Elvis inspired Lennon to start his own band (The Quarrymen) after the young Liverpudlian first heard him, and the influence on his writing and playing was clear. In the early years of The Beatles, they would frequently perform songs made famous by The King, such as "That's Alright Mama," "I'm Gonna Sit Right Down and Cry Over You," and "I Forgot to Remember to Forget," and would even wear their hair slicked back to imitate his style.

Nothing really affected me until I heard Elvis. If there hadn't been an Elvis, there wouldn't have been The Beatles.

John Lennon

ALBUM OVERVIEW

Released: December 3, 1965
Producer: George Martin
Engineer: Norman Smith

Rubber Soul signaled a change in direction for The Beatles.
It marked the first time the band took full control in the
studio and moved away from their early puppy love songs
to explore different subject matters, songwriting styles,
and instrumentation. It could be argued that *Rubber Soul*
is Lennon's songwriting peak, featuring some of his most
memorable creations.

There was, however, a bit of a rush to complete the album
in time for Christmas, so they brought in some older songs,
including "Wait," which had been written for *Help!*, and
"Michelle," which McCartney wrote in 1959. The album title
came from a comment a US musician had made about The
Rolling Stones, saying they were "plastic soul."

RUBBER SOUL
DECEMBER 1965

January 3, 1966
The first "Acid Test" is conducted
at the Fillmore, San Jose.

March 1, 1966
The British government announces
plans for the decimalization of the pound
sterling, to come into effect in 1971.

April 21, 1966
The opening of the Parliament
of the United Kingdom is
televised for the first time.

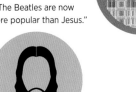

February 3, 1966
The unmanned Soviet
Luna 9 spacecraft makes
the first controlled rocket-
assisted landing on the Moon.

March 4, 1966
John Lennon claims
The Beatles are now
"more popular than Jesus."

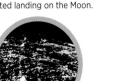

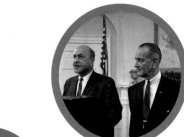

January 13, 1966
Robert C. Weaver
becomes the first African
American cabinet
member in the USA.

April 3, 1966
Luna 10 is the first man-made
object to enter lunar orbit.

December 22, 1965
A 70 mph (110 km/h) speed limit
is imposed on British roads.

March 1, 1966
Soviet space probe
Venera 3 crashes on Venus,
becoming the first spacecraft
to land on another planet's
surface.

June 14, 1966
The Vatican abolishes the Index Librorum Prohibitorum (index of banned books).

April 29, 1966
US troops in Vietnam total 250,000.

July 30, 1966
England beats West Germany 4–2 to win the 1966 FIFA World Cup at Wembley after extra time.

April 30, 1966
Regular hovercraft service begins over the English Channel.

July 11, 1966
British Motor Corporation and Jaguar Cars announce plans to merge as British Motor Holdings.

April 21, 1966
An artificial heart is installed in the chest of Marcel DeRudder in a Houston, Texas, hospital.

May 16, 1966
The legendary album *Pet Sounds* by The Beach Boys is released.

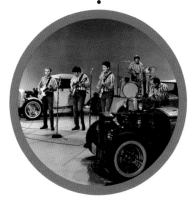

July 18, 1966
Gemini 10 is launched. After docking with an Agena target vehicle, the astronauts then set a world altitude record of 474 miles.

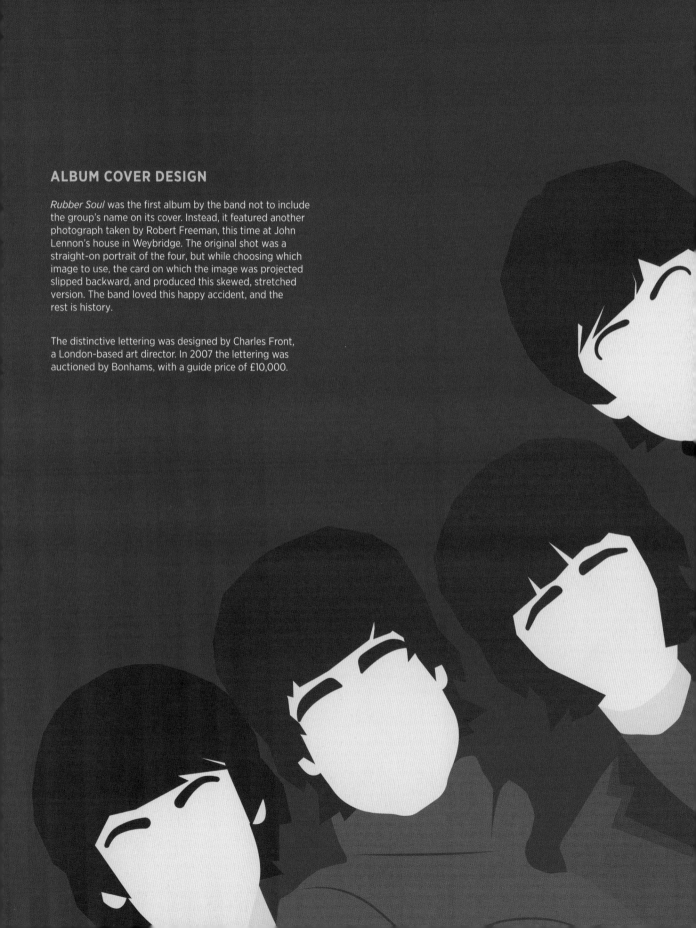

ALBUM COVER DESIGN

Rubber Soul was the first album by the band not to include the group's name on its cover. Instead, it featured another photograph taken by Robert Freeman, this time at John Lennon's house in Weybridge. The original shot was a straight-on portrait of the four, but while choosing which image to use, the card on which the image was projected slipped backward, and produced this skewed, stretched version. The band loved this happy accident, and the rest is history.

The distinctive lettering was designed by Charles Front, a London-based art director. In 2007 the lettering was auctioned by Bonhams, with a guide price of £10,000.

"

WE WERE JUST GETTING
BETTER
TECHNICALLY AND MUSICALLY, THAT'S ALL.

"

—— JOHN LENNON ——

1971, ON THE ALBUM RUBBER SOUL

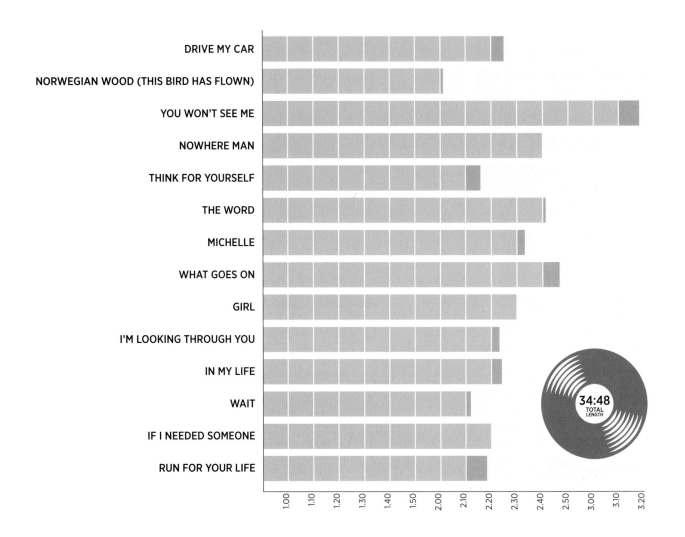

DRIVE MY CAR

NORWEGIAN WOOD (THIS BIRD HAS FLOWN)

YOU WON'T SEE ME

NOWHERE MAN

THINK FOR YOURSELF

THE WORD

MICHELLE

WHAT GOES ON

GIRL

I'M LOOKING THROUGH YOU

IN MY LIFE

WAIT

IF I NEEDED SOMEONE

RUN FOR YOUR LIFE

34:48
TOTAL
LENGTH

1.00 1.10 1.20 1.30 1.40 1.50 2.00 2.10 2.20 2.30 2.40 2.50 3.00 3.10 3.20

0 COVERS

VS

14 ORIGINALS

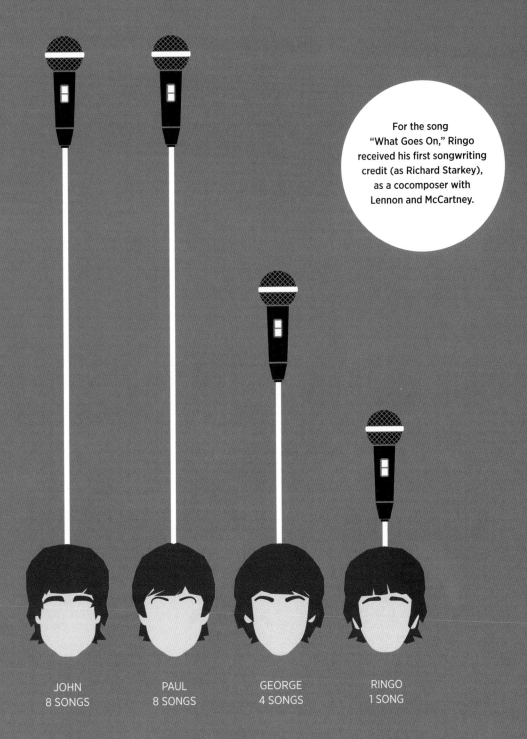

For the song "What Goes On," Ringo received his first songwriting credit (as Richard Starkey), as a cocomposer with Lennon and McCartney.

JOHN
8 SONGS

PAUL
8 SONGS

GEORGE
4 SONGS

RINGO
1 SONG

When band members shared lead vocals, both are listed. As a result, the total may add up to more than the number of tracks on the album.

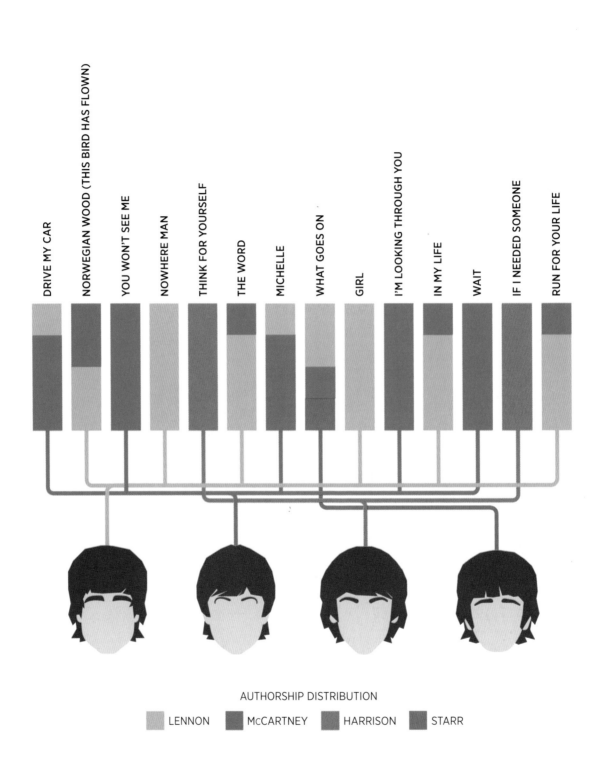

DRIVE MY CAR

NORWEGIAN WOOD (THIS BIRD HAS FLOWN)

YOU WON'T SEE ME

NOWHERE MAN

THINK FOR YOURSELF

THE WORD

MICHELLE

WHAT GOES ON

GIRL

I'M LOOKING THROUGH YOU

IN MY LIFE

WAIT

IF I NEEDED SOMEONE

RUN FOR YOUR LIFE

AUTHORSHIP DISTRIBUTION

LENNON McCARTNEY HARRISON STARR

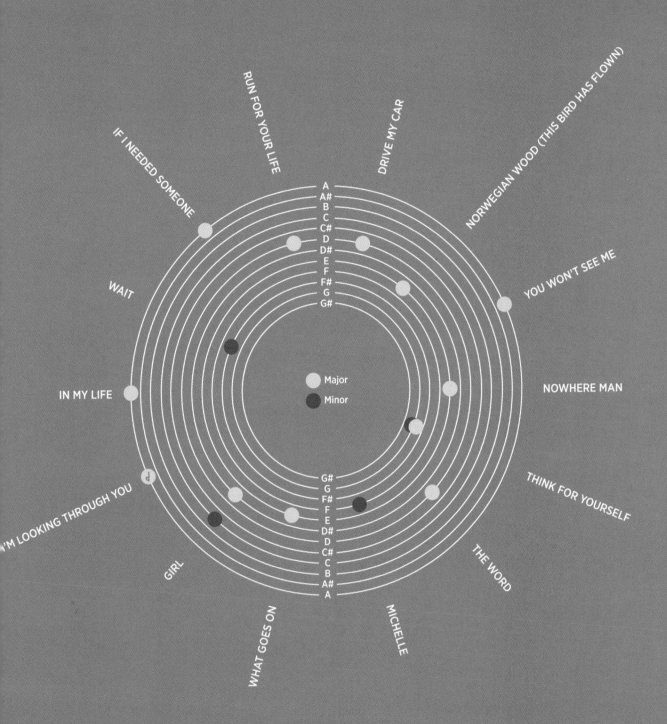

RUN FOR YOUR LIFE

IF I NEEDED SOMEONE

DRIVE MY CAR

NORWEGIAN WOOD (THIS BIRD HAS FLOWN)

YOU WON'T SEE ME

WAIT

IN MY LIFE

NOWHERE MAN

THINK FOR YOURSELF

I'M LOOKING THROUGH YOU

GIRL

THE WORD

WHAT GOES ON

MICHELLE

A
A#
B
C
C#
D
D#
E
F
F#
G
G#

○ Major
● Minor

G#
G
F#
F
E
D#
D
C#
C
B
A#
A

UK SINGLE RELEASES

DRIVE MY CAR
NORWEGIAN WOOD (THIS BIRD HAS FLOWN)
YOU WON'T SEE ME
NOWHERE MAN
THINK FOR YOURSELF
THE WORD
MICHELLE
WHAT GOES ON
GIRL
I'M LOOKING THROUGH YOU
IN MY LIFE
WAIT
IF I NEEDED SOMEONE
RUN FOR YOUR LIFE

No songs from *Rubber Soul* were released as singles; however, the band recorded "We Can Work It Out" and "Day Tripper" (which were released as a double A-side single on the same day as the album) in the same studio sessions. *Rubber Soul* replaced *Help!* at the top of the charts on Christmas Day and spent nine weeks at number 1, remaining in the charts for 42 weeks. In 2012 it was ranked number 5 on *Rolling Stone* magazine's list of the "500 Greatest Albums of All Time."

NOT RELEASED
TOP 20
TOP 10

ALBUM CHART POSITIONS

UNITED KINGDOM
Number One

GERMANY
Number One

UNITED STATES
Number One

AUSTRALIA
Number One

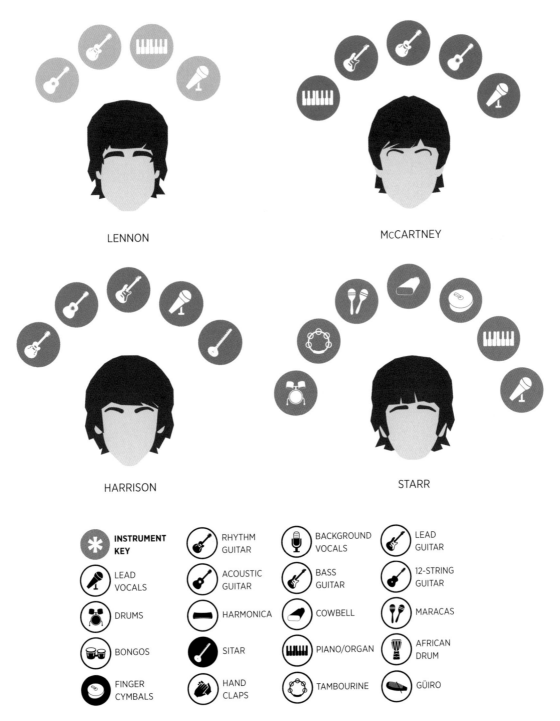

LENNON

McCARTNEY

HARRISON

STARR

INSTRUMENT KEY	RHYTHM GUITAR	BACKGROUND VOCALS	LEAD GUITAR
LEAD VOCALS	ACOUSTIC GUITAR	BASS GUITAR	12-STRING GUITAR
DRUMS	HARMONICA	COWBELL	MARACAS
BONGOS	SITAR	PIANO/ORGAN	AFRICAN DRUM
FINGER CYMBALS	HAND CLAPS	TAMBOURINE	GÜIRO

Black circle indicates instruments used for the first time in a Beatles' album.

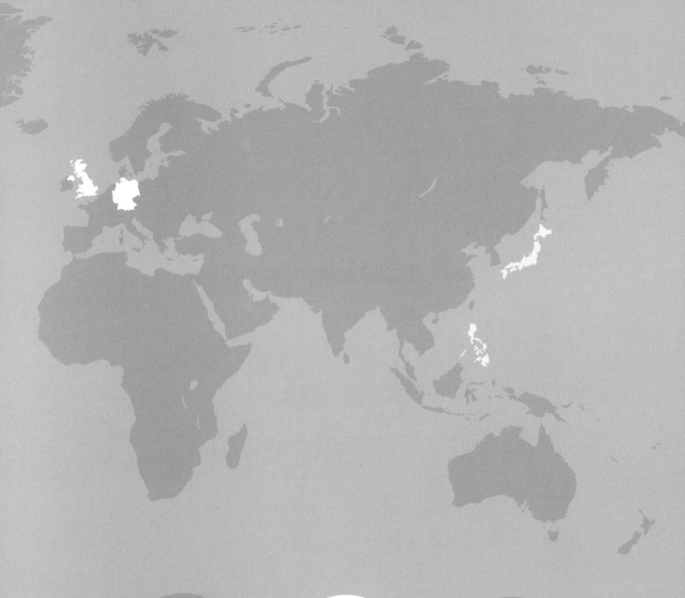

4

COUNTRIES

3

TOURS

32

LIVE SHOWS

Filmography

As well as musical performances, The Beatles turned their hand to acting several times. Five films were made featuring the Fab Four in various guises:

A Hard Day's Night (1964)

Written by Alun Owen during the height of Beatlemania, *A Hard Day's Night* gives viewers a glimpse into several days in the lives of the band. It's often credited as being one of the most influential music films of all time, inspiring countless pop videos, spy films, and even *The Monkees* TV show.

Budget

£189,000

Length

87 mins

Rating

Locations

London
Somerset
Devon
Sussex

Magical Mystery Tour (1967)

Magical Mystery Tour originally aired on Boxing Day 1967 on BBC1. It is the story of a group of people on a coach embarking on a mystery tour around Britain, and was produced by the band themselves. The initial showing of the film was poorly received by critics and audiences, although it is now warmly regarded by many fans.

Budget

£30,000

Length

55 mins

Rating

Locations

Cornwall
Kent
Surrey
Nice

Help! (1965)

The second feature film, *Help!* is a comedy adventure that sees The Beatles come up against an evil cult, who are after a sacrificial ring worn by Ringo. *Help!* was given positive reviews at the time of release and is often regarded as a huge influence on the development of music videos.

Budget

$1,500,000

Length

92 mins

Rating

Locations

Salzburg
Bahamas
Liverpool
Wiltshire
London
Buckinghamshire

Yellow Submarine (1968)

The penultimate Beatles film was an animated musical comedy, inspired by the music of the band. Although The Beatles composed and performed the songs for the soundtrack and made a guest appearance at the end of the film, the characters were voiced by actors. *Yellow Submarine* was extremely well received and is credited with positioning animation as a serious art form.

Budget

£250,000

Length

90 mins

Rating

Locations

London
(TVC Animation
Studios)

Let It Be (1970)

Length

81 mins

Rating

Locations

London
(Twickenham
Studios, Apple
HQ)

Let It Be began as a project to film The Beatles creating an album from the ground up, but became a documentary of a band nearing its end. Simmering tensions and uncomfortable exchanges feature highly, but it shines a light on a difficult period for the band. Despite the myriad problems the four were experiencing, from business woes to girl troubles, creative tensions to personal issues, the music flows through the whole film and unites the increasingly disparate group, and makes this an incredibly interesting insight into the band.

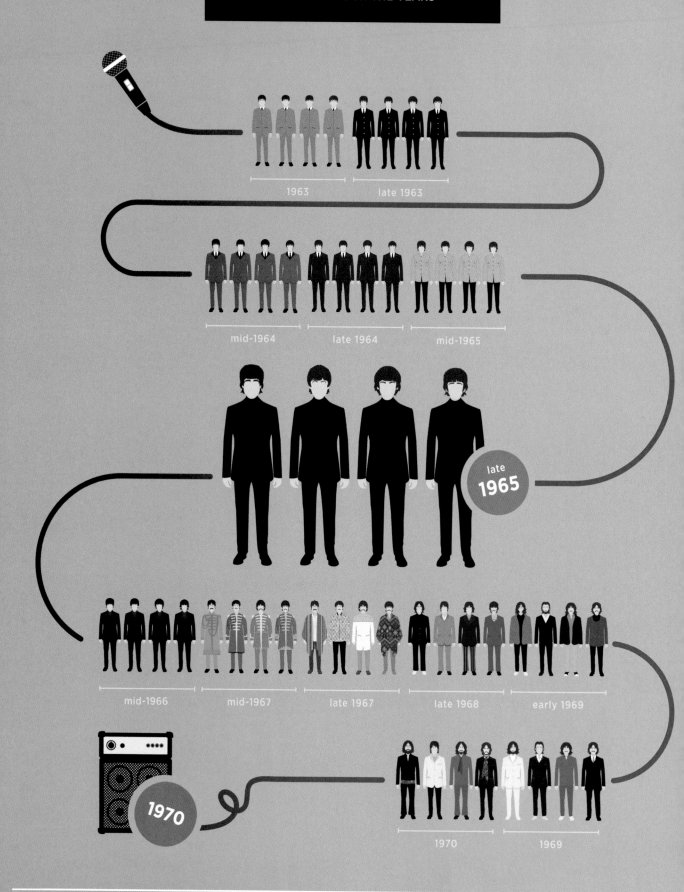

1963 late 1963

mid-1964 late 1964 mid-1965

late 1965

mid-1966 mid-1967 late 1967 late 1968 early 1969

1970

1970 1969

Despite the fashions between band members beginning to change during this period, they still often wore matching suits at gigs. This time a dark blue classic-fit suit paired with a black polo-neck jumper for a more relaxed look.

I Was Admired by All These Hippies

Ravi Shankar was particularly influential on George Harrison, who sought him out in order to learn the sitar. George played the instrument with a Western tuning on "Norwegian Wood (This Bird Has Flown)," but reached out to Shankar—a musical idol in India—in order to learn the instrument properly. The pair spent weeks together in England, Kashmir, and California working on lessons.

He was the first person
who ever impressed
me in my life.

George Harrison

Lennon's MBE

In 1965, John Lennon was awarded an MBE in the queen's birthday honors (along with the other members of The Beatles). Although he initially accepted the honor, he returned his MBE in 1969 as a protest at Britain's involvement in a civil war, along with America's involvement in Vietnam and Lennon's "Cold Turkey" slipping down the UK charts.

The letter he sent returning the MBE now resides in the Royal Archives, although a draft version of the letter was discovered in a vinyl sleeve in 2016, and was valued at $75,000 by experts at a Beatles Story valuation day in Liverpool, England. It is thought that Lennon wrote this one first, but decided to write another as the signature on the original was smudged, and if you're going to send a letter to the queen, it should really be free of smudges!

Lennon's letter returning his MBE read:

BAG PRODUCTIONS, 3 SAVILE ROW, LONDON W1

TO

Her Majesty The Queen

Your Majesty

I am returning this MBE in protest against Britain's involvement in the Nigeria-Biafra thing, against our support of America in Vietnam and against Cold Turkey slipping down the charts.

with love John Lennon

John Lennon of Bag

UK Touring Heat Map, 1963–1966

During their touring years The Beatles played all over the United Kingdom, including Northern Ireland, Scotland, and Wales. This map shows how many live dates they played in each of these countries, as well as each county in England.

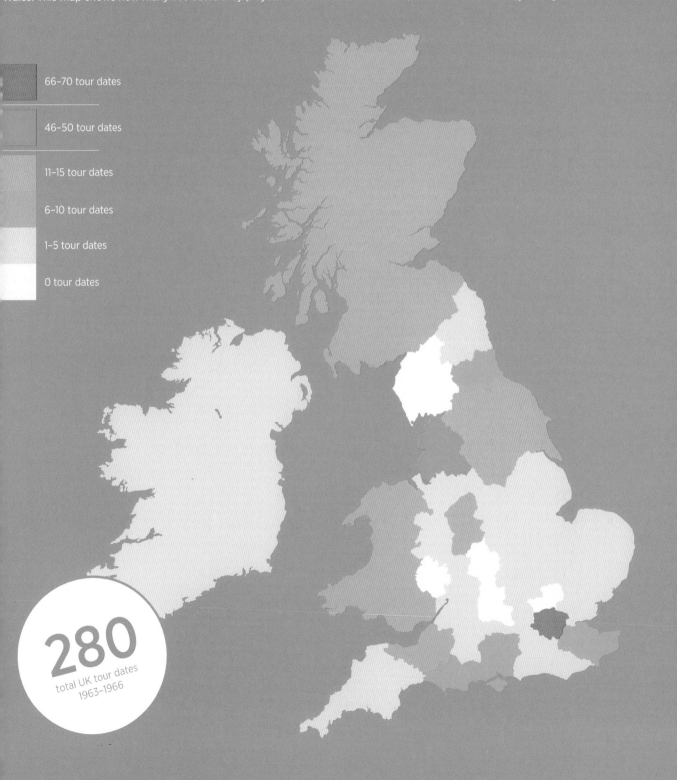

66–70 tour dates

46–50 tour dates

11–15 tour dates

6–10 tour dates

1–5 tour dates

0 tour dates

280 total UK tour dates 1963–1966

ALBUM OVERVIEW

Released: August 5, 1966
Producer: George Martin
Engineers: Geoff Emerick, Peter Vince

Revolver is considered by many to be the band's finest work,
with all four members collaborating and at their creative
peak. It marked another distinct shift in the group's music,
demonstrating how they had grown up as musicians and
heralding the start of an era of experimentation, particularly
when it came to studio recording techniques.

These included ADT (artificial double tracking), a method that
allowed the band to, firstly, double track their vocals without
having to overdub a second vocal performance (this would
go on to become a well-used and established production
technique); and, secondly, to speed up and slow down their
recordings via an oscillator. The implementation of backward
recording on "I'm Only Sleeping" and "Tomorrow Never Knows"
was another innovation. Tape loops were used extensively.

REVOLVER

AUGUST 1966

August 29, 1966
The Beatles end their US tour with a concert at Candlestick Park in San Francisco. It is their last performance as a live touring band.

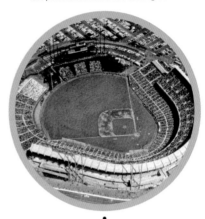

September 8, 1966
Star Trek, the science fiction television series, debuts on NBC.

October 26, 1966
NATO moves its HQ from Paris to Brussels.

November 24, 1966
The Beatles begin recording sessions for their *Sgt. Pepper's Lonely Hearts Club Band* LP.

September 1, 1966
Ralph Baer develops the idea of a video game to be played on television, the start of a multibillion-dollar industry.

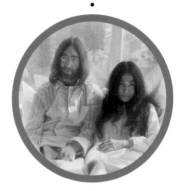

August 5, 1966
The Caesars Palace hotel and casino opens in Las Vegas.

October 6, 1966
LSD is made illegal in the United States.

November 9, 1966
John Lennon meets Yoko Ono at the Indica Gallery, London.

April 8, 1967
"Puppet on a String" by Sandie Shaw wins the
Eurovision Song Contest 1967 for the United Kingdom.

May 11, 1967
The United Kingdom and Ireland
apply officially for European Economic
Community membership.

January 27, 1967
The United States, Soviet Union,
and United Kingdom sign the Outer Space Treaty.

February 2, 1967
The American Basketball
Association is formed.

April 9, 1967
The first Boeing 737
takes its maiden flight.

December 15, 1966
Walt Disney dies while
producing *The Jungle Book*,
the last animated feature
under his personal supervision.

March 4, 1967
The first North Sea gas
is pumped ashore at Easington,
East Riding of Yorkshire.

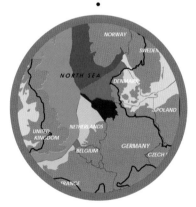

April 28, 1967
Muhammad Ali refuses military
service. He is stripped of his boxing title and
not allowed to fight for three years.

REVOLVER

ALBUM COVER DESIGN

The cover artwork for *Revolver* was done by Klaus Voormann, an artist and musician the band met in Hamburg. It was mostly made up of pen drawings, but it also contained collage sections which included photographs by Robert Freeman and Robert Whitaker.

Voormann was invited by the band to work on the cover and they brought him into the studio to listen to the *Revolver* recordings before he started. Voormann then worked on the cover from his studio in Parliament Hill, London, spending two weeks on the concept. He won the Grammy Award for Best Album Cover, Graphic Arts, in 1967.

"

THEY GAVE ME AN AWFUL LOT OF
ENCOURAGEMENT.
THEIR REACTION HAS BEEN VERY GOOD. IF
IT HADN'T I WOULD HAVE JUST CRAWLED AWAY.

"

— GEORGE HARRISON —
ON SHOWING SONGS TO PAUL AND JOHN

Revolver — The Alternatives

Any creative process is an iterative one, and there will always be a certain number of unused ideas that never see the light of day. But we're here to change that and to bring you some of the album titles that were considered for *Revolver*...

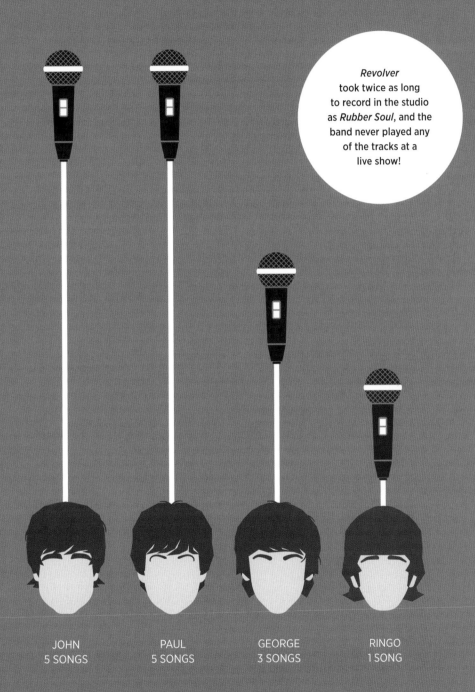

Revolver took twice as long to record in the studio as *Rubber Soul*, and the band never played any of the tracks at a live show!

JOHN
5 SONGS

PAUL
5 SONGS

GEORGE
3 SONGS

RINGO
1 SONG

When band members shared lead vocals, both are listed. As a result, the total may add up to more than the number of tracks on the album.

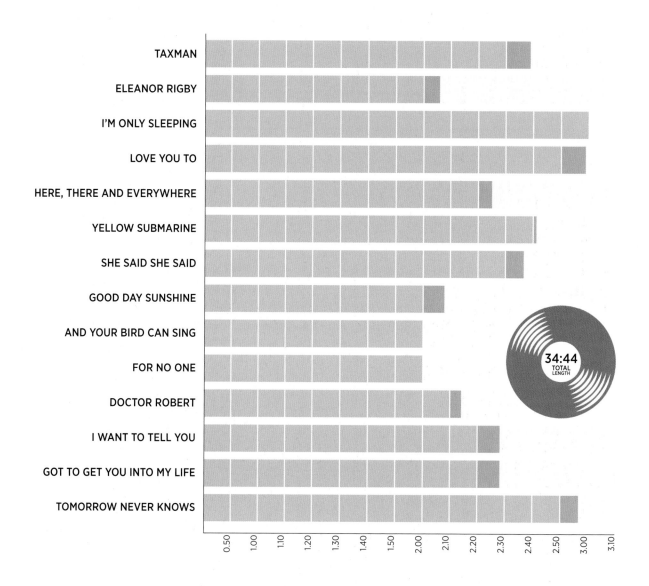

TAXMAN

ELEANOR RIGBY

I'M ONLY SLEEPING

LOVE YOU TO

HERE, THERE AND EVERYWHERE

YELLOW SUBMARINE

SHE SAID SHE SAID

GOOD DAY SUNSHINE

AND YOUR BIRD CAN SING

FOR NO ONE

DOCTOR ROBERT

I WANT TO TELL YOU

GOT TO GET YOU INTO MY LIFE

TOMORROW NEVER KNOWS

0.50 1.00 1.10 1.20 1.30 1.40 1.50 2.00 2.10 2.20 2.30 2.40 2.50 3.00 3.10

34:44
TOTAL
LENGTH

0 COVERS

VS

14 ORIGINALS

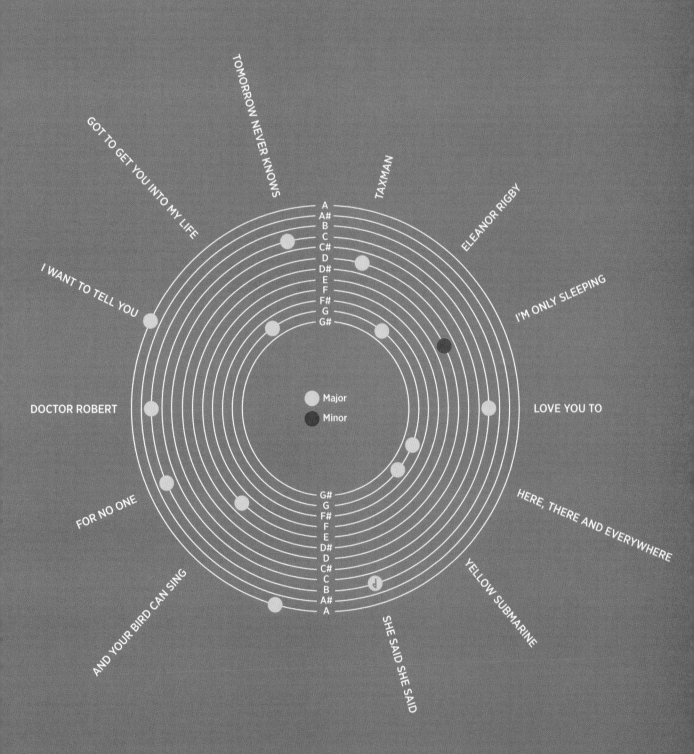

SONG KEYS

TOMORROW NEVER KNOWS

GOT TO GET YOU INTO MY LIFE

TAXMAN

ELEANOR RIGBY

I WANT TO TELL YOU

I'M ONLY SLEEPING

DOCTOR ROBERT

LOVE YOU TO

FOR NO ONE

HERE, THERE AND EVERYWHERE

AND YOUR BIRD CAN SING

YELLOW SUBMARINE

SHE SAID SHE SAID

A
A#
B
C
C#
D
D#
E
F
F#
G
G#

G#
G
F#
F
E
D#
D
C#
C
B
A#
A

Major
Minor

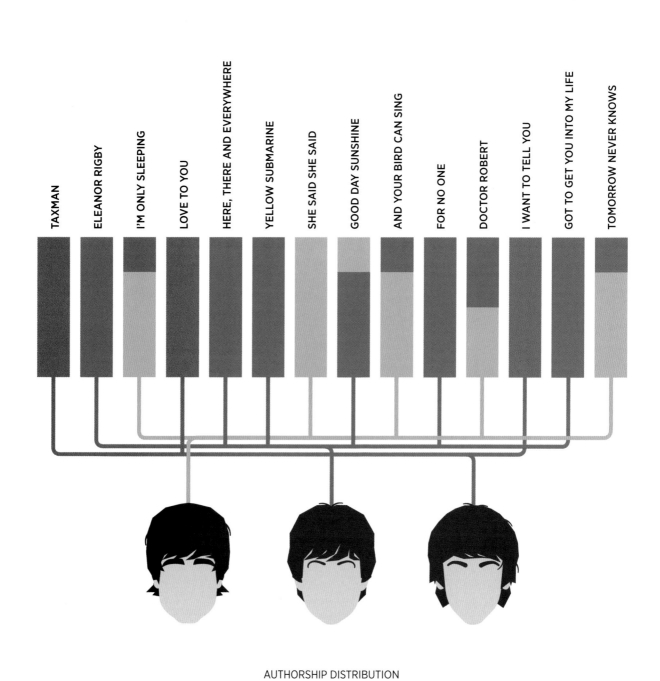

TAXMAN

ELEANOR RIGBY

I'M ONLY SLEEPING

LOVE TO YOU

HERE, THERE AND EVERYWHERE

YELLOW SUBMARINE

SHE SAID SHE SAID

GOOD DAY SUNSHINE

AND YOUR BIRD CAN SING

FOR NO ONE

DOCTOR ROBERT

I WANT TO TELL YOU

GOT TO GET YOU INTO MY LIFE

TOMORROW NEVER KNOWS

AUTHORSHIP DISTRIBUTION

LENNON McCARTNEY HARRISON

UK SINGLE RELEASES

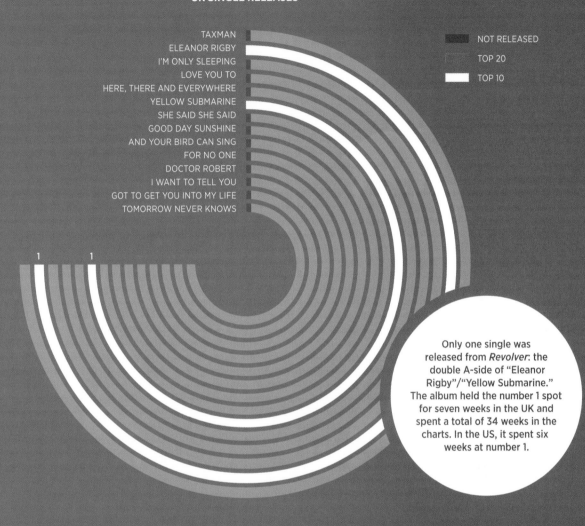

- TAXMAN
- ELEANOR RIGBY
- I'M ONLY SLEEPING
- LOVE YOU TO
- HERE, THERE AND EVERYWHERE
- YELLOW SUBMARINE
- SHE SAID SHE SAID
- GOOD DAY SUNSHINE
- AND YOUR BIRD CAN SING
- FOR NO ONE
- DOCTOR ROBERT
- I WANT TO TELL YOU
- GOT TO GET YOU INTO MY LIFE
- TOMORROW NEVER KNOWS

NOT RELEASED
TOP 20
TOP 10

Only one single was released from *Revolver*: the double A-side of "Eleanor Rigby"/"Yellow Submarine." The album held the number 1 spot for seven weeks in the UK and spent a total of 34 weeks in the charts. In the US, it spent six weeks at number 1.

ALBUM CHART POSITIONS

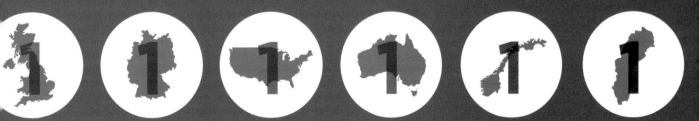

ITED KINGDOM Number One | **GERMANY** Number One | **UNITED STATES** Number One | **AUSTRALIA** Number One | **NORWAY** Number One | **SWEDEN** Number One

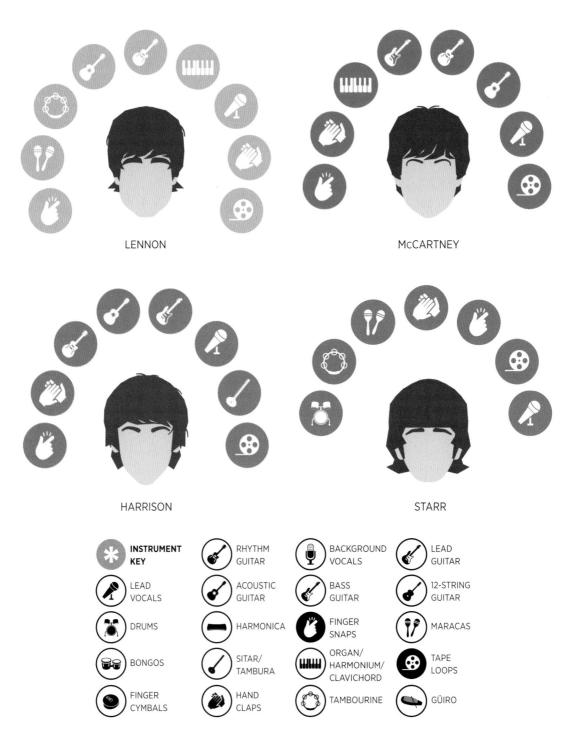

LENNON

McCARTNEY

HARRISON

STARR

INSTRUMENT KEY	RHYTHM GUITAR	BACKGROUND VOCALS	LEAD GUITAR
LEAD VOCALS	ACOUSTIC GUITAR	BASS GUITAR	12-STRING GUITAR
DRUMS	HARMONICA	FINGER SNAPS	MARACAS
BONGOS	SITAR/ TAMBURA	ORGAN/ HARMONIUM/ CLAVICHORD	TAPE LOOPS
FINGER CYMBALS	HAND CLAPS	TAMBOURINE	GÜIRO

Black circle indicates instruments used for the first time in a Beatles' album.

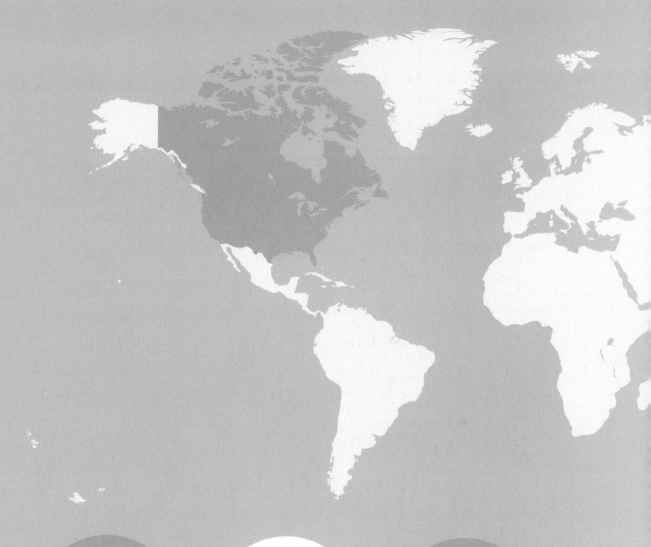

2
COUNTRIES

1
TOUR

19
LIVE SHOWS

1963 late 1963 mid-1964

late 1964 mid-1965 late 1965

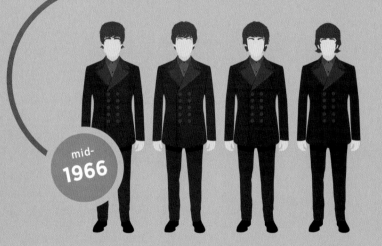

mid-**1966**

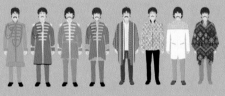

mid-1967 late 1967

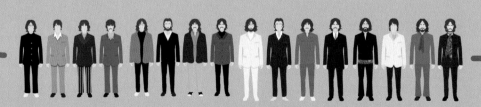

late 1968 early 1969 1969 1970

1970

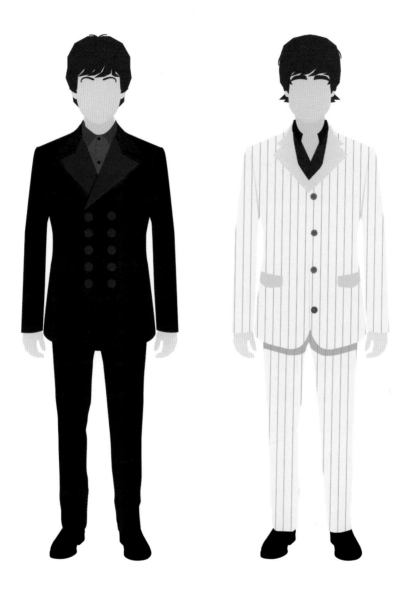

Throughout 1966, The Beatles took the stage wearing one of two iconic designs: a dark double-breasted suit with a green trim known as the "Budokan," and a cream-colored number with oxblood pinstripes. The former was clearly the preferred choice, with the band wearing it twice as much as the pinstripe model. It is also the suit to feature in their final concert at Candlestick Park in San Francisco.

The Times They Are A-changin'

Bob Dylan had a major influence on The Beatles from 1964 onward. Firstly, he introduced the band to marijuana, which led to an increasing use of drugs for the band. More importantly, however, he freed them from the conventions of pop music, influencing the songwriting of Lennon, in particular, who began to write more introspective and personal songs.

In Paris in sixty-four was the first time I ever heard Dylan at all. Paul got the record "The Freewheelin' Bob Dylan" from a French DJ. For the next three weeks in Paris we didn't stop playing it at all. We all went potty about Dylan.

John Lennon

Inspiration Behind the Music

The Beatles' music has always led to questions about inspiration and subject matter, with fans often speculating over what a song might be about. Here we look at the inspiration behind nine of the band's iconic songs.

PENNY LANE
1967

"Penny Lane" has been described as Paul's answer to John's "Strawberry Fields Forever." It's essentially an aerial view of their hometown, in particular an area of Liverpool that they were all very nostalgic for. Paul has said that all of the things in the song (with the exception of the banker in a plastic mac) are completely true.

PAPERBACK WRITER
1966

"Paperback Writer" is a tale of ambition, frustration, and a desire to please others. Inspired by an article from the *Daily Mail* about an aspiring novelist, McCartney wrote the lyrics in the style of a form letter, and the song represents a shift away from the love songs the band had been writing so much of to this point.

HELP!
1965

"Help!" was quite literally a cry for help from Lennon, who thought of himself in this period as "fat and depressed." Unhappy in his marriage and taking a lot of drugs, Lennon wrote this song as a cathartic exercise, and it was one of the first steps in moving away from the band's happy and dashing public veneer.

COME TOGETHER
1969

"Come Together" was inspired by the former Harvard professor Timothy Leary, who preached taking LSD and dropping out of college. Leary was planning on running for president, and his campaign tagline was going to be "Come Together." Lennon offered to help write the campaign song, and later made it his own.

I AM THE WALRUS
1967

John Lennon set out to write a song with lyrics that would be deliberately hard to analyze, after being informed by a lecturer of a class that examined Beatles lyrics. It's filled with references to nursery rhymes and pop culture, in particular the popular Lewis Carroll poem "The Walrus and the Carpenter," hence the title.

HEY JUDE
1968

This iconic song was written by Paul with John Lennon's son Julian in mind. McCartney wrote this song to cheer up Jules during his parents' divorce (changing the title to Jude for lyrical aesthetic). John felt the lyrics were also about him, however, in particular his growing relationship with Yoko Ono.

SHE SAID SHE SAID
1966

"She Said She Said" is inspired by actor Peter Fonda, who consoled George Harrison during a bad acid trip in Los Angeles. When Harrison felt like he was going to die, Fonda recounted to him a childhood near-death experience, telling Harrison "I know what it's like to be dead," and inspiring Lennon to write this song.

SAVOY TRUFFLE
1968

This Harrison song is inspired by guitarist Eric Clapton, who was a friend of The Beatles. Clapton had something of a sweet tooth and liked to indulge it. After a warning from his dentist that he would lose his teeth if he didn't cut back on the sweets, Harrison wrote "Savoy Truffle" as a private joke between him and his friend. The candy names are lifted verbatim from "Mackintosh's Good News."

YOU NEVER GIVE ME YOUR MONEY
1969

After the passing of manager Brian Epstein, the band struggled to find a suitable replacement. Eventually they settled on Allen Klein, who also comanaged The Rolling Stones. McCartney was not at all comfortable with this decision, writing this song to vent his frustration about how Klein handled the band's money.

More Popular Than Jesus

By 1966 The Beatles were huge in America, but their popularity would take a hit in the summer of that year. During an interview with journalist Maureen Cleave, John Lennon was talking about the decline of Christianity, making the following remark:

"We're more popular than Jesus now. I don't know which will go first, rock 'n' roll or Christianity. Jesus was all right but his disciples were thick and ordinary. It's them twisting it that ruins it for me."

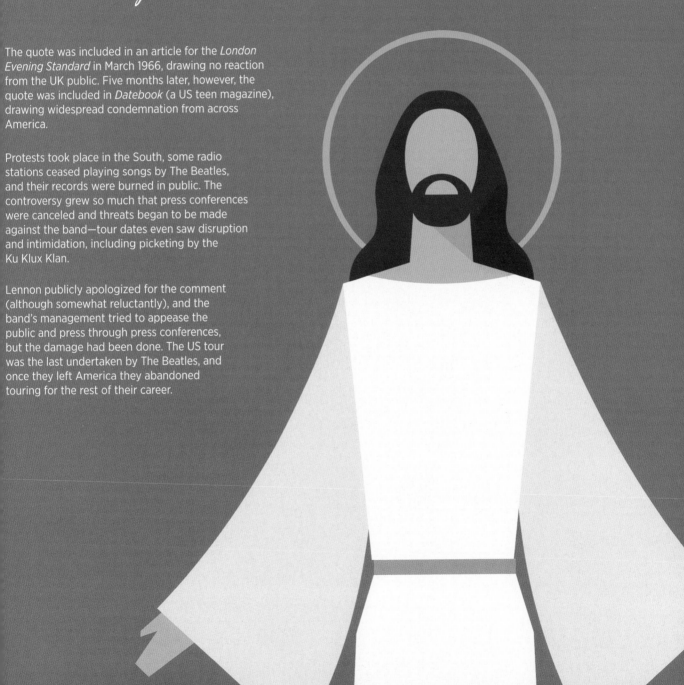

The quote was included in an article for the *London Evening Standard* in March 1966, drawing no reaction from the UK public. Five months later, however, the quote was included in *Datebook* (a US teen magazine), drawing widespread condemnation from across America.

Protests took place in the South, some radio stations ceased playing songs by The Beatles, and their records were burned in public. The controversy grew so much that press conferences were canceled and threats began to be made against the band—tour dates even saw disruption and intimidation, including picketing by the Ku Klux Klan.

Lennon publicly apologized for the comment (although somewhat reluctantly), and the band's management tried to appease the public and press through press conferences, but the damage had been done. The US tour was the last undertaken by The Beatles, and once they left America they abandoned touring for the rest of their career.

ALBUM OVERVIEW

Released: June 1, 1967
Producer: George Martin
Engineers: Geoff Emerick, Adrian Ibbetson, Malcolm Addey,
Ken Townsend, Peter Vince

The band's eighth UK album played a huge part in defining
the midsixties period and, in particular, the '67 "Summer of
Love." Many consider this album, which took over 400 hours
to record during a 129-day period, to be a significant step
in the progression of modern music. It certainly pushed the
boundaries of what was possible in studio recording, producing
sounds that were completely unique for the time. Numerous
session musicians and orchestras were utilized, combining
several different styles of music.

Before the release of the album, many music journalists
suspected The Beatles were finished. They were no longer
touring and had retreated from the public. Music papers had
explicitly questioned where the band were and speculated that
their creativity had run dry. Paul has said that before writing
the album they had become bored of being The Beatles and
thought of themselves as artists rather than just performers.
Sgt. Pepper's was a way for the band to develop alter egos and
project a different image to the world.

The album won four Grammy Awards in 1968 and, in 2003, was
ranked number 1 by *Rolling Stone* magazine in their "500
Greatest Albums of All Time."

SGT. PEPPER'S LONELY HEARTS CLUB BAND
JUNE 1967

June 25, 1967
400 million viewers watch *Our World,* the first live, international, satellite television production. It features the live debut of The Beatles' song "All You Need Is Love."

July 1, 1967
Canada celebrates its first 100 years of Confederation.

July 4, 1967
The British Parliament decriminalizes homosexuality.

July 10, 1967
New Zealand decimalizes its currency from pound to dollar.

June 27, 1967
The first automatic cash machine (voucher-based) is installed, in the office of the Barclays Bank in Enfield, England.

June 5, 1967
Murderer Richard Speck is sentenced to death in the electric chair for killing eight student nurses in Chicago.

July 1, 1967
The first UK color television broadcasts begin on BBC2. The first one is from the Wimbledon tennis championships.

July 7, 1967
"All You Need Is Love" is released in the UK.

October 3, 1967
An X-15 research aircraft with test pilot William J. Knight establishes an unofficial world fixed-wing speed record of Mach 6.7.

August 13, 1967
The first lineup of Fleetwood Mac makes their live debut at the Windsor Jazz and Blues Festival.

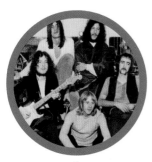

August 27, 1967
Beatles manager Brian Epstein is found dead in his locked bedroom.

October 8, 1967
Guerrilla leader Che Guevara and his men are captured in Bolivia; they are executed the following day.

September 3, 1967
At 5:00 a.m. local time, all road traffic in Sweden switches from a left-hand traffic pattern to right-hand traffic.

August 5, 1967
Pink Floyd release their debut album, *The Piper at the Gates of Dawn*.

November 28, 1967
The first pulsar, named PSR B1919+21, was discovered by Jocelyn Bell Burnell and Antony Hewish.

ALBUM COVER DESIGN

Originally, The Beatles wanted to use an illustration created by the design group The Fool for the cover of the album. They were dissuaded by friend and art dealer Robert Fraser, who suggested pop artists Peter Blake and his wife, Jann Haworth.

The band, along with Fraser and Blake, made lists of who they would like to invite to an imaginary *Sgt. Pepper's* concert. Various people were chosen from these lists and featured in the background of the cover (including Carl Jung, Bob Dylan, Stuart Sutcliffe, Aldous Huxley, Edgar Allan Poe, Marilyn Monroe, Albert Einstein, Karl Marx, Laurel and Hardy, Oscar Wilde, Lewis Carroll, and Marlene Dietrich). We've visualized the incredible outfits the band wore here.

"

SGT. PEPPER'S IS ONE OF THE MOST

IMPORTANT

STEPS

OF OUR CAREER. IT HAD TO BE JUST RIGHT.

"

— JOHN LENNON —

1967, ON SGT. PEPPER'S

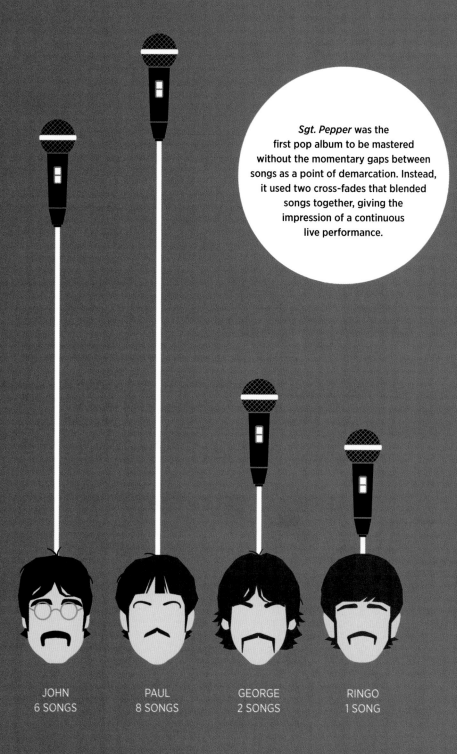

Sgt. Pepper was the first pop album to be mastered without the momentary gaps between songs as a point of demarcation. Instead, it used two cross-fades that blended songs together, giving the impression of a continuous live performance.

JOHN
6 SONGS

PAUL
8 SONGS

GEORGE
2 SONGS

RINGO
1 SONG

When band members shared lead vocals, both are listed. As a result, the total may add up to more than the number of tracks on the album.

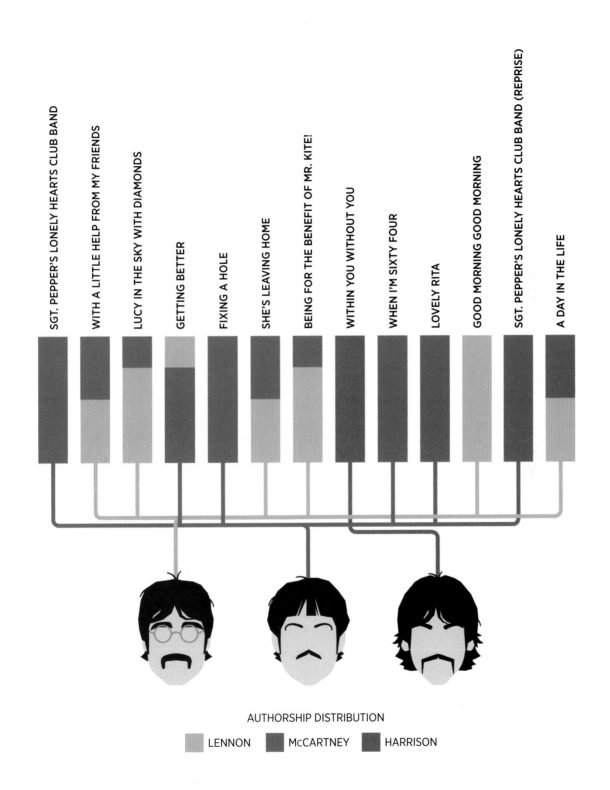

AUTHORSHIP DISTRIBUTION

LENNON McCARTNEY HARRISON

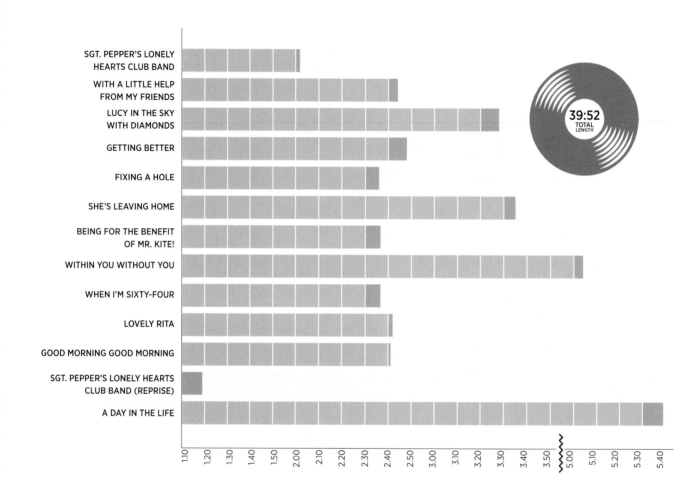

| | SGT. PEPPER'S LONELY HEARTS CLUB BAND |
| WITH A LITTLE HELP FROM MY FRIENDS |
| LUCY IN THE SKY WITH DIAMONDS |
| GETTING BETTER |
| FIXING A HOLE |
| SHE'S LEAVING HOME |
| BEING FOR THE BENEFIT OF MR. KITE! |
| WITHIN YOU WITHOUT YOU |
| WHEN I'M SIXTY-FOUR |
| LOVELY RITA |
| GOOD MORNING GOOD MORNING |
| SGT. PEPPER'S LONELY HEARTS CLUB BAND (REPRISE) |
| A DAY IN THE LIFE |

39:52 TOTAL LENGTH

1.10 1.20 1.30 1.40 1.50 2.00 2.10 2.20 2.30 2.40 2.50 3.00 3.10 3.20 3.30 3.40 3.50 5.00 5.10 5.20 5.30 5.40

0 COVERS

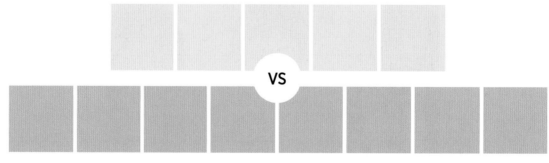

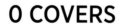

VS

13 ORIGINALS

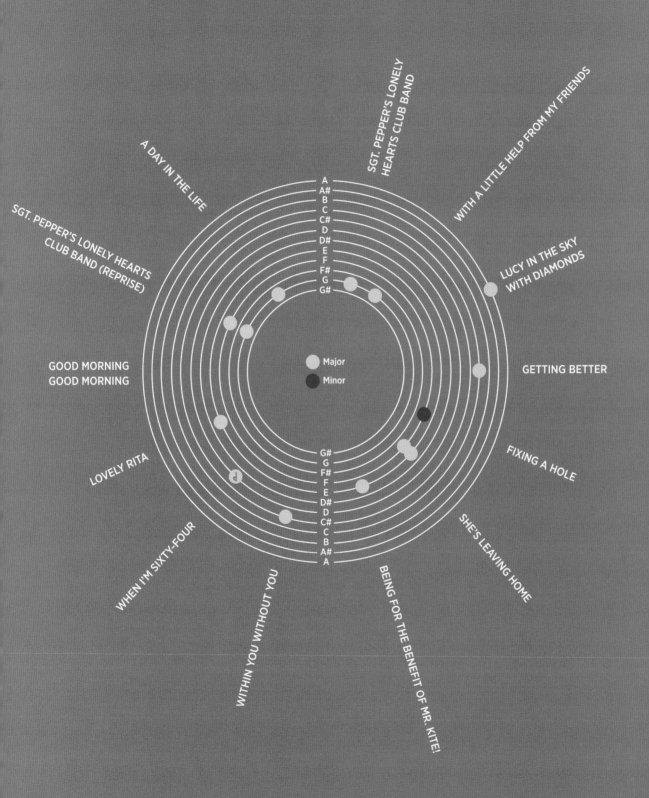

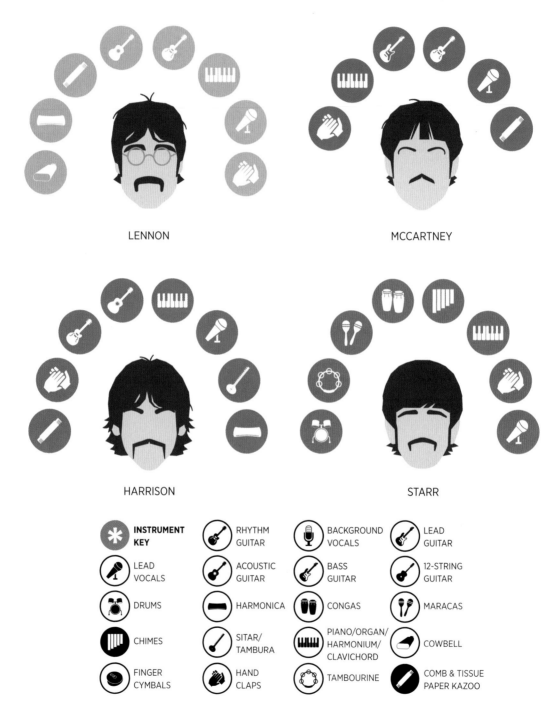

LENNON

MCCARTNEY

HARRISON

STARR

INSTRUMENT KEY

LEAD VOCALS

DRUMS

CHIMES

FINGER CYMBALS

RHYTHM GUITAR

ACOUSTIC GUITAR

HARMONICA

SITAR/ TAMBURA

HAND CLAPS

BACKGROUND VOCALS

BASS GUITAR

CONGAS

PIANO/ORGAN/ HARMONIUM/ CLAVICHORD

TAMBOURINE

LEAD GUITAR

12-STRING GUITAR

MARACAS

COWBELL

COMB & TISSUE PAPER KAZOO

Black circle indicates instruments used for the first time in a Beatles' album.

UK SINGLE RELEASES

SGT. PEPPER'S LONELY HEARTS CLUB BAND
WITH A LITTLE HELP FROM MY FRIENDS
LUCY IN THE SKY WITH DIAMONDS
GETTING BETTER
FIXING A HOLE
SHE'S LEAVING HOME
BEING FOR THE BENEFIT OF MR. KITE!
WITHIN YOU WITHOUT YOU
WHEN I'M SIXTY-FOUR
LOVELY RITA
GOOD MORNING GOOD MORNING
SGT. PEPPER'S (REPRISE)
A DAY IN THE LIFE

63* 63* 63*

No singles were taken from the album (initially given a working title of *One Down, Six to Go* in reference to their recording contract with EMI). But "Sgt. Pepper's Lonely Hearts Club Band" and "With a Little Help from My Friends" charted in 1978 on the rerelease (with "A Day in the Life" as the B-side). The album topped the UK charts for a total of 27 weeks, 23 of them consecutive, and remained in the charts for 148 weeks. Worldwide, it sold 30 million copies and spent 15 weeks at number 1 in the US charts.

NOT RELEASED

TOP 20

TOP 10

*Charted in 1978 on rerelease.

ALBUM CHART POSITIONS

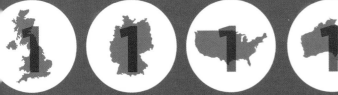

ITED KINGDOM
Number One

GERMANY
Number One

UNITED STATES
Number One

AUSTRALIA
Number One

NORWAY
Number One

SWEDEN
Number One

CANADA
Number One

1963 late 1963 mid-1964

late 1964 mid-1965 late 1965 mid-1966

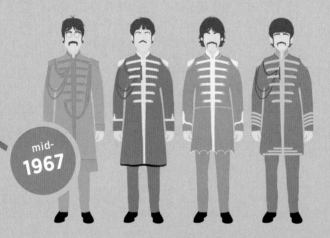

mid-**1967**

late 1967 late 1968

early 1969 1969 1970

1970

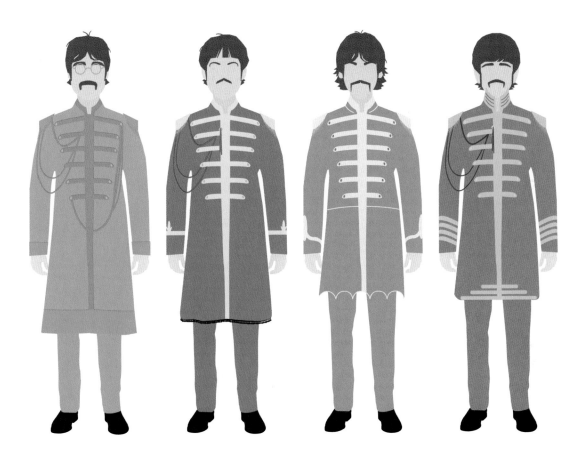

The iconic psychedelic outfits worn for the cover of *Sgt. Pepper's* are one of the most recognizable Beatles images of all time. The group are dressed as members of the Lonely Hearts Club band, and the faux military uniforms were designed to poke fun at the vogue in Britain for military fashions.

Beatles Island

In the summer of 1967, The Beatles agreed to buy a set of Greek islands in the Aegean Sea, totaling approximately 100 acres. Encouraged in particular by John Lennon, the band wanted to purchase what could have been known as "Beatles Island" as a base for them to live and work, alongside friends and family.

The main island was surrounded by four smaller islands, where the band were to have separate villas, with the main island serving as a base for all Beatles-related operations.

Ultimately, the purchase never went through, as by the time the band managed to get permission to move the required £90,000 (over $250,000 at the time) from Britain to Greece, they had cooled on the idea and moved on to other plans. Luckily, however, in selling the dollars back to the government the band made over £10,000 ($28,000) profit.

That Chord—A Day in the Life

One of the band's most famous songs, "A Day in the Life," also contains one of the most iconic and memorable moments in The Beatles' repertoire. Let's have a look at the story behind that famous final chord.

The "full" sound of the chord is achieved by Lennon, McCartney, and Starr (along with Mal Evans) playing simultaneously on three different pianos. George Martin is also playing the chord on a harmonium.

As the vibration of the chord faded, the recording level was gradually increased in order to get the desired effect. By the end of the song, the recording level is so high that studio sounds can be heard on the recording (including rustling papers and a squeaking chair). Interestingly, the piano chord was a replacement for a failed vocal experiment, in which all four Beatles hummed the chord. However, after multiple overdubs, the band decided that they required something with more impact, leading to the combined piano chords you hear playing the final note.

The final chord is an E-major, which provides musical relief from the tension of the final section. Although the song is in G-major, its true center is in the minor and major keys of E.

The final chord lasts over 40 seconds, with the recording level increasing as the vibration fades out in order to make it last longer. The chord lasts from 4:21 to 5:05 at the end of the song.

The Ballad of John and Yoko

John Lennon met Yoko Ono in 1966, when he attended a preview of her art exhibition at a gallery in London. A year later they began an affair, and married after John's divorce from Cynthia Lennon, saying their vows in Gibraltar in 1969. Yoko Ono was a major influence on Lennon's work, both with and without The Beatles.

After the breakup of The Beatles, John and Yoko moved to New York, giving birth to their son Sean Ono Lennon in 1975. The couple collaborated on numerous creative projects, including iconic songs such as "Imagine" and "Give Peace a Chance." They also held the now infamous "Bed-in for Peace," in protest against America's involvement in the Vietnam War.

On December 8, 1980, John Lennon was shot and killed outside the couple's New York apartment building. Yoko Ono has always worked to preserve his memory, founding the Strawberry Fields Memorial in Central Park, New York, as well as the John Lennon Museum in Japan and the Imagine Peace Tower in Reykjavik, Iceland. The latter is a tower of light projected from a white stone monument, with "imagine peace" carved into the stone in 24 languages.

She also undertakes charitable projects associated with Lennon, including the "Imagine There's No Hunger" campaign. A collaborative campaign between Yoko Ono, WhyHunger, and Hard Rock International, the project aims to fulfill John Lennon's vision for a world free from hunger by ensuring every child has the right to sustainable, nutritious food.

US Singles

Many of the band's most famous songs, from "She Loves You" to "Hey Jude," were never released on a stand-alone album (or not on the core UK releases). Instead, they were released as singles, either in the UK and the US or in the US in a different version. In this section we look at the US singles released from 1962 right through to 1996.

We've only included here the singles that weren't included on one of the 13 core albums, and only releases that made it into the US top 20. There were a handful of other singles that didn't do so well, such as "From Me To You" / "Thank You Girl," which reached 116, and "Why" / "Cry for a Shadow," which reached 88.

She Loves You / I'll Get You

I Want to Hold Your Hand / This Boy

Twist & Shout / There's a Place

Do You Want to Know a Secret / Thank You Girl

Ain't She Sweet / Nobody's Child (with Tony Sheridan)

Matchbox / Slow Down

I Feel Fine / She's a Woman

Eight Days a Week / I Don't Want to Spoil the Party

Yesterday / Act Naturally

We Can Work It Out / Day Tripper

Nowhere Man / What Goes On

Paperback Writer / Rain

Lady Madonna / The Inner Light

Hey Jude / Revolution

Get Back / Don't Let Me Down

Ballad of John and Yoko / Old Brown Shoe

Let It Be / You Know My Name
(Look Up the Number)

Got to Get You into My Life / Helter Skelter

The Beatles Movie Medley / I'm Happy
Just to Dance with You

Free as a Bird / Christmas Time
(Is Here Again)

Real Love / Baby's in Black

ALBUM OVERVIEW

Released: December 8, 1967
Producers: George Martin, Dave Harries
Engineers: Geoff Emerick, Dave Harries, Malcolm Addey, Keith
Grant, Eddie Kramer, John Timperley, Peter Vince, Ken Scott

This album came about in the wake of Brian Epstein's death
(August 27, 1967), leaving the band suddenly without the direction
and guidance of their manager. *Magical Mystery Tour* was Paul
McCartney's idea. He wanted to produce a TV special about
a group of ordinary people taking a mystery coach trip. The
album is the soundtrack to the program broadcast by the
BBC in December 1967. Four of the six songs from the EP were
recorded before filming began on September 11, 1967. Despite
the film being slated by critics and public audiences, the
soundtrack was well received and a commercial success.

The US version of the album contained five other songs released
by The Beatles in 1967, contrary to the wishes of the band. In
1976 the full album version was released in the UK, and in 1987
this became the standard version worldwide when the band's
back catalog was rereleased on CD.

MAGICAL MYSTERY TOUR
DECEMBER 1967

December 26, 1967
The Beatles' film *Magical Mystery Tour* has its world premier on BBC Television in the UK.

February 11, 1968
Madison Square Garden in New York City opens at its current location.

April 2, 1968
The film *2001: A Space Odyssey* premieres in Washington, D.C.

April 23, 1968
Surgeons at the Hôpital de la Pitié, Paris, perform Europe's first heart transplant, on Clovis Roblain.

December 31, 1967
Evel Knievel attempts to jump 141 feet over the Caesars Palace fountains on the Las Vegas Strip.

December 9, 1967
Jim Morrison is arrested on stage in New Haven, Connecticut, for attempting to spark a riot in the audience during a Doors concert.

March 12, 1968
Mauritius achieves independence from British rule.

April 4, 1968
Martin Luther King Jr. is shot dead at the Lorraine Motel in Memphis, Tennessee. Riots erupt in major American cities, lasting for several days afterward.

July 20, 1968
The first International Special Olympics Summer
Games are held at Soldier Field in Chicago, Illinois.

May 29, 1968
Manchester United win the
European Cup Final, becoming
the first English team to do so.

October 15, 1968
Led Zeppelin perform their first live gig
at Surrey University in England.

June 5, 1968
US presidential candidate
Robert F. Kennedy is shot at the
Ambassador Hotel in Los Angeles.

September 30, 1968
Boeing officially rolls out its new
747 for the media and the public.

July 18, 1968
The semiconductor
company Intel is founded.

May 14, 1968
The Beatles announce
the creation of Apple Records
in a New York press conference.

October 11, 1968
NASA launches *Apollo 7*, the first manned Apollo
mission. Goals include the first live television broadcast
from orbit and testing the lunar module docking maneuver.

ALBUM COVER DESIGN

This cover was an explosion of color. The photograph on the front features the four band members in the animal costumes they wore for the *Magical Mystery Tour* film. John Lennon wore a walrus costume, Paul McCartney a hippopotamus costume, George Harrison a rabbit costume, and Ringo Starr a chicken costume.

The double EP had a gatefold cover, with a 24-page booklet containing photographs from the filming of *Magical Mystery Tour*, as well as a cartoon strip telling the story of the film. The EP also contained a four-page lyrics section in the center of the booklet.

"

MAGICAL MYSTERY TOUR IS ONE OF MY
FAVORITE ALBUMS
BECAUSE IT WAS SO → WEIRD.

"

—— JOHN LENNON ——
1974, ON MAGICAL MYSTERY TOUR

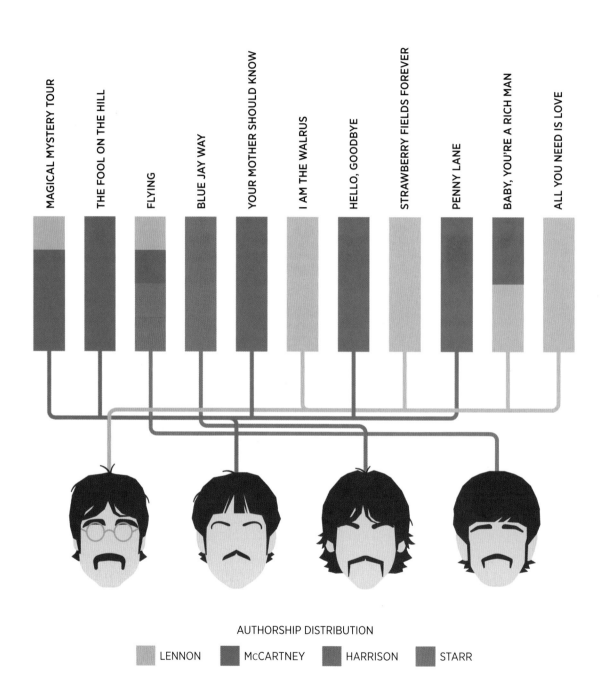

AUTHORSHIP DISTRIBUTION

LENNON McCARTNEY HARRISON STARR

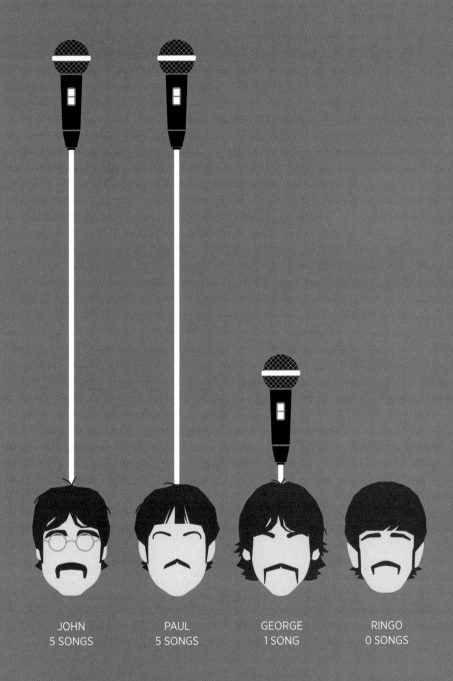

JOHN
5 SONGS

PAUL
5 SONGS

GEORGE
1 SONG

RINGO
0 SONGS

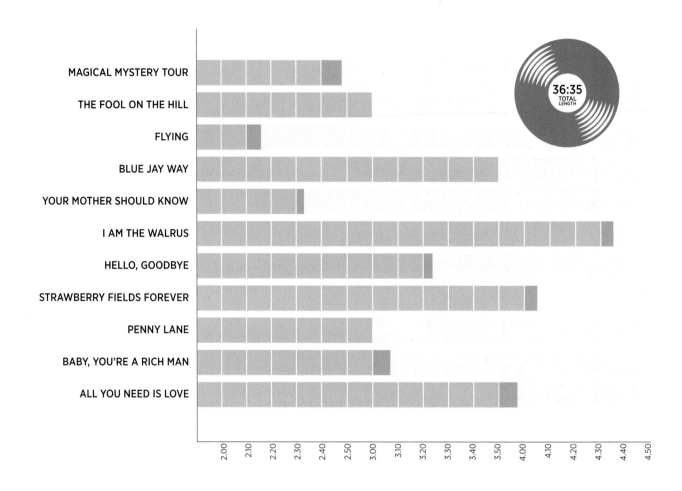

MAGICAL MYSTERY TOUR
THE FOOL ON THE HILL
FLYING
BLUE JAY WAY
YOUR MOTHER SHOULD KNOW
I AM THE WALRUS
HELLO, GOODBYE
STRAWBERRY FIELDS FOREVER
PENNY LANE
BABY, YOU'RE A RICH MAN
ALL YOU NEED IS LOVE

36:35 TOTAL LENGTH

2.00 2.10 2.20 2.30 2.40 2.50 3.00 3.10 3.20 3.30 3.40 3.50 4.00 4.10 4.20 4.30 4.40 4.50

0 COVERS

VS

11 ORIGINALS

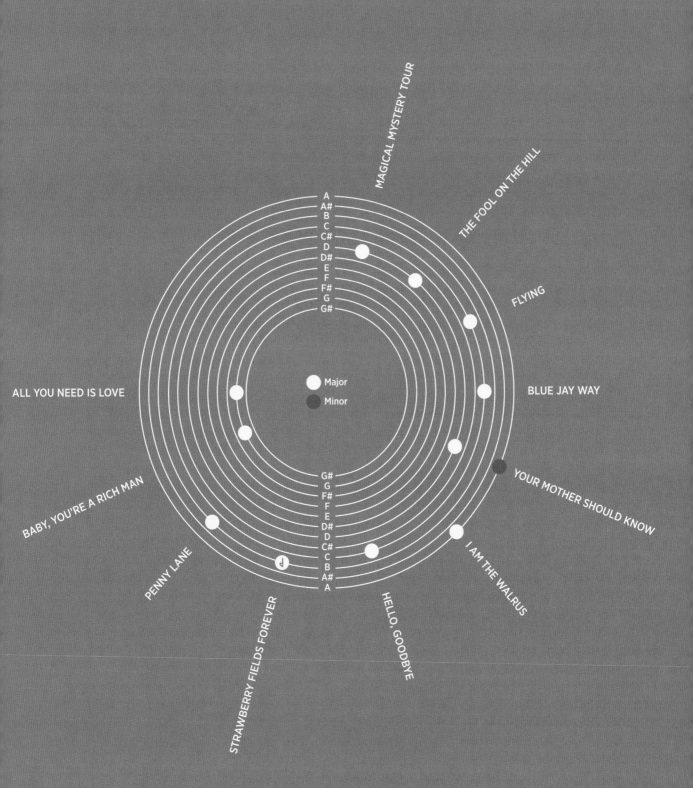

MAGICAL MYSTERY TOUR

THE FOOL ON THE HILL

FLYING

BLUE JAY WAY

YOUR MOTHER SHOULD KNOW

I AM THE WALRUS

HELLO, GOODBYE

STRAWBERRY FIELDS FOREVER

PENNY LANE

BABY, YOU'RE A RICH MAN

ALL YOU NEED IS LOVE

A
A#
B
C
C#
D
D#
E
F
F#
G
G#

Major

Minor

G#
G
F#
F
E
D#
D
C#
C
B
A#
A

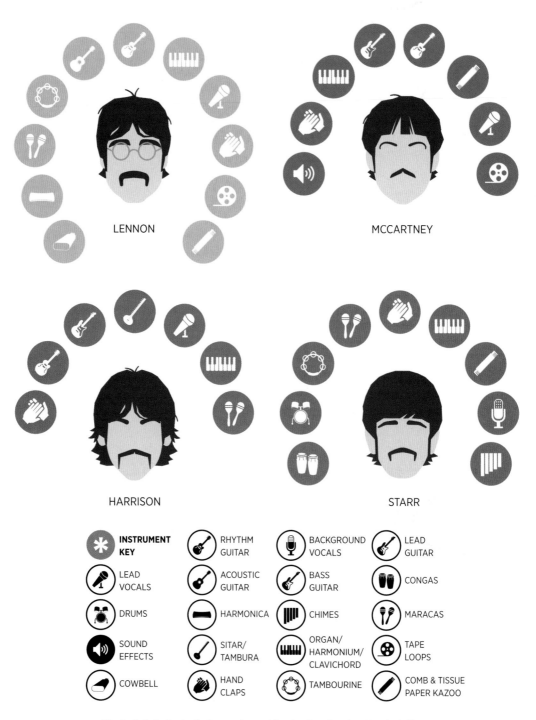

LENNON

MCCARTNEY

HARRISON

STARR

INSTRUMENT KEY

LEAD VOCALS

DRUMS

SOUND EFFECTS

COWBELL

RHYTHM GUITAR

ACOUSTIC GUITAR

HARMONICA

SITAR/ TAMBURA

HAND CLAPS

BACKGROUND VOCALS

BASS GUITAR

CHIMES

ORGAN/ HARMONIUM/ CLAVICHORD

TAMBOURINE

LEAD GUITAR

CONGAS

MARACAS

TAPE LOOPS

COMB & TISSUE PAPER KAZOO

Black circle indicates instruments used for the first time in a Beatles' album.

UK SINGLE RELEASES

MAGICAL MYSTERY TOUR
THE FOOL ON THE HILL
FLYING
BLUE JAY WAY
YOUR MOTHER SHOULD KNOW
I AM THE WALRUS
HELLO, GOODBYE
STRAWBERRY FIELDS FOREVER
PENNY LANE
BABY, YOU'RE A RICH MAN
ALL YOU NEED IS LOVE

1 1 2 2 1 1

In total, *Magical Mystery Tour* spent 12 weeks at number 2. The US version of the album was imported into the UK, and peaked at number 31 in the charts in January 1968, despite the fact that it wasn't officially available in the UK. Across the pond, *Magical Mystery Tour* enjoyed the largest initial sales figure of any album in history, selling $8 million worth in only three weeks.

NOT RELEASED
TOP 20
TOP 10

ALBUM CHART POSITIONS

UNITED STATES
Number One

FRANCE
Number Two

GERMANY
Number Eight

1963 late 1963 mid-1964

late 1964 mid-1965 late 1965 mid-1966

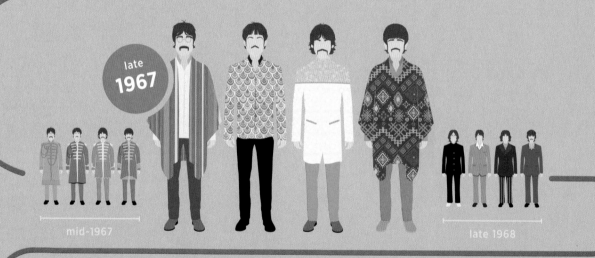

late **1967**

mid-1967 late 1968

early 1969 1969 1970

1970

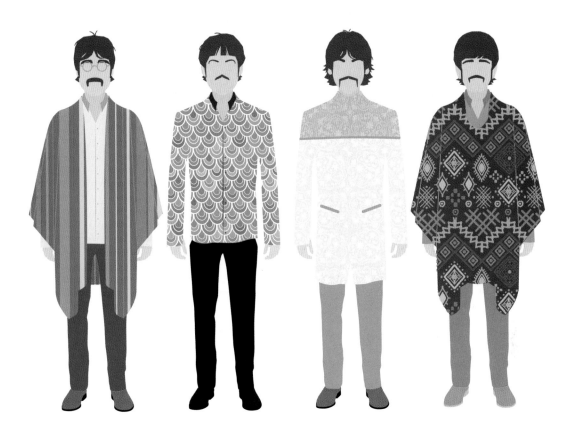

The outfits worn throughout *Magical Mystery Tour* show the continuation of the psychedelic theme running through this period of The Beatles' career. A wide range of colors and patterns give an eclectic look, with a real mix of styles. Many of these clothes were designed by Dutch group The Fool, who narrowly missed out on producing the cover artwork for *Sgt. Pepper*.

Turn me on, dead man ☠

One of the most enduring Beatles conspiracy theories centers around the supposed death of Paul McCartney, and subsequent replacement by the winner of a lookalike competition. A phone call to an American radio station in 1969, followed by a tongue-in-cheek article in the *Michigan Daily,* set the world alight, with people searching for clues that one of their beloved Beatles had died.

To this day, people still believe that Paul died in a car crash in 1966, and hundreds of different pieces of "evidence" have been cited. Many have been debunked, but here are some of our favorites:

Sgt. Pepper's Cover

The complex and eclectic mix of items and characters on the cover of the album gave fans hunting for clues a wealth of material. Here are just a few of the things they picked out:

As well as Paul being the only Beatle playing a black instrument (symbolizing death?), he appears to have a hand raised above his head. In certain Eastern societies this is a symbol of death. What is more strange is that a hand appears over the head of Paul in seven other photographs included in various Beatles' albums.

Many have pointed out that the cover also looks like a funeral scene. The fact that many of the "mourners" are dead, the flowers, the younger version of the band looking down, and the priest on the left are all cited as clues that this is a funeral for Paul.

Resting on the Rolling Stones doll on the bottom right is a model of an Aston Martin, the car it is said Paul was driving when he was killed.

The wreath at the bottom right of the album is in the shape of a bass guitar, and the left-handed version which Paul played. With some interpretation it can also be seen to spell the word "Paul."

A favorite pastime of clue hunters was to listen to Beatles tracks backward. If you listen hard enough you can hear almost anything, but some tracks that produced interesting results are:

"Revolution No. 9"—produces the words "turn me on, dead man"

"I'm So Tired"—produces "Paul is dead, man, miss him, miss him"

"Let It Be"—produces "he is dead"

Abbey Road Cover

The cover of *Abbey Road* is again one of the more visually interesting album designs, and there's no shortage of theories as to its symbolism:

A popular theory is that the cover depicts a funeral scene, with Ringo as the undertaker (dressed in black), George as the gravedigger (in denim), and John as the preacher (in white). Paul is barefoot, and is thought to represent the "corpse."

A VW Beetle can be seen in the background of the cover photo, with the last part of the license plate reading "28IF." Conspiracy theorists say this was the age Paul would have been if he were still alive.

Paul is also seen walking across the road with a cigarette in hand, which is unusual for an album cover. A well-known slang term for cigarettes is the "coffin nail." Could this be another clue?

In the *Magical Mystery Tour* film, Paul is seen wearing a black carnation, something normally associated with funerals, while the rest of the band have red ones. When asked about it, he claimed that they had run out of red ones, despite the fact he is passed a big bunch of them in the same scene...

At the end of the song "Strawberry Fields Forever," John Lennon is heard muttering in the background. It's not clear what he is saying, but many people have interpreted it as "I buried Paul." However, John himself is quoted as saying the words were "cranberry sauce."

THE PEDALS

John, Paul, and George used relatively few effects pedals during their career, at least compared to modern bands. Here are a few of the pedals they used during their performances and recordings.

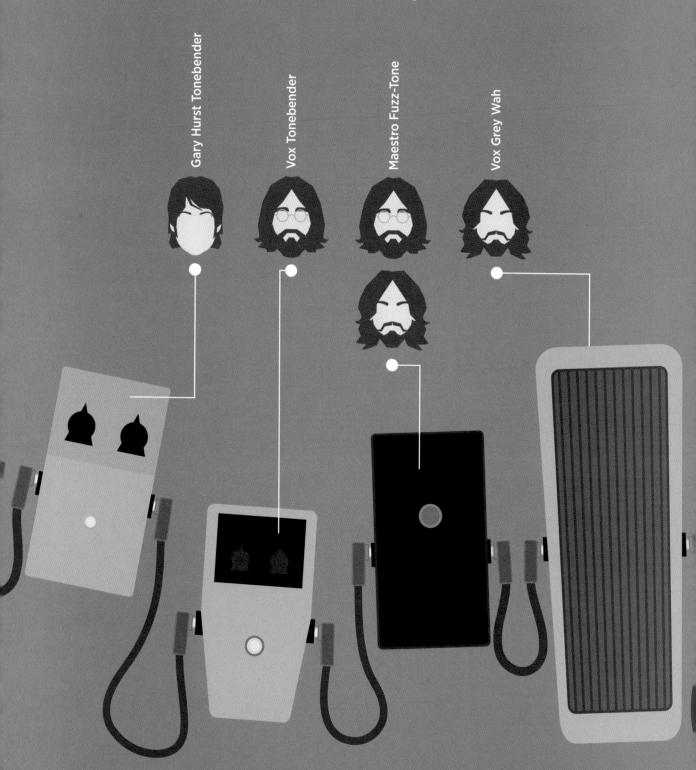

Gary Hurst Tonebender

Vox Tonebender

Maestro Fuzz-Tone

Vox Grey Wah

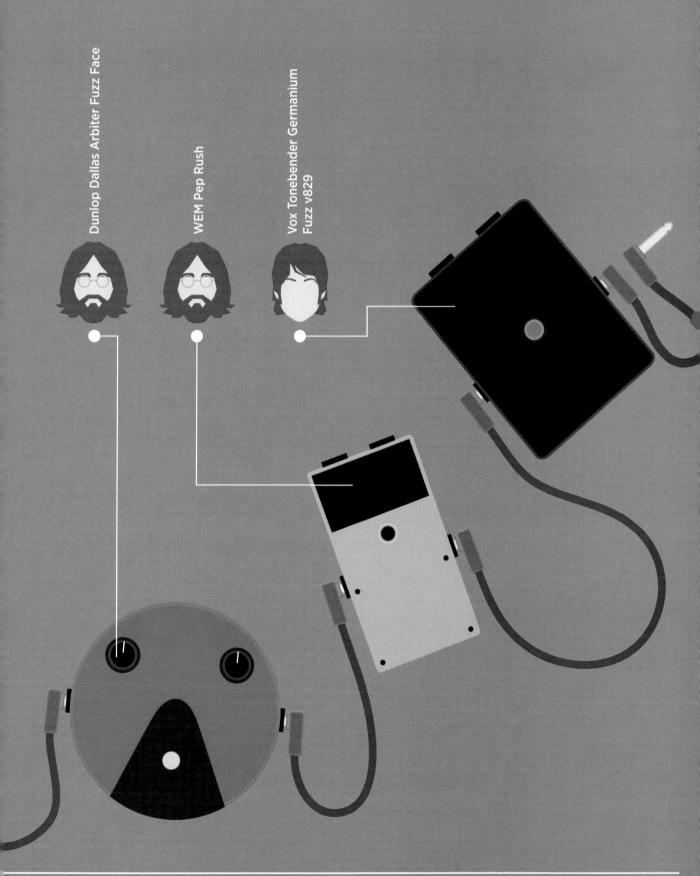

Dunlop Dallas Arbiter Fuzz Face

WEM Pep Rush

Vox Tonebender Germanium Fuzz v829

ALBUM OVERVIEW

Released: November 22, 1968
Producers: George Martin, Chris Thomas, John Lennon, Paul
McCartney
Engineers: Geoff Emerick, Peter Bown, Ken Scott, Barry Sheffield,
Ken Townsend

The album is called *The Beatles* but is commonly known as "The
White Album" to fans. It was the band's first double-length release,
consisting of 30 songs, many of which were written in India. George
Martin wanted to cut some of the weaker ones and release a
stronger single-disc album instead, but The Beatles insisted. During
the writing and recording, the band were setting up Apple Corps,
and dealing with press speculation, substance abuse, relationship
issues, and problems with the authorities.

They were now working more separately, and sessions often drifted
without any direction. By the third month of recording, tensions
began to rise in the studio. There were frequent conflicts and
disagreements, and the authority of George Martin began to lessen.
In August, Ringo Starr walked out. It was only when he returned two
weeks later that the band finally began working together again, and
the album started to fully take shape.

THE BEATLES
(WHITE ALBUM)
NOVEMBER 1968

November 20, 1968
The Farmington Mine disaster in Farmington,
West Virginia, kills 78 men.

December 9, 1968
Douglas Engelbart publicly
demonstrates his pioneering hypertext
system, NLS, in San Francisco.

December 10, 1968
Japan's biggest heist, the
never-solved "300 million
yen robbery," occurs in Tokyo.

November 8, 1968
John and Cynthia Lennon divorce.

November 11, 1968
John Lennon and Yoko
Ono release *Two Virgins.*

November 22, 1968
"Plato's Stepchildren," the tenth episode of
Star Trek's third season, is aired, featuring
the first-ever interracial kiss on US
national television between Lieutenant
Uhura and Captain James T. Kirk.

The BEATLES

ALBUM COVER DESIGN

The band enlisted pop artist Richard Hamilton to design the cover. He suggested a minimalist approach and also numbered sleeves, which early copies of the album had. The band originally intended it to have a see-through sleeve but were told it couldn't be done and settled on a plain white one with "The Beatles" lightly embossed on one side.

NUMBER
9
ROUND RIGHT
I'D
JULIA
GUN TELL
SON CRY
GUITAR GOES DIE MM NIGHT
KNOW LOVE GONNA EASY ROCKY ROAD
HEY
MAKE COME NOW
OLD AH GIRL DON'T
AH BOY
WELL
PIE SEE SING YEAH
I'M BUNGALOW LET TU LA GO
OOH BILL DEAR
BACK DA LIFE GOOD
LIKE FLY GET YES HONEY
KILL TAKE JOY
OH

"

LOOK WHAT MEDITATION'S DONE FOR

RINGO.

AFTER ALL THIS TIME HE'S WRITTEN

HIS FIRST SONG.

"

—— JOHN LENNON ——

ON SONGWRITING FOR THE WHITE ALBUM

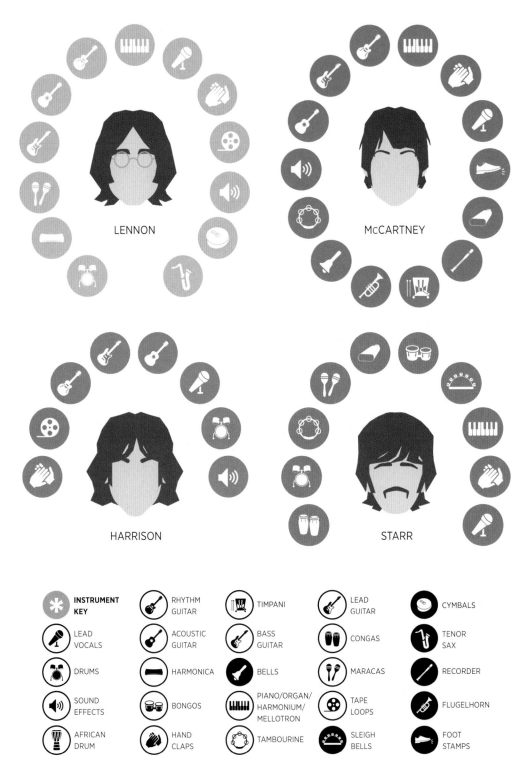

Black circle indicates instruments used for the first time in a Beatles' album.

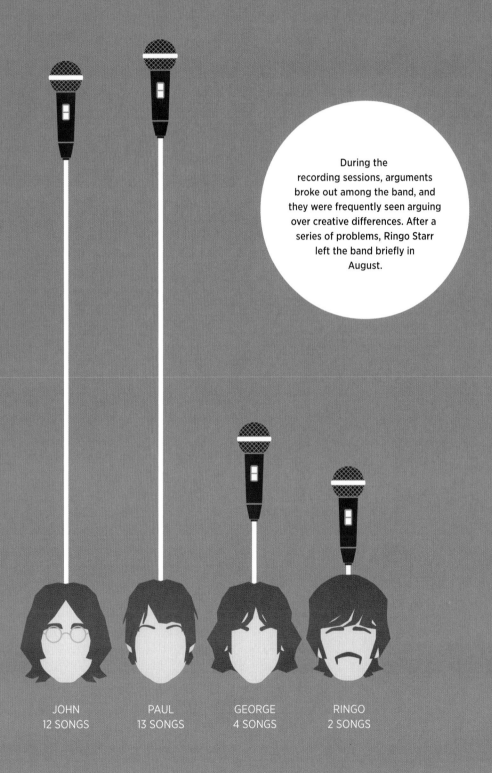

During the recording sessions, arguments broke out among the band, and they were frequently seen arguing over creative differences. After a series of problems, Ringo Starr left the band briefly in August.

JOHN
12 SONGS

PAUL
13 SONGS

GEORGE
4 SONGS

RINGO
2 SONGS

When band members shared lead vocals, both are listed. As a result, the total may add up to more than the number of tracks on the album.

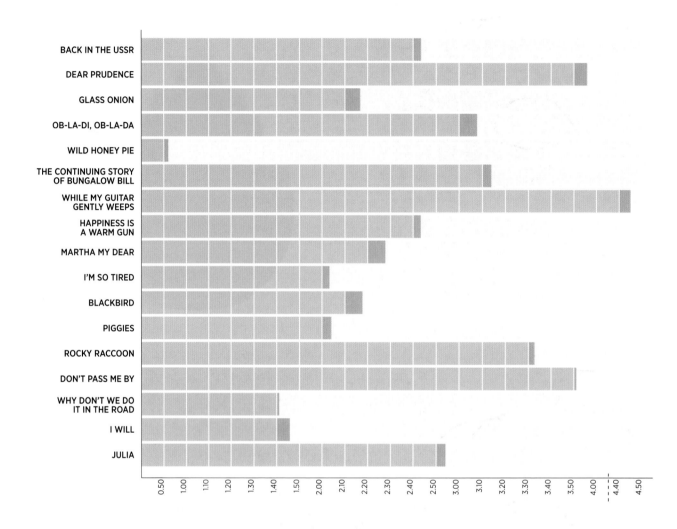

	0.50	1.00	1.10	1.20	1.30	1.40	1.50	2.00	2.10	2.20	2.30	2.40	2.50	3.00	3.10	3.20	3.30	3.40	3.50	4.00	4.40	4.50

BACK IN THE USSR

DEAR PRUDENCE

GLASS ONION

OB-LA-DI, OB-LA-DA

WILD HONEY PIE

THE CONTINUING STORY OF BUNGALOW BILL

WHILE MY GUITAR GENTLY WEEPS

HAPPINESS IS A WARM GUN

MARTHA MY DEAR

I'M SO TIRED

BLACKBIRD

PIGGIES

ROCKY RACCOON

DON'T PASS ME BY

WHY DON'T WE DO IT IN THE ROAD

I WILL

JULIA

0 COVERS

VS

17 ORIGINALS

TRACK LENGTHS AND COVERS VS. ORIGINALS

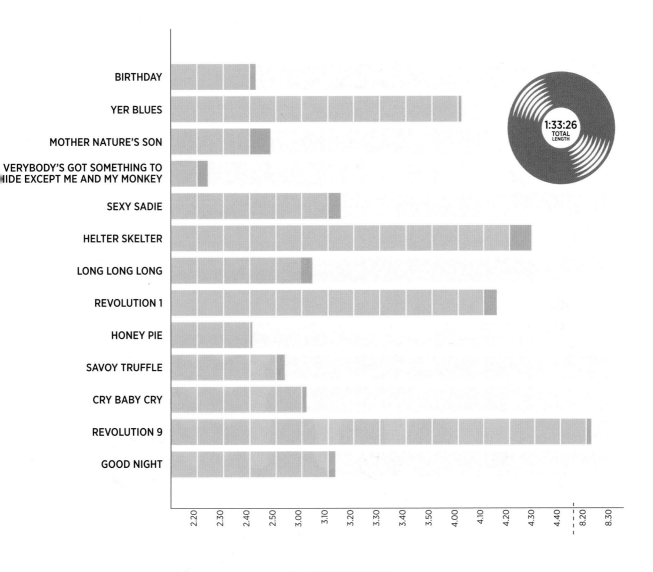

BIRTHDAY

YER BLUES

MOTHER NATURE'S SON

~~V~~ERYBODY'S GOT SOMETHING TO ~~H~~IDE EXCEPT ME AND MY MONKEY

SEXY SADIE

HELTER SKELTER

LONG LONG LONG

REVOLUTION 1

HONEY PIE

SAVOY TRUFFLE

CRY BABY CRY

REVOLUTION 9

GOOD NIGHT

1:33:26 TOTAL LENGTH

2.20 · 2.30 · 2.40 · 2.50 · 3.00 · 3.10 · 3.20 · 3.30 · 3.40 · 3.50 · 4.00 · 4.10 · 4.20 · 4.30 · 4.40 · 8.20 · 8.30

0 COVERS

VS

13 ORIGINALS

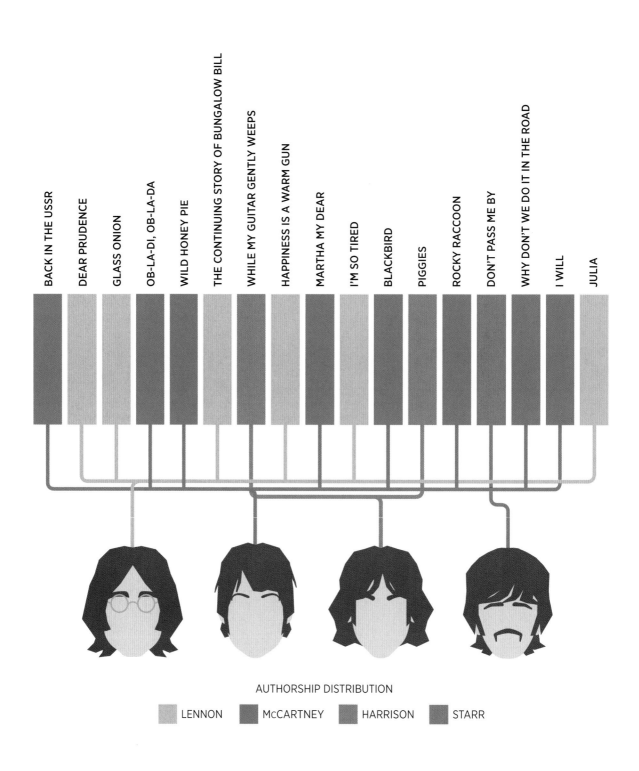

BACK IN THE USSR
DEAR PRUDENCE
GLASS ONION
OB-LA-DI, OB-LA-DA
WILD HONEY PIE
THE CONTINUING STORY OF BUNGALOW BILL
WHILE MY GUITAR GENTLY WEEPS
HAPPINESS IS A WARM GUN
MARTHA MY DEAR
I'M SO TIRED
BLACKBIRD
PIGGIES
ROCKY RACCOON
DON'T PASS ME BY
WHY DON'T WE DO IT IN THE ROAD
I WILL
JULIA

AUTHORSHIP DISTRIBUTION

LENNON McCARTNEY HARRISON STARR

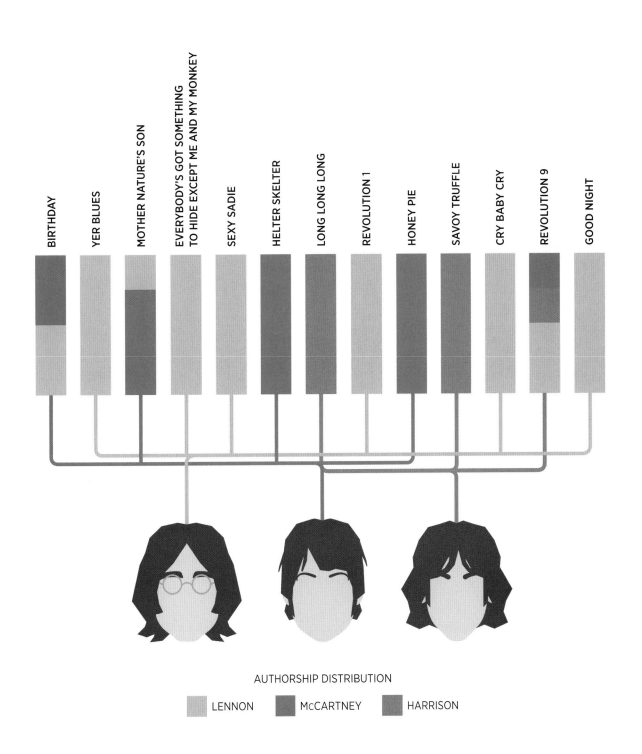

BIRTHDAY

YER BLUES

MOTHER NATURE'S SON

EVERYBODY'S GOT SOMETHING
TO HIDE EXCEPT ME AND MY MONKEY

SEXY SADIE

HELTER SKELTER

LONG LONG LONG

REVOLUTION 1

HONEY PIE

SAVOY TRUFFLE

CRY BABY CRY

REVOLUTION 9

GOOD NIGHT

AUTHORSHIP DISTRIBUTION

LENNON McCARTNEY HARRISON

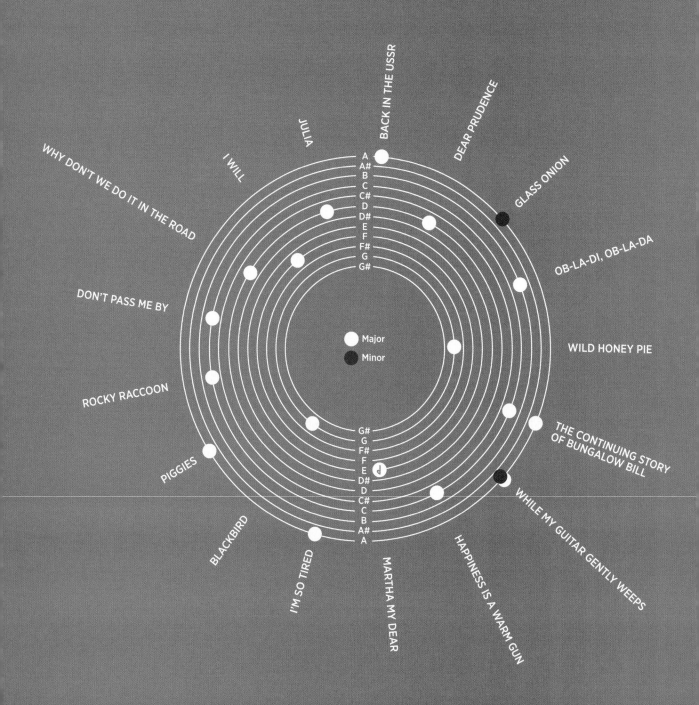

BACK IN THE USSR

DEAR PRUDENCE

JULIA

GLASS ONION

I WILL

OB-LA-DI, OB-LA-DA

WHY DON'T WE DO IT IN THE ROAD

WILD HONEY PIE

DON'T PASS ME BY

THE CONTINUING STORY
OF BUNGALOW BILL

ROCKY RACCOON

WHILE MY GUITAR GENTLY WEEPS

PIGGIES

BLACKBIRD

I'M SO TIRED

MARTHA MY DEAR

HAPPINESS IS A WARM GUN

A
A#
B
C
C#
D
D#
E
F
F#
G
G#

Major
Minor

G#
G
F#
F
E
D#
D
C#
C
B
A#
A

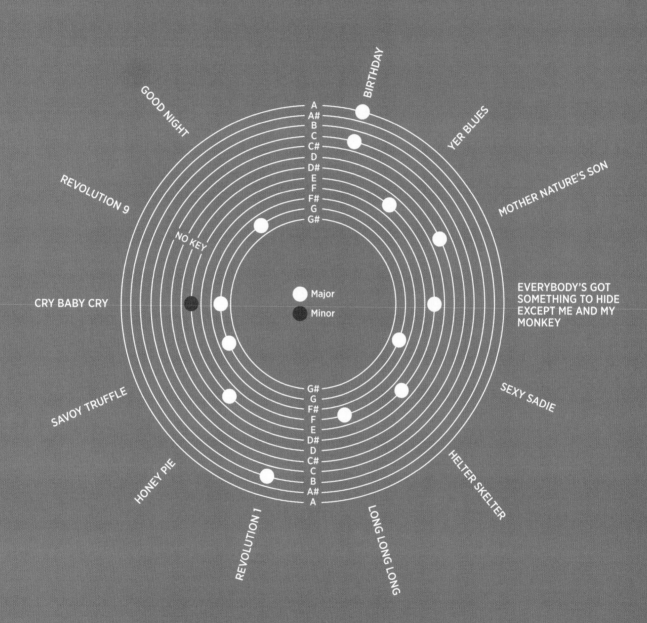

BIRTHDAY

YER BLUES

MOTHER NATURE'S SON

EVERYBODY'S GOT
SOMETHING TO HIDE
EXCEPT ME AND MY
MONKEY

SEXY SADIE

HELTER SKELTER

LONG LONG LONG

REVOLUTION 1

HONEY PIE

SAVOY TRUFFLE

CRY BABY CRY

REVOLUTION 9

GOOD NIGHT

NO KEY

Major

Minor

A
A#
B
C
C#
D
D#
E
F
F#
G
G#

G#
G
F#
F
E
D#
D
C#
C
B
A#
A

UK SINGLE RELEASES (SIDE 1)

BACK IN THE USSR
DEAR PRUDENCE
GLASS ONION
OB-LA-DI, OB-LA-DA
WILD HONEY PIE
THE CONTINUING STORY OF BUNGALOW BILL
WHILE MY GUITAR GENTLY WEEPS
HAPPINESS IS A WARM GUN
MARTHA MY DEAR
I'M SO TIRED
BLACKBIRD
PIGGIES
ROCKY RACCOON
DON'T PASS ME BY
WHY DON'T WE DO IT IN THE ROAD
I WILL
JULIA

19*

After the creative failure of the *Magical Mystery Tour* television film, and the release of the accompanying EP and "Lady Madonna" single, there was widespread speculation from music writers that the band had finished. But the White Album debuted at number 1 in the UK chart, spending a total of seven weeks there and 24 weeks in the charts in total. In the US, the album spent nine weeks at number 1, and 155 weeks on the Billboard 200. No singles were taken from the White Album, although "Hey Jude"/"Revolution" was recorded during the same sessions and released as a stand-alone single. "Back in the USSR" charted in the UK on the 1976 rerelease.

NOT RELEASED
TOP 20
TOP 10

*Charted in the UK on the 1976 rerelea[s]

ALBUM CHART POSITIONS

UNITED KINGDOM
Number One

GERMANY
Number One

CANADA
Number One

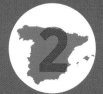

SPAIN
Number Two

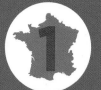

FRANCE
Number One

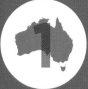

AUSTRALIA
Number One

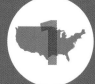

UNITED STATES
Number One

NORWAY
Number Two

SWEDEN
Number One

BIRTHDAY
YER BLUES
MOTHER NATURE'S SON
EVERYBODY'S GOT SOMETHING TO HIDE
SEXY SADIE
HELTER SKELTER
LONG LONG LONG
REVOLUTION 1
HONEY PIE
SAVOY TRUFFLE
CRY BABY CRY
REVOLUTION 9
GOOD NIGHT

Most of the songs
on the album were written
during March and April
1968 at a Transcendental
Meditation course in
Rishikesh, India.

NOT RELEASED TOP 20 TOP 10

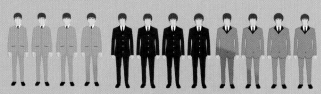

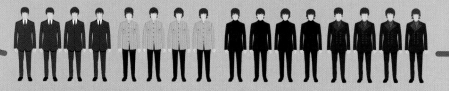

1963 late 1963 mid-1964

late 1964 mid-1965 late 1965 mid-1966

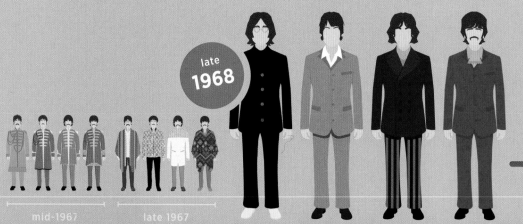

late **1968**

mid-1967 late 1967

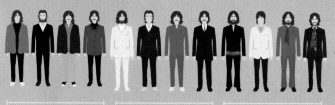

early 1969 1969 1970

1970

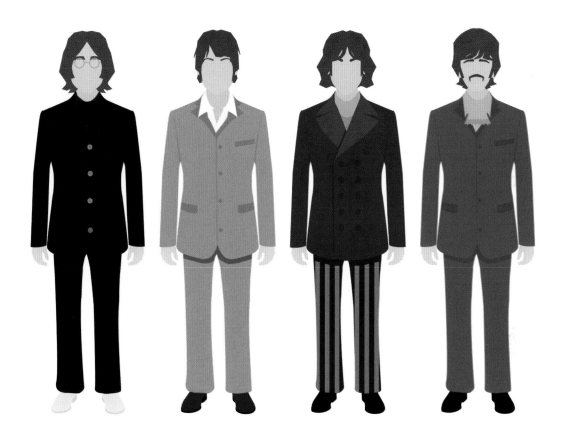

On Sunday, July 28, 1968, while in the midst of recording the White Album, The Beatles invited renowned war photographer Don McCullin to produce for them a new set of publicity images, including a cover photo for *Life* magazine. McCullin jumped at the chance and, accompanied by five others with cameras, they set off on a daylong jaunt around London, more famously known as the "Mad Day Out."

ALBUM OVERVIEW

Released: January 17, 1969
Producer: George Martin
Engineers: Geoff Emerick, Dave Siddle, Eddie Kramer

Yellow Submarine came about due to a contractual obligation
for the band to supply new songs for the soundtrack to the
Yellow Submarine animated film. It is reported that the band
showed minimal enthusiasm for the project and didn't view it
as a significant release. It contains only six songs by The Beatles.
The remainder are rerecordings of the orchestral soundtrack
to the film by George Martin.

The album is often criticized by music journalists, who feel it
falls short of the band's usual high standards.

YELLOW SUBMARINE

JANUARY 1969

January 20, 1969
Richard Nixon succeeds Lyndon B. Johnson as
the 37th president of the United States of America.

March 20, 1969
John Lennon and Yoko Ono are
married at Gibraltar, and proceed to their
honeymoon "Bed-In for Peace" in Amsterdam.

February 8, 1969
The Allende meteorite
explodes over Mexico.

May 15, 1969
An American teenager known as
"Robert R." dies in St. Louis, Missouri,
in what becomes the first case of
HIV/AIDS in North America.

January 30, 1969
The Beatles give their last
public performance, filming
several tracks on the roof
of Apple Records, London.

January 2, 1969
Rupert Murdoch purchases the
largest-selling British Sunday
newspaper, The News of the World.

March 2, 1969
In Toulouse, France, the first
Concorde test flight is conducted.

April 22, 1969
Robin Knox-Johnston becomes
the first person to sail around the
world solo without stopping.

July 31, 1969
The halfpenny ceases to be
legal tender in the UK.

August 15–18, 1969
The Woodstock Festival is held
in upstate New York, featuring some of
the top rock musicians of the era.

July 1, 1969
Charles, Prince of Wales, is invested
with his title at Caernarfon.

July 14, 1969
The United States officially
withdraws $500, $1,000, $5,000,
and $10,000 bills from circulation.

August 8, 1969
The iconic *Abbey Road* photo
is taken by photographer
Iain Macmillan.

June 28, 1969
The Stonewall riots in New York City
mark the start of the modern gay rights
movement in the US.

July 20, 1969
Apollo 11 lands on the Moon.
An estimated 500 million people worldwide
watch in awe as Neil Armstrong takes his
historic first steps on the lunar surface.

August 9, 1969
Charles Manson's cult kill five people at Hollywood
director Roman Polanski's house, including his wife,
actress Sharon Tate, in what becomes known as the
"Tate Murders."

ALBUM COVER DESIGN

The cover artwork for *Yellow Submarine* features
wonderful and iconic illustrations by Heinz Edelmann.
Since we can't bring you that, this is our interpretation
of the lyrics in the title track. The back of the cover
contains a review of the White Album by Tony
Palmer, written for the *Observer*.

"

THAT SCORE PROVED ENORMOUSLY

SUCCESSFUL

AND EARNED ME A LOAD

OF FAN MAIL.

"

—— GEORGE MARTIN ——
ON THE SCORE FOR YELLOW SUBMARINE

Yellow Submarine
was considered a contractual
obligation by The Beatles, who did
not view the album as a significant release
and showed minimal enthusiasm for the project.
Despite this, the film was critically acclaimed,
psychedelic fun which helped animation
to be seen as an art form, and many
of the tracks have become
fan favorites.

JOHN
3 SONGS

PAUL
2 SONGS

GEORGE
2 SONGS

RINGO
1 SONG

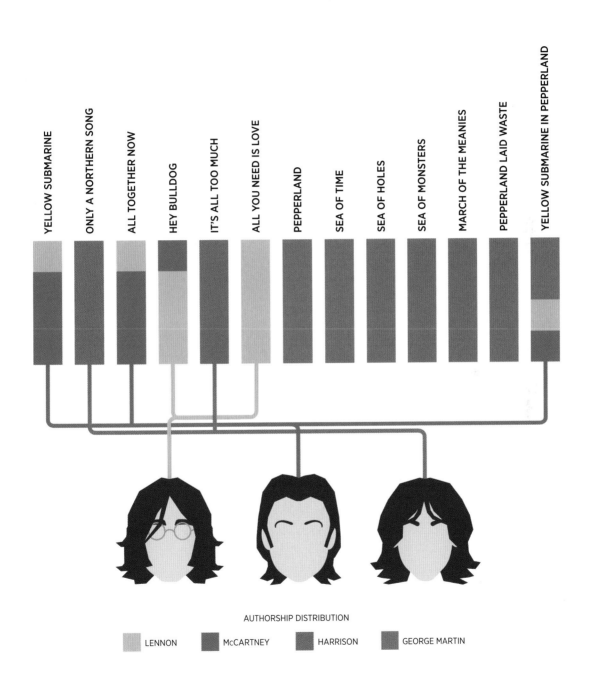

YELLOW SUBMARINE

ONLY A NORTHERN SONG

ALL TOGETHER NOW

HEY BULLDOG

IT'S ALL TOO MUCH

ALL YOU NEED IS LOVE

PEPPERLAND

SEA OF TIME

SEA OF HOLES

SEA OF MONSTERS

MARCH OF THE MEANIES

PEPPERLAND LAID WASTE

YELLOW SUBMARINE IN PEPPERLAND

AUTHORSHIP DISTRIBUTION

LENNON McCARTNEY HARRISON GEORGE MARTIN

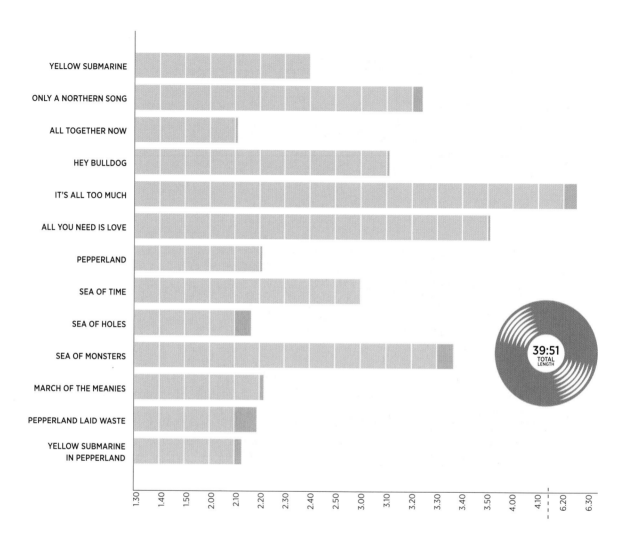

YELLOW SUBMARINE
ONLY A NORTHERN SONG
ALL TOGETHER NOW
HEY BULLDOG
IT'S ALL TOO MUCH
ALL YOU NEED IS LOVE
PEPPERLAND
SEA OF TIME
SEA OF HOLES
SEA OF MONSTERS
MARCH OF THE MEANIES
PEPPERLAND LAID WASTE
YELLOW SUBMARINE IN PEPPERLAND

1.30 1.40 1.50 2.00 2.10 2.20 2.30 2.40 2.50 3.00 3.10 3.20 3.30 3.40 3.50 4.00 4.10 5.50 6.20 6.30

39:51 TOTAL LENGTH

0 COVERS

VS

13 ORIGINALS

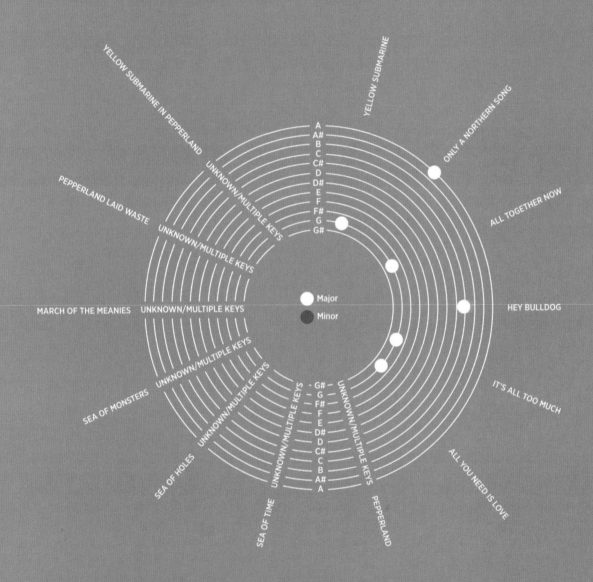

NB: The orchestral film score that comprises the second half of this album, performed by the 41-piece George Martin Orchestra, has never been released.

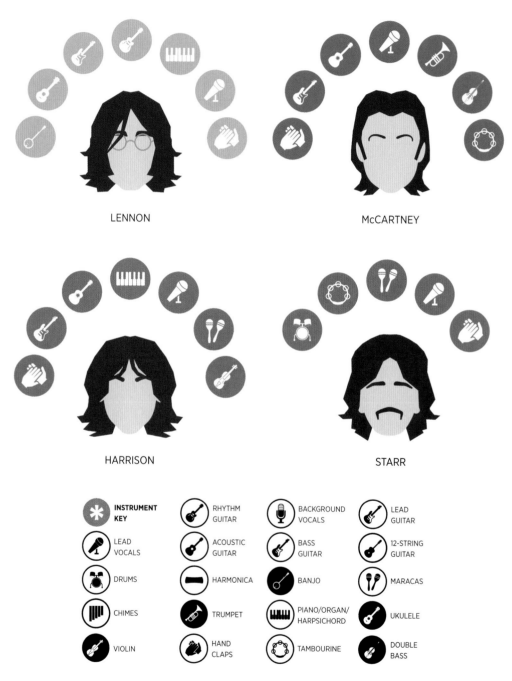

LENNON

McCARTNEY

HARRISON

STARR

INSTRUMENT KEY

LEAD VOCALS

DRUMS

CHIMES

VIOLIN

RHYTHM GUITAR

ACOUSTIC GUITAR

HARMONICA

TRUMPET

HAND CLAPS

BACKGROUND VOCALS

BASS GUITAR

BANJO

PIANO/ORGAN/ HARPSICHORD

TAMBOURINE

LEAD GUITAR

12-STRING GUITAR

MARACAS

UKULELE

DOUBLE BASS

Black circle indicates instruments used for the first time in a Beatles' album.

Beatles' Guitars

The Beatles used many different guitars throughout their careers, but here we take a look at some of the favorites from each member of the band, along with when they were first used.

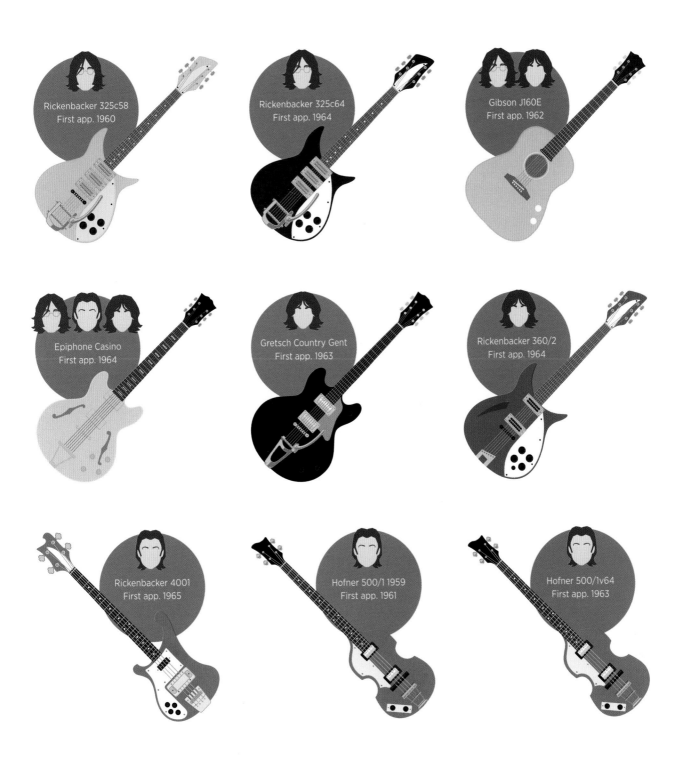

Rickenbacker 325c58
First app. 1960

Rickenbacker 325c64
First app. 1964

Gibson J160E
First app. 1962

Epiphone Casino
First app. 1964

Gretsch Country Gent
First app. 1963

Rickenbacker 360/2
First app. 1964

Rickenbacker 4001
First app. 1965

Hofner 500/1 1959
First app. 1961

Hofner 500/1v64
First app. 1963

UK SINGLE RELEASES

YELLOW SUBMARINE
ONLY A NORTHERN SONG
ALL TOGETHER NOW
HEY BULLDOG
IT'S ALL TOO MUCH
ALL YOU NEED IS LOVE
PEPPERLAND
SEA OF TIME
SEA OF HOLES
SEA OF MONSTERS
MARCH OF THE MEANIES
PEPPERLAND LAID WASTE
YELLOW SUBMARINE IN PEPPERLAND

Yellow Submarine failed to top the charts in either the US or the UK, though the single "Yellow Submarine," which was included in *Revolver* and charted in 1966, was included on this album as well. Martin's orchestral score is generally well reviewed. "All You Need Is Love" was originally released on July 7, 1967, as a non-album single.

1 1

NOT RELEASED
TOP 20
TOP 10

ALBUM CHART POSITIONS

UNITED KINGDOM
Number Three

GERMANY
Number Five

UNITED STATES
Number Two

AUSTRALIA
Number Four

NORWAY
Number One

CANADA
Number One

The Rooftop Concert

After numerous plans for their final gig had fallen through (including the Sahara Desert and the *QE2*), John proposed that they play on top of their Apple Corps headquarters at 3 Savile Row, London. Plans were made, and on January 30, 1969, The Beatles played a show that would go down in rock history.

Along with keyboardist Billy Preston, the band played nine takes of five songs in a 42-minute set, before the Metropolitan Police service asked them to stop. This last-ever live performance was filmed, and footage from the performance was used in the 1970 documentary *Let It Be*.

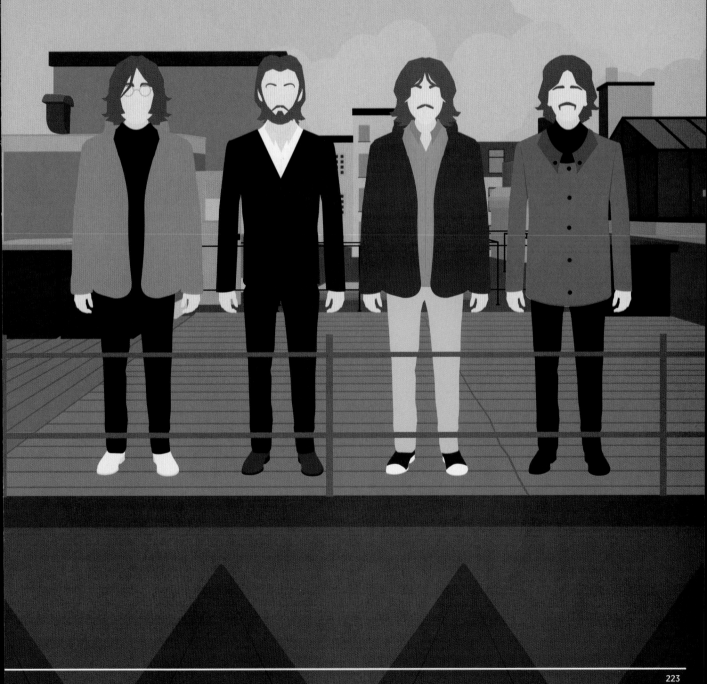

1963 late 1963 mid-1964

late 1964 mid-1965 late 1965 mid-1966

mid-1967 late 1967 late 1968

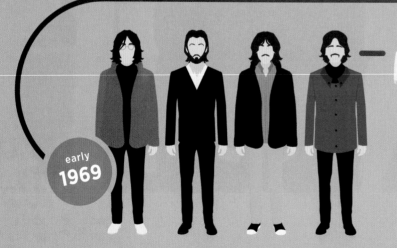

early **1969**

1969 1970

On January 30, 1969, shortly after the release of *Yellow Submarine*, The Beatles performed live for the very last time, above Apple's then headquarters at 3 Savile Row, London. Each member chose his own outfit, but it proved to be so cold that day that John borrowed a fur coat from Yoko, and Ringo a red mackintosh from his wife, Maureen.

Rock-and-Roll Music

Few artists had as strong an influence on The Beatles as Chuck Berry, with many calling him (along with Elvis) the single biggest influencer on a young John Lennon. Whereas Elvis's strength was performance, Chuck Berry was multidimensional—he wrote, performed, and recorded his own music. The Beatles and The Quarrymen played at least 15 Chuck Berry songs in their live shows, including "Too Much Monkey Business," "Carol," "Johnny B. Goode," "Memphis, Tennessee," "Sweet Little Sixteen," "Rock and Roll Music," and more, with The Beatles releasing their own version of "Roll Over Beethoven" on *With the Beatles*.

If you tried to give rock and roll another name, you might call it Chuck Berry.

John Lennon

ALBUM OVERVIEW

Released: September 26, 1969
Producers: George Martin, Chris Thomas, Glyn Johns
Engineers: Geoff Emerick, Phil McDonald, Jeff Jarratt, Glyn Johns,
Barry Sheffield, Tony Clark

Although *Abbey Road* was the penultimate album released by the
band, it was the last album they ever recorded. As a result, many see
it as the band's true final album, and it is also thought that the band
members knew it would be their swan song. The album was finished
less than a month before Lennon told the group he was going to
leave. Despite the tensions, Lennon remarked that once the band was
together in the studio they were as strong as ever.

Lennon missed some of the recording sessions due to being injured in a
car crash in Scotland. Yoko Ono also suffered injuries during the crash,
and was pregnant at the time. As Lennon wanted to keep an eye on her
during her recuperation, he arranged for a double bed to be delivered
to the studio so she could be there while the band recorded.

Abbey Road remained untitled until the recording sessions were well
under way. The working title was "Everest," named after the cigarettes
smoked by Geoff Emerick. After the band decided they didn't want to
fly out to Mount Everest for a photo shoot, Paul suggested they name
the album after the studio they were in. It made the building and street
famous the world over and, in the early '70s, EMI changed the name
from EMI Studios to Abbey Road Studios to reflect this.

ABBEY ROAD

SEPTEMBER 1969

ALBUM COVER DESIGN

On August 8, 1969, photographer Iain Macmillan (a friend of John Lennon and Yoko Ono) set up a stepladder in the middle of Abbey Road. A policeman stopped traffic. With a Hasselblad camera, he took six photographs of The Beatles walking away from EMI Studios, a symbol of what was to come.

In shots 1, 2, 3, 4, and 6 the band were walking out of step. The fifth shot was perfect and was chosen by Paul McCartney for the album cover. The VW Beetle in the background was sold at auction in 1986 for £2,530 and is currently in the Autostadt museum in Germany.

November 10, 1969
Sesame Street is broadcast for the first time, on the National Educational Television (NET) network.

December 2, 1969
The Boeing 747 jumbo jet makes its first passenger flight.

February 13, 1970
Black Sabbath's eponymous debut album is released, often regarded as the first true heavy metal album.

April 10, 1970
In a press release written in mock interview style that is included in promotional copies of his first solo album, Paul McCartney announces that he has left The Beatles.

November 19, 1969
Soccer great Pelé scores his 1,000th goal.

October 19, 1969
The first message is sent over ARPANET, the forerunner of the internet.

January 1, 1970
Unix time begins at 00:00:00 UTC.

March 31, 1970
NASA's *Explorer 1,* the first American satellite and Explorer program spacecraft, reenters Earth's atmosphere after 12 years in orbit.

"

THE SECOND SIDE OF ABBEY ROAD IS MY FAVORITE. I LOVE IT. ♥♥

"

——— RINGO STARR ———
1976, ON ABBEY ROAD

BAD
I'LL
PAPER
HEAVY
SLOWLY
CRY
DRIVING
ROUND
OCTOPUSS
NEARLY
KNEE
GIRL
PRETTY

DARLING
DAY
BANG
COMES
I'D
LEAVE
OH

WANT

CAME
BELIEVE
KNEW
HOMEWARD
SHOOT

ROLLER
HIGH
AMORE
BABE
COME
SLEEPS
GO
SUN
I'M
FEELING
LOT

SKY
SOMEDAY
MINE
ONE
YES
WORLD
BLUE
TOGETHER
SEE

LOVE
SHE'S
ALWAYS
MI
MAGIC
BAG
LIKE

LITTLE
MAD
NEVER
GONNA

CAME
BELIEVE

FREE
PAM
TRUE
HEH
LONG
YEARS
GIVE
DON'T
YEAH
RIGHT
CARRY
SURE
NOW

KNOW
DIDN'T
GARDEN
THOUGH
TELLS
AH
WEIGHT
TAKE
DAY
GOT

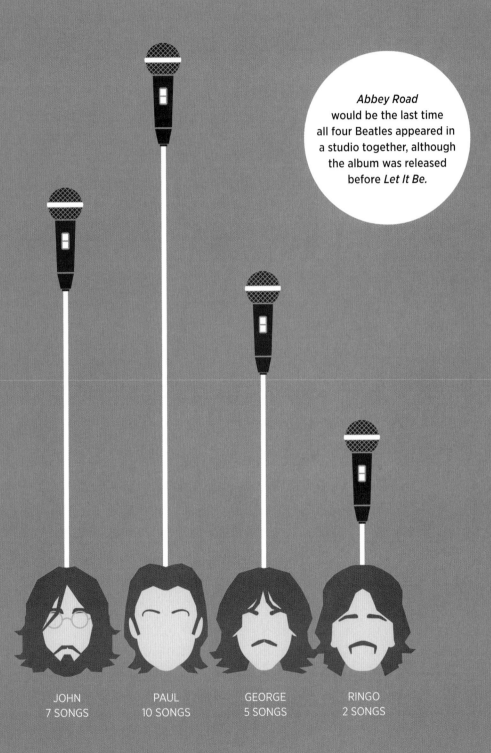

Abbey Road would be the last time all four Beatles appeared in a studio together, although the album was released before *Let It Be.*

JOHN
7 SONGS

PAUL
10 SONGS

GEORGE
5 SONGS

RINGO
2 SONGS

When band members shared lead vocals, both are listed. As a result, the total may add up to more than the number of tracks on the album.

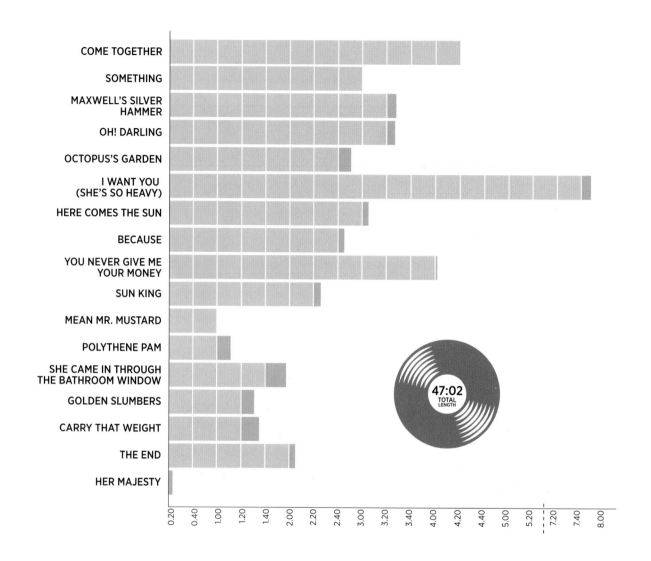

COME TOGETHER
SOMETHING
MAXWELL'S SILVER HAMMER
OH! DARLING
OCTOPUS'S GARDEN
I WANT YOU (SHE'S SO HEAVY)
HERE COMES THE SUN
BECAUSE
YOU NEVER GIVE ME YOUR MONEY
SUN KING
MEAN MR. MUSTARD
POLYTHENE PAM
SHE CAME IN THROUGH THE BATHROOM WINDOW
GOLDEN SLUMBERS
CARRY THAT WEIGHT
THE END
HER MAJESTY

0.20 | 0.40 | 1.00 | 1.20 | 1.40 | 2.00 | 2.20 | 2.40 | 3.00 | 3.20 | 3.40 | 4.00 | 4.20 | 4.40 | 5.00 | 5.20 | 7.20 | 7.40 | 8.00

47:02
TOTAL LENGTH

0 COVERS

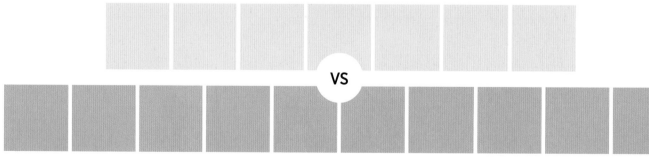

VS

17 ORIGINALS

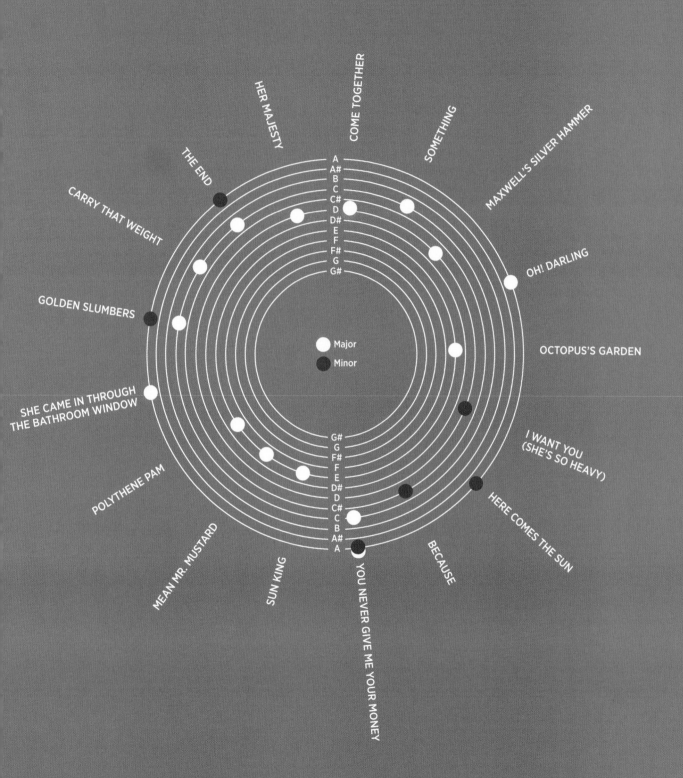

COME TOGETHER

HER MAJESTY

SOMETHING

THE END

MAXWELL'S SILVER HAMMER

CARRY THAT WEIGHT

OH! DARLING

GOLDEN SLUMBERS

OCTOPUS'S GARDEN

SHE CAME IN THROUGH
THE BATHROOM WINDOW

I WANT YOU
(SHE'S SO HEAVY)

POLYTHENE PAM

HERE COMES THE SUN

MEAN MR. MUSTARD

BECAUSE

SUN KING

YOU NEVER GIVE ME YOUR MONEY

A
A#
B
C
C#
D
D#
E
F
F#
G
G#

Major
Minor

G#
G
F#
F
E
D#
D
C#
C
B
A#
A

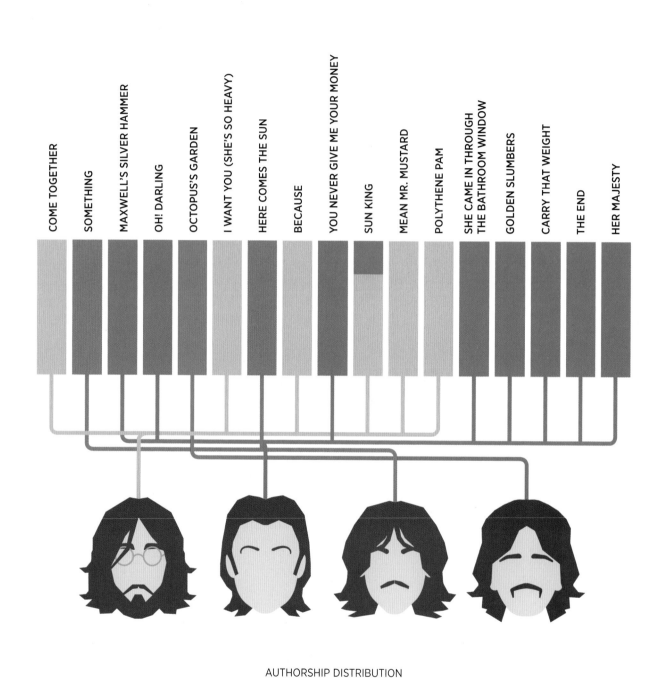

AUTHORSHIP DISTRIBUTION

LENNON McCARTNEY HARRISON STARR

UK SINGLE RELEASES

COME TOGETHER
SOMETHING
MAXWELL'S SILVER HAMMER
OH! DARLING
OCTOPUS'S GARDEN
I WANT YOU (SHE'S SO HEAVY)
HERE COMES THE SUN
BECAUSE
YOU NEVER GIVE ME YOUR MONEY
SUN KING
MEAN MR. MUSTARD
POLYTHENE PAM
SHE CAME IN THROUGH THE BATHROOM WINDOW
GOLDEN SLUMBERS
CARRY THAT WEIGHT
THE END
HER MAJESTY

4 4

Abbey Road was the first Beatles album to sell more than 10 million copies worldwide. It is the UK's bestselling album of 1969 and the fourth-highest-selling album of the 1960s, entering the charts at number 1 and staying there for 11 consecutive weeks. In the US, *Abbey Road* spent 11 (nonconsecutive) weeks at number 1 and was in the top 200 for 83 weeks in total.

Non-album singles that reached number 1 at this time include "Get Back"/"Don't Let Me Down" with Billy Preston (4/11/69) and "The Ballad of John and Yoko"/"Old Brown Shoe" (5/30/69).

▬ NOT RELEASED
▬ TOP 20
▬ TOP 10

ALBUM CHART POSITIONS

UNITED KINGDOM
Number One

GERMANY
Number One

CANADA
Number One

NETHERLANDS
Number One

SPAIN
Number One

JAPAN
Number Three

AUSTRALIA
Number One

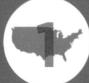

UNITED STATES
Number One

NORWAY
Number One

SWEDEN
Number One

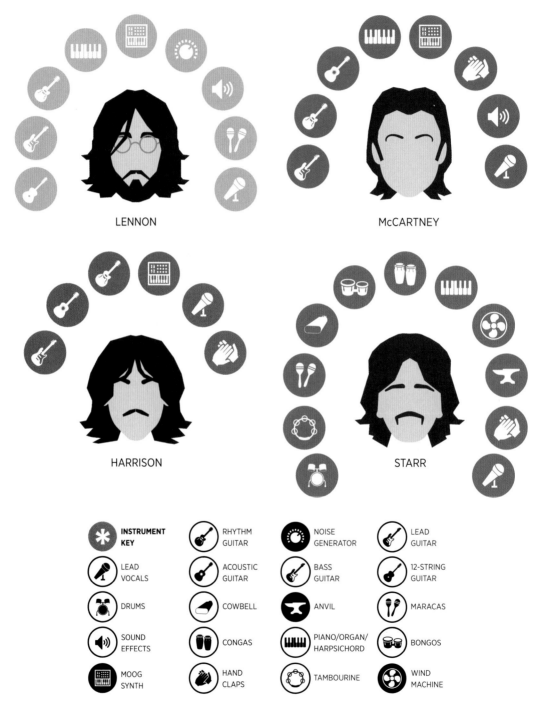

LENNON

McCARTNEY

HARRISON

STARR

INSTRUMENT KEY	RHYTHM GUITAR	NOISE GENERATOR	LEAD GUITAR
LEAD VOCALS	ACOUSTIC GUITAR	BASS GUITAR	12-STRING GUITAR
DRUMS	COWBELL	ANVIL	MARACAS
SOUND EFFECTS	CONGAS	PIANO/ORGAN/ HARPSICHORD	BONGOS
MOOG SYNTH	HAND CLAPS	TAMBOURINE	WIND MACHINE

Black circle indicates instruments used for the first time in a Beatles' album.

The Studio: Abbey Road

The studio located at 3 Abbey Road, St. John's Wood, London, is possibly the single most important location in the band's history, as it was the location where almost all of their studio material was recorded, in particular in Studio Two, which is quite possibly the most famous recording location in the world.

Although it is now known as Abbey Road Studios, The Beatles knew it as EMI Studios. It was only after the release of the *Abbey Road* LP in 1969 that the location became world famous, and EMI decided to formally change the name in 1970. The iconic photograph from the cover of that album was taken just outside the studio on August 8, 1969, by Iain Macmillan.

The Beatles' audition for EMI took place here (in Studio Two) on June 6, 1962, where four songs were recorded. A couple of months later on September 4, 1962, the band returned for their first proper session, recording versions of "Love Me Do" and "How Do You Do It."

The Beatles went on to record approximately 90% of their singles and albums at Abbey Road Studios between 1962 and 1970. So synonymous was the studio with the band that fans would stand outside in all weather waiting for the chance to see The Beatles. The white walls outside the studio are still to this day covered in graffiti from fans, although this is discouraged by the studio, who often whitewash the walls.

The Beatles were afforded more or less unlimited time in the studio, particularly after they ceased touring in 1966. This gave them time to continually innovate and push boundaries, and produce technical innovations still used in studios today. They did this with the help of George Martin and the talented Abbey Road sound engineers (notably Norman Smith, Geoff Emerick, Ken Scott, Alan Parsons, Phil McDonald, Richard Lush, John Kurlander, and Ken Townsend).

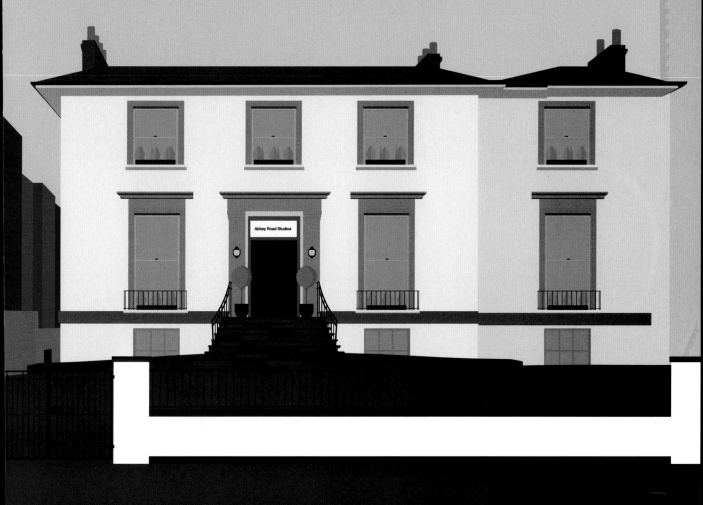

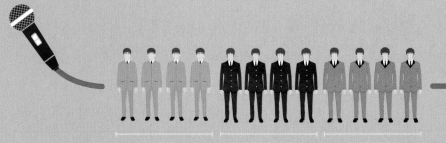

1963 late 1963 mid-1964

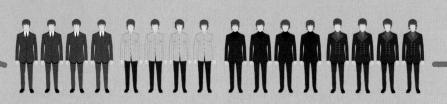

late 1964 mid-1965 late 1965 mid-1966

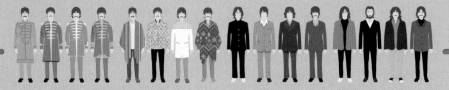

mid-1967 late 1967 late 1968 early 1969

1969

1970

1970

The *Abbey Road* photo shoot is another iconic Beatles image, and one used on the album of the same name. Shot by Iain Macmillan, it sees the band in semiformal style, but with interesting tweaks such as Paul barefoot and George in his now trademark denim outfit.

The Set Lists

The Beatles played scores of iconic and much-talked-about shows during their career, but a handful stand out as particularly significant. Here are the set lists from six of the most famous shows.

Get Back (5x versions)
I Want You (She's So Heavy)*
Don't Let Me Down (2x vers.)
I've Got a Feeling
One After 909
Danny Boy*
Dig a Pony (2x vers.)
God Save the Queen*
A Pretty Girl Is like a Melody*

*incomplete song

Apple Corps Rooftop, London
January 30, 1969

The very last public performance of The Beatles, this impromtu concert in the heart of London was a now iconic 42-minute set that was halted by the Metropolitan Police.

Some Other Guy
Kansas City / Hey-Hey-Hey-Hey
Money (That's What I Want)
Twist and Shout
Ask Me Why

Cavern Club, Liverpool
August 22, 1962

The Beatles played here almost 300 times, but this lunchtime show was the first time they were the focus of TV cameras, with Granada Television filming.

Rock and Roll Music
She's a Woman
If I Needed Someone
Day Tripper
Baby's in Black
I Feel Fine
Yesterday
I Wanna Be Your Man
Nowhere Man
Paperback Writer
Long Tall Sally
In My Life*

*incomplete song

Candlestick Park, San Francisco
August 29, 1966

This show was particularly significant, as it was the last ticketed Beatles concert ever. They played for approximately 30 minutes, before leaving the stage for good.

Roll Over Beethoven
From Me to You
I Saw Her Standing There
This Boy
All My Loving
I Wanna Be Your Man
Please Please Me
Till There Was You
She Loves You
I Want to Hold Your Hand
Twist and Shout
Long Tall Sally

Washington Coliseum, Washington, D.C.
February 11, 1964

This was The Beatles' first concert in North America, in front of just over 8,000 people. This show also featured the world's first revolving stage!

From Me to You
She Loves You
Till There Was You
Twist and Shout

Prince of Wales Theatre, London
November 4, 1963

The Beatles' only performance in front of the Queen Mother, this Royal Command Performance saw them perform four songs, appearing seventh of a 19-act bill.

PT.1
All My Loving
Till There Was You
She Loves You

PT.2
I Saw Her Standing There
I Want to Hold Your Hand

Ed Sullivan Show, New York
February 9, 1964

They may have played in front of only 728 people in the studio, but it was broadcast to over 70 million people across the US, cementing Beatlemania in America.

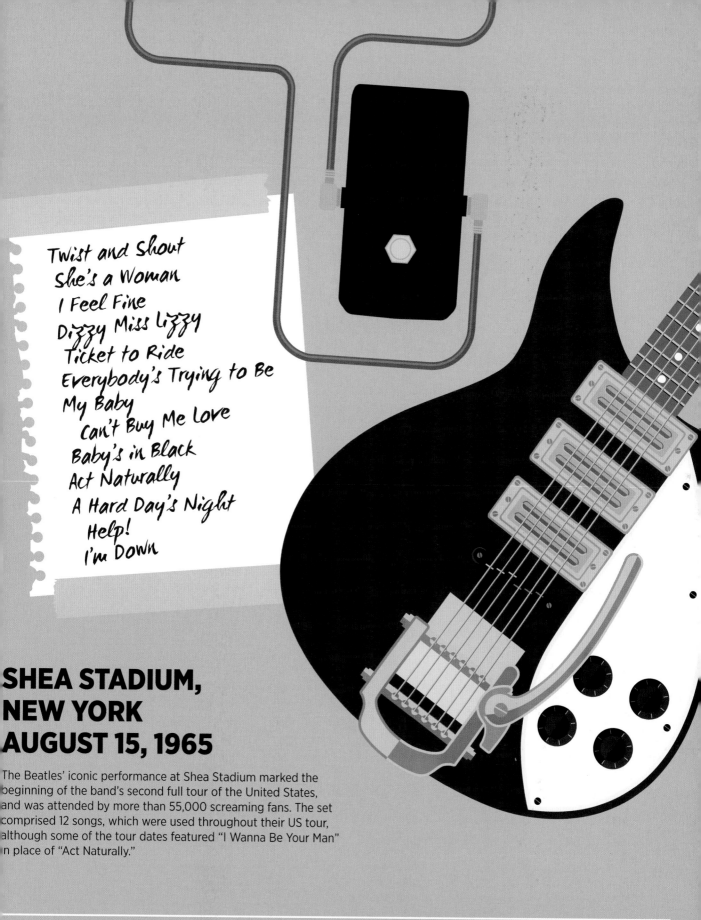

Twist and Shout
She's a Woman
I Feel Fine
Dizzy Miss Lizzy
Ticket to Ride
Everybody's Trying to Be
My Baby
Can't Buy Me Love
Baby's in Black
Act Naturally
A Hard Day's Night
Help!
I'm Down

SHEA STADIUM, NEW YORK AUGUST 15, 1965

The Beatles' iconic performance at Shea Stadium marked the beginning of the band's second full tour of the United States, and was attended by more than 55,000 screaming fans. The set comprised 12 songs, which were used throughout their US tour, although some of the tour dates featured "I Wanna Be Your Man" in place of "Act Naturally."

ALBUM OVERVIEW

Released: May 8, 1970
Producers: George Martin, Phil Spector
Engineers: Glyn Johns, Martin Benge, Ken Scott, Peter Bown,
Phil McDonald, Jeff Jarratt

Despite being recorded before *Abbey Road, Let It Be* was the last
album to be released by The Beatles. It was a move away from the
band's elaborate and intricate studio work and was recorded with a
"back to basics" ethos. In 1969 the band got together at Twickenham
Film Studios to work on what they called the "Get Back" project. They
initially planned the project to include one or more live shows, a
television show, and an album. The sessions began as a rehearsal for
a concert which they planned to film.

Enthusiasm in the band was low. They were all exhausted and John
Lennon was addicted to heroin. Continual arguments led to George
Harrison temporarily leaving the band. On his return he insisted that
the idea of a live show be dropped. So they decided to finish their
record in the basement of Apple's headquarters in Savile Row, London.
They were joined by keyboard player Billy Preston, whom they knew
from their days in Hamburg. These Apple studio sessions culminated
in the famous rooftop performance on January 30, which would
become known as the band's last-ever live performance in public.

Once all the recording and filming was complete, there were hours
of recordings to go through. Glyn Johns did this for the band and
produced two versions of the album. Both were rejected. In March
1970 Phil Spector began working on it instead, at the invitation of
Lennon and Harrison. McCartney and Martin knew nothing about
it. Glyn Johns heavily criticized Spector's involvement but it was
Spector's version that was finally released.

In 2003 a new version of the recordings was released, called *Let It Be...
Naked*. It was produced under McCartney's direction and is meant to
sound closer to what the band originally envisioned for the project.

LET IT BE
MAY 1970

June 7, 1970
The Who becomes the first act to perform rock music at the Metropolitan Opera House, New York.

August 26, 1970
The Isle of Wight Festival 1970 begins on East Afton Farm off the coast of England. Some 600,000 people attend the largest rock festival of all time.

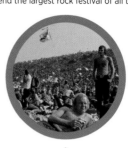

September 13, 1970
The first New York City Marathon begins.

July 21, 1970
The Aswan High Dam in Egypt is completed.

June 7, 1970
"The Long and Winding Road" becomes The Beatles' 20th and final single to reach number 1 on the US Billboard Hot 100 chart.

September 5, 1970
Formula One driver Jochen Rindt is killed in qualifying for the Italian Grand Prix. He becomes World Driving Champion anyhow, the first to earn the honor posthumously.

May 8, 1970
The New York Knicks win their first NBA championship.

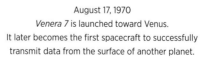

August 17, 1970
Venera 7 is launched toward Venus. It later becomes the first spacecraft to successfully transmit data from the surface of another planet.

November 17, 1970
The Soviet Union lands *Lunokhod 1* on the Moon.
It is the first roving remote-controlled robot to visit another world.

December 31, 1970
The Beatles officially break up
after Paul McCartney sues the
remaining members in British court.

September 20, 1970
Luna 16 lands on the Moon and lifts off the next
day with samples. It lands on Earth September 24.

October 2, 1970
Pink Floyd releases *Atom Heart
Mother*. It becomes their first
number 1 album.

November 27, 1970
Bolivian artist Benjamin Mendoza
tries to assassinate Pope Paul VI
during his visit in Manila.

September 18, 1970
American musician Jimi Hendrix
dies from an overdose of sleeping pills.

November 13, 1970
Bhola tropical cyclone hits the densely
populated Ganges Delta region of East
Pakistan (now Bangladesh), killing an
estimated 500,000 people.

December 23, 1970
The North Tower of the World Trade
Center is topped out at 1,368 feet (417 m),
making it the tallest building in the world.

ALBUM COVER DESIGN

Let It Be features portraits of each of The Beatles taken during their recording sessions. Each member was separated by a thick black bar, symbolizing the fact they were no longer together.

"

WE WERE ALL FRAUGHT WITH EACH OTHER
AND JUST ABOUT EVERYTHING ELSE. WE
WERE PROBABLY ALL ON THE VERGE OF
NERVOUS
BREAKDOWNS.

"

———— PAUL MCCARTNEY ————
1996, ON RECORDING LET IT BE

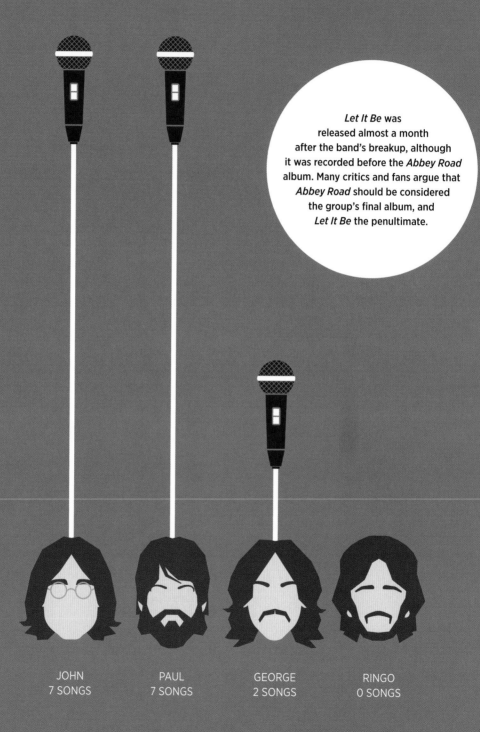

Let It Be was released almost a month after the band's breakup, although it was recorded before the *Abbey Road* album. Many critics and fans argue that *Abbey Road* should be considered the group's final album, and *Let It Be* the penultimate.

JOHN
7 SONGS

PAUL
7 SONGS

GEORGE
2 SONGS

RINGO
0 SONGS

When band members shared lead vocals, both are listed. As a result, the total may add up to more than the number of tracks on the album.

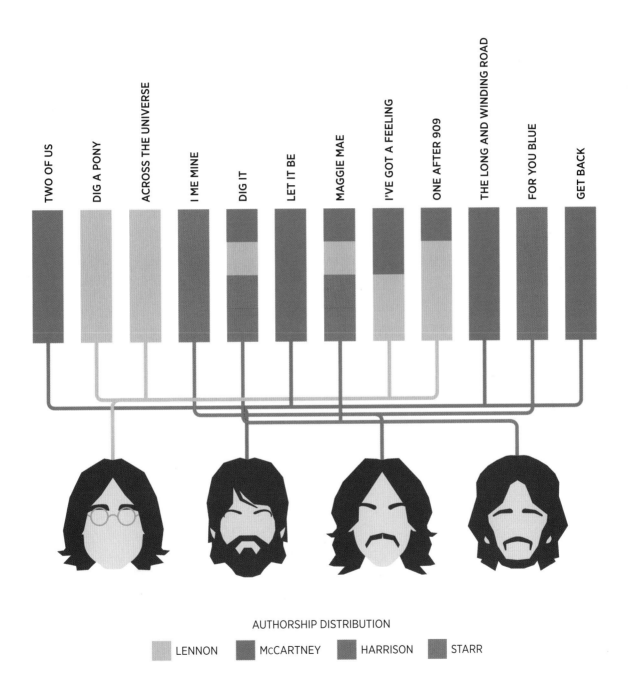

TWO OF US

DIG A PONY

ACROSS THE UNIVERSE

I ME MINE

DIG IT

LET IT BE

MAGGIE MAE

I'VE GOT A FEELING

ONE AFTER 909

THE LONG AND WINDING ROAD

FOR YOU BLUE

GET BACK

AUTHORSHIP DISTRIBUTION

LENNON McCARTNEY HARRISON STARR

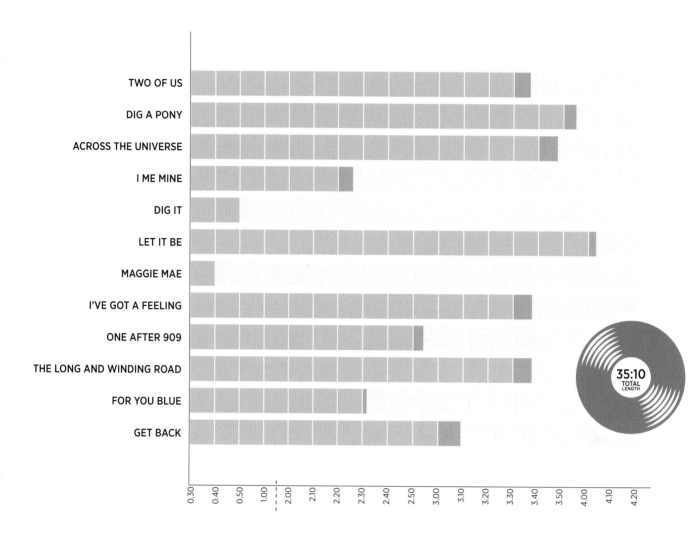

TWO OF US
DIG A PONY
ACROSS THE UNIVERSE
I ME MINE
DIG IT
LET IT BE
MAGGIE MAE
I'VE GOT A FEELING
ONE AFTER 909
THE LONG AND WINDING ROAD
FOR YOU BLUE
GET BACK

0.30 0.40 0.50 1.00 2.00 2.10 2.20 2.30 2.40 2.50 3.00 3.10 3.20 3.30 3.40 3.50 4.00 4.10 4.20

35:10
TOTAL
LENGTH

1 COVER

VS

11 ORIGINALS

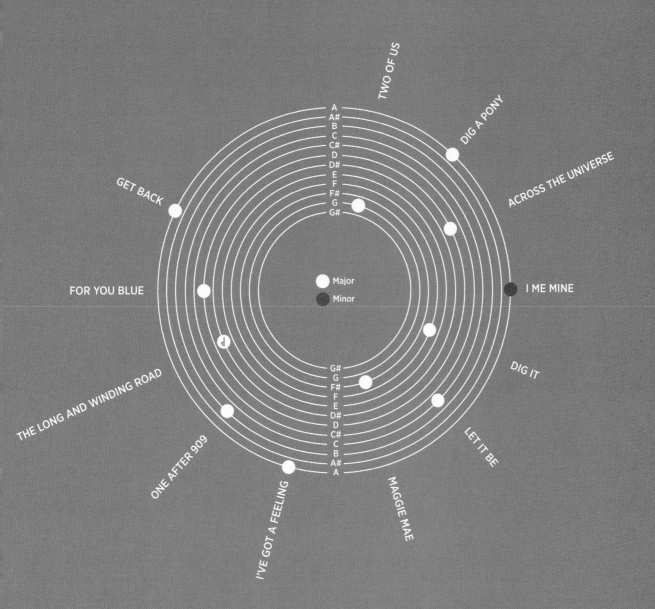

TWO OF US

DIG A PONY

ACROSS THE UNIVERSE

GET BACK

A
A#
B
C
C#
D
D#
E
F
F#
G
G#

FOR YOU BLUE

● Major

● Minor

I ME MINE

DIG IT

THE LONG AND WINDING ROAD

G#
G
F#
F
E
D#
D
C#
C
B
A#
A

LET IT BE

ONE AFTER 909

I'VE GOT A FEELING

MAGGIE MAE

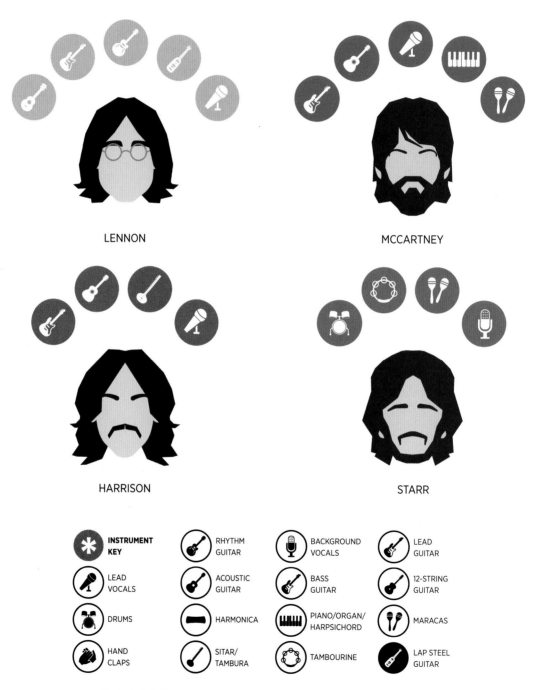

LENNON

MCCARTNEY

HARRISON

STARR

✳ **INSTRUMENT KEY**	RHYTHM GUITAR	BACKGROUND VOCALS	LEAD GUITAR
LEAD VOCALS	ACOUSTIC GUITAR	BASS GUITAR	12-STRING GUITAR
DRUMS	HARMONICA	PIANO/ORGAN/ HARPSICHORD	MARACAS
HAND CLAPS	SITAR/ TAMBURA	TAMBOURINE	LAP STEEL GUITAR

Black circle indicates instruments used for the first time in a Beatles' album.

UK SINGLE RELEASES

TWO OF US
DIG A PONY
ACROSS THE UNIVERSE
I ME MINE
DIG IT
LET IT BE
MAGGIE MAE
I'VE GOT A FEELING
ONE AFTER 909
THE LONG AND WINDING ROAD
FOR YOU BLUE
GET BACK

2

Let It Be was generally badly received, and fans felt it somewhat of a letdown after *Abbey Road*. The band had already gone their separate ways, and Paul McCartney had released his first solo album a few weeks previously. "Let It Be," the single, had been released prior to the album on March 6, 1970. "Get Back" was also released as a single, but this version of it, featuring Billy Preston, was totally different from the one included in *Let It Be* (hence why it isn't shown here). The album still reached number 1 but spent only three weeks at the top. In the US, the album had over 3.7 million advance orders, which at the time was the highest number of advance orders for any album in US history.

NOT RELEASED

TOP 20

TOP 10

ALBUM CHART POSITIONS

UNITED KINGDOM
Number One

GERMANY
Number Three

CANADA
Number One

NETHERLANDS
Number One

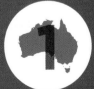

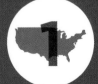

JAPAN
Number Two

AUSTRALIA
Number One

UNITED STATES
Number One

NORWAY
Number One

SWEDEN
Number Two

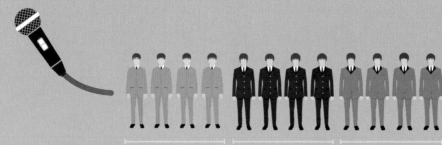

1963 late 1963 mid-1964

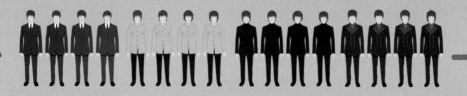

late 1964 mid-1965 late 1965 mid-1966

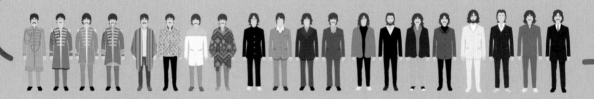

mid-1967 late 1967 late 1968 early 1969 1969

1970

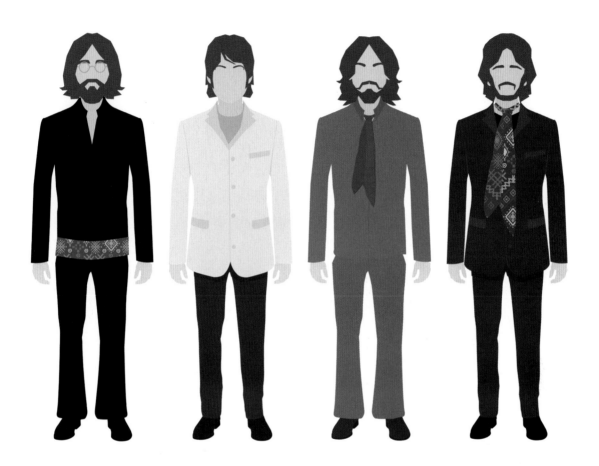

On August 22, 1969, two days after they had finished recording *Abbey Road*, The Beatles met at John's estate, Tittenhurst Park, for what would be their final photo session. Much like the *Abbey Road* shoot, the band chose to dress in the casual, relaxed style they had all become comfortable with, each with an air of individuality.

Beatles Cover Versions

We know The Beatles have always been hugely popular, but just how popular?
Here is everyone to date who has recorded one or more songs originally written by The Beatles...

10cc
7B
801
The 12 cellists of the Berlin Philharmonic
The 5th Dimension
Bryan Adams
Aerosmith
The Aggrolites
Agua De Annique
Air Supply
Monty Alexander
Alice
Alice Donut
Kris Allen
Allister
Herb Alpert & The Tijuana Brass
Alvin and the Chipmunks
Alvin and the Chipmunks and The Chipettes
AM & Tina Dico
Ambrose Slade (pre-Slade)
Ambrosia
Aman Corner
Tori Amos
Ana Gabriel
Anathema
Thomas Anders
Joe Anderson
Marc Anthony
Fiona Apple
The Applejacks
April Wine
David Archuleta
Arctic Monkeys
Arno (Arno Hintjens)
P. P. Arnold
Aritzia
Daniel Ash
Susan Ashton & Gary Chapman
Assagai
Athlete
Atomic Kitten
Jean-Louis Aubert
Emilie Autumn
Ayreon
Pedro Aznar
B5
Babyshambles
Bad Brains
Bad Company
Joan Baez
Bajaga & Instruktori
David Ball
Kenny Ball
Bananarama
Carl Barât
Carl Barât & Pete Doherty
Cris Barber
Sara Bareilles
Barnes & Barnes
Baskin & Copperfield
Shirley Bassey
Bathory
The Beach Boys
Beady Eye
Beastie Boys
Beatallica
BECK
Jeff Beck
Bee Gees
Béla Fleck and the Flecktones
Adrian Belew
Drake Bell
Belle & Sebastian
John Belushi
Pat Benatar
Cliff Bennett and the Rebel Rousers
Cliff Bennett Band
Tony Bennett
David Benoit
George Benson
Cathy Berberian
Matraca Berg
John Berry
Betty
Big Daddy
Big Time Rush
Billie Joe Armstrong
Björk
The Black Crowes
The Black Keys
Black Oak Arkansas
Black Sabbath
Blessid Union of Souls

Blondie
Bloodrock
Blood, Sweat & Tears
James Blunt
Suzy Bogguss & Chet Atkins
Michael Bolton
Gary U.S. Bonds
Bon Jovi
Graham Bonnet
Boney M.
Bono
Booker T. & the M.G.'s
Boris
Alexei Borisov
David Bowie
Boxer
Boyz II Men
Paul Brady
Billy Bragg
Billy Bragg with Cara Tivey
Russell Brand
Eva Braun
Breakfast Club
The Breeders
Brian Bromberg
Herman Brood
Gary Brooker
The Brothers Four
The Brothers Johnson
James Brown
Joe Brown
Michael Bublé
Jeff Buckley
Enrique Bunbury
Los Bunkers
Buranovskiye Babushki
Eric Burdon & War
Chris de Burgh
Jean-Jacques Burnel
George Burns
Sam Bush
Butthole Surfers
Max Bygraves
Junior Campbell
Canadian Brass
Candy Flip
Brandi Carlile
The Carpenters
T. V. Carpio
Vikki Carr
Paul Carrack
Jim Carrey
Waterson-Carthy
Johnny Cash
Rosanne Cash
David Cassidy
Eva Cassidy
Jason Castro
Nick Cave
Nick Cave and The Bad Seeds
Peter Cetera
Eugene Chadbourne
Chapterhouse
Ray Charles
Chayanne
Cheap Trick
Cher
Chicago
Chikezie
Alex Chilton
Chocolate Genius
Wang Chung
Jennifer Cihi
Eric Clapton
Petula Clark
Cloud Cult
Kurt Cobain
Riccardo Cocciante
Bruce Cockburn
Joe Cocker
CoH
Avishai Cohen
Coldplay
Holly Cole
Chris Colfer
Chris Colfer & Lea Michele
Judy Collins
Phil Collins
Shawn Colvin
Perry Como
Les Compagnons de la chanson
Arthur Conley
Sean Connery

Harry Connick Jr.
Billy Connolly
David Cook
Kristy Lee Cook
Coope Boyes and Simpson
Alice Cooper
Copy
Chick Corea
Chick Corea with Hiromi Uehara
Chris Cornell
Cornershop
Coroner
Andrea Corr
The Corrs
Larry Coryell
Bill Cosby
Elvis Costello
Jonathan Coulton
Count Basie
Counting Crows
Cowboy Junkies
Crash Kings
The Crickets
Bing Crosby
Crosby, Stills & Nash
Sheryl Crow
Crowded House
Celia Cruz
The Cryan' Shames
Dejan Cukić
Jamie Cullum
The Damned
Danger Mouse
Bobby Darin
Dave Matthews Band
Craig David
David and Jonathan
Sammy Davis Jr.
P. M. Dawn
Danielle Dax
Howie Day
dc Talk
Dead Kennedys
Billy Dean
Deep Purple
Def Leppard
Defunkt
John Denver
The Detroit Emeralds
Neil Diamond
Dillard & Clark
The Dillards
Cara Dillon & Sam Lakeman
Phyllis Dillon
Pat DiNizio
Céline Dion
Divididos
Pete Doherty
Dollar
Plácido Domingo
Fats Domino
Tanya Donelly
The Donnas
Val Doonican
Dream Theater
Dr. Sin
Bob Dylan
Steve Earle and Allison Moorer
Earth, Wind & Fire
Easy Star All-Stars
Easy Star All-Stars ft. Bunny Rugs & U-Roy
Easy Star All-Stars ft. Frankie Paul
Easy Star All-Stars ft. Junior Jazz
Easy Star All-Stars ft. Kirsty Rock
Easy Star All-Stars ft. Luciano
Easy Star All-Stars ft. Matisyahu
Easy Star All-Stars ft. Max Romeo
Easy Star All-Stars ft. Michael Rose and Menny More
Easy Star All-Stars ft. Ranking Roger
Easy Star All-Stars ft. Steel Pulse
Easy Star All-Stars ft. Sugar Minott
Easy Star All-Stars ft. The Mighty Diamonds
Echo & The Bunnymen
Eels
akoostik hookah
Electric Light Orchestra
Električni Orgazam
Cássia Eller
Andy Ellison
Elmo
Tommy Emmanuel
En Vogue
David Essex

Ethel the Frog
Eurythmics
Extreme
Los Fabulosos Cadillacs (feat. Deborah Harry)
Fairground Attraction
Andy Fairweather-Low
Marianne Faithfull
Falco
Jason Falkner
The Fall
Georgie Fame
Sandy Farina
John Farnham
Father
The Feelies
José Feliciano
Jay Ferguson
Maynard Ferguson
Bryan Ferry
Ferry Aid
The Fiery Furnaces
Neil Finn & Liam Finn
Firewater
Ella Fitzgerald
The Flamin' Groovies
Florence + the Machine
The Flowers
Ben Folds
Foo Fighters
Fool's Garden
Tennessee Ernie Ford
The Format
David Foster with Katharine McPhee
The Fourmost
The Four Seasons
Four Tops
Samantha Fox
Les Fradkin
Nikolai Fraiture
Roddy Frame
Peter Frampton
Aretha Franklin
Franz Ferdinand
The Fray
The Free Design
Russ Freeman
Paul Frees
John Frusciante
Dana Fuchs
Lowell Fulson
Peter Gabriel
Eric Gales Band
Noel Gallagher
James Galway
Garbage
Charly García
Charly García, Pedro Aznar & Gustavo Cerati
Jerry Garcia
Jerry Garcia Band
Art Garfunkel
Marvin Gaye
Gene
Bobbie Gentry
James Genus
George Martin Orchestra
The Georgia Satellites
Ghost
Barry Gibb
Robin Gibb
Seru Giran
GLAY
Glee Cast
Godhead
Godsmack
Golden Earring
Grandaddy
Peter Grant
The Grass Roots
Grateful Dead
Al Green
Green Day
Marcia Griffiths
Paul Griggs
Dave Grohl
Groove Collective
Henry Gross
Dave Grusin
Vince Guaraldi
The Guess Who
Guns N' Roses
Guster
Guys 'n' Dolls
Gyliene Tider

Bill Haley & His Comets
Johnny Hallyday
Herbie Hancock
Hanson
Steve Harley & Cockney Rebel
Ben Harper
Emmylou Harris
Harry J All Stars
Donny Hathaway
Richie Havens
Greg Hawkes
Goldie Hawn
Salma Hayek
Isaac Hayes
Jeff Healey
Heart
The Helio Sequence
Helloween
Jimi Hendrix
The Heptones
David Hernandez
Kristin Hersh
Boo Hewerdine & Eddi Reader
Taylor Hicks
Steve Hillage
The Hobos
Allan Holdsworth
Xaviera Hollander
The Hollies
The Hollyridge Strings
Hoodoo Gurus
The Hooters
The Hour Glass
House of Heroes
Frankie Howerd
Jennifer Hudson
Humble Pie
Hush Sound
Hüsker Dü
Hyde
I Against I
Ibex & Freddie Mercury
The Ides of March
Julio Iglesias
The Impressions
indexi
James Ingram
The Inmates
Inner Circle
Eddie Izzard
Joe Jackson
Michael Jackson
Willis Jackson
The Jam
Bobby Jameson
Jan and Dean
Al Jarreau
Jefferson Starship
Joan as Police Woman
Billy Joel
Billy Joel with Paul McCartney
John Butler Trio
John's Children
Elton John
Marc Johnson
Syl Johnson
Jonas Brothers
Jonas Brothers and Demi Lovato
Norah Jones
Rickie Lee Jones
Tom Jones
Stanley Jordan
Journey
Laurence Juber
Jump5
Kaiser Chiefs
Kansas
Kasabian
Phil Keaggy & PFR
Keane
Dustin Kensrue
Sammy Kershaw
Alicia Keys
Bob Khaleel
Chaka Khan
Kids Incorporated
The Killers
King Crimson
King Missile
Morgana King
King's Singers
Gershon Kingsley
The Kingsmen

David Kitt
Gladys Knight
Diana Krall
Billy J. Kramer with The Dakotas
K's Choice
Kult
Erich Kunzel & Cincinnati Pops Orchestra
Ben Kweller with Albert Hammond, Jr.
Labyrinth
Francis Lai
Laibach
Denny Laine
Frankie Laine
Lakeside
Lana Lane
James Last
Jim Lauderdale
Cyndi Lauper
Led Zeppelin
Ben Lee
Brenda Lee
Peggy Lee
Rita Lee
Claudia Lennear
Julian Lennon
Sean Lennon
Sean Lennon, Moby, & Rufus Wainwright
Sean Lennon & Rufus Wainwright
Ted Leo
Phil Lesh
Huey Lewis
Jerry Lee Lewis with Little Richard
Jon Peter Lewis
Ramsey Lewis
Liberace
The Libertines
Lil Wayne
Arto Lindsay
Linkin Park
Little Richard
Little Texas
The Living End
Nils Lofgren
Kenny Loggins
Kenny Loggins & Alison Krauss
Kenny Loggins & Jim Messina
Fred Lonberg-Holm
Julie London
London Symphony Orchestra
Claudine Longet
Los Lobos
Demi Lovato & Naya Rivera
Low
Arjen Anthony Lucassen
Lulu
Lydia Lunch
Lydia
Kenny Lynch
Jeff Lynne
Yo-Yo Ma & James Taylor
Mae
Vanessa-Mae
The Magic Numbers
Mägo de Oz
Miriam Makeba
Will Malone & Lou Reizner
Ramiele Malubay
Mamá Ladilla
The Mamas & the Papas
Mando Diao
Manfred Mann's Earth Band
The Manhattan Transfer
Barry Manilow
Aimee Mann & Michael Penn
Johnny Mann Singers
Marilyn Manson
The Manvils
Marillion
Marmalade
Maroon 5
Martha & The Vandellas
Moon Martin
Steve Martin
Hank Marvin
Richard Marx
Matchbox Twenty
Dave Matthews
Paul Mauriat
Jesse McCartney
Delbert McClinton
Del McCoury Band
Martin Luther McCoy
The McCrary Sisters
Bobby McFerrin
McFly
Maureen McGovern
Ewan McGregor
Roger McGuinn
Nellie McKay
Sarah McLachlan
Katharine McPhee
Ralph McTell
Me First and The Gimme Gimmes
Meat Loaf
Brad Mehldau Trio
Farhad Mehrad
Rose Melberg
Men Without Hats

Sérgio Mendes
Syesha Mercado
Natalie Merchant
MercyMe
Helen Merrill
Metallica
Pat Metheny
George Michael
Lea Michele
Bette Midler
Buddy Miller
Marcus Miller
Mrs. Miller
Rhett Miller
The Miracles
Kylie Minogue
The Mission
Chad Mitchell Trio
Eddy Mitchell
Mocca
Brian Molko
Taylor Momsen
Eddie Money
Monsoon
Wes Montgomery
Keith Moon
R. Stevie Moore
Jim Moray
Alanis Morissette
Chisato Moritaka
Alison Mosshart and Carla Azar
Mötley Crüe
Nana Mouskouri
Moving Sidewalks
Jason Mraz
Megan Mullally and Supreme Music Program
Gerry Mulligan
The Muppets
Anne Murray
MxPx
Nada Surf
Ricky Nelson
Willie Nelson
Nevershoutnever!
The New Seekers
Olivia Newton-John
Night Ranger
Harry Nilsson
Nirvana
The Nits
No Doubt
Emmerson Nogueira
Noir Désir
Heather Nova
Ted Nugent
Adam Nussbaum
The Nylons
Oasis
Billy Ocean
Ocean Colour Scene
Odetta
of Montreal
Oingo Boingo
OK Go
Ollabelle
Omar
One Direction
Joan Osborne
Ozzy Osbourne
Our Lady Peace
Outside Royalty
Amanda Overmyer
Pain
Robert Palmer
Panic! at the Disco
Junior Parker
Doug Parkinson
Dolly Parton
Jaco Pastorius
Lynsey de Paul
Pearl Jam
Marti Pellow
Joe Perry
Peters and Lee
Bernadette Peters
Oscar Peterson
Tom Petty and The Heartbreakers
Tom Petty and The Heartbreakers & Jeff Lynne
Madeleine Peyroux
Esther Phillips
Phish
Phoenix
Wilson Pickett
Pink Fairies
Pixies
The Plague
Plain White T's
Robert Plant
David Porter
Power Station
The Presidents of the United States of America
Elvis Presley
Billy Preston
Prince
Prince Buster
Procol Harum
Queen

The Radiators
Corinne Bailey Rae
Zé Ramalho
Rancid
Peter Randall and The Raindogs
Nelson Rangell
Kenny Rankin
Rare Earth
Rascal Flatts
Collin Raye
Razorlight
The Real Group
Redd Kross
Otis Redding
Helen Reddy
Red Hot Chili Peppers
The Redwalls
Elis Regina
Jim Reid
The Residents
Buddy Rich Big Band
Cliff Richard
Stevie Riks
Lee Ritenour
Rockwell
Johnny Rodriguez
Kenny Rogers and The First Edition
The Rolling Stones
Rooney
Rootjoose
The Roots
Axl Rose & Bruce Springsteen
Rosenberg Trio
Diana Ross
David Lee Roth
Roxette
Todd Rundgren
Running Wild
Saga
Arturo Sandoval
The Sandpipers
Santana
Telly Savalas
Leo Sayer
Say Hi
S Club 7
Scorpions
Tom Scott
B. B. Seaton & The Gaylads
The Secret Machines
Seether
Shigeo Sekito
Peter Sellers
Camilo Sesto
Sfinx
The Shadows
Shameless
Shampoo
Del Shannon
William Shatner
Sandie Shaw
She & Him
Shenandoah
Sherbet
Ringo Shiina
Jake Shimabukuro
Michelle Shocked
Show of Hands
The Silkie
Silverstein
Nina Simone
Martin Simpson
Frank Sinatra
Nancy Sinatra
Siouxsie and The Banshees
The Skatalites
The Slackers
Slaughter
Smash Mouth
Elliott Smith
Kate Smith
Mindy Smith
Patti Smith
The Smithereens
Carly Smithson
The Smokin' Mojo Filters
Smothers Brothers
Soda Stereo
Sonic Youth
Sonny & Cher
Soundgarden
Sparks
Spineshank
Luis Alberto Spinetta
The Spokesmen
Spooky Tooth
Rick Springfield
Bruce Springsteen
Spyro Gyra
Stackridge
Michael Stanley
Stars on 45
Status Quo
Steel Pulse
Stereophonics
Leni Stern
Sufjan Stevens
Rod Stewart

Stephen Stills
Sting
Sting & Jeff Beck
Stone Temple Pilots
Barbra Streisand
Jim Sturgess
St. Vincent
Styx
Suede
Sugababes
Sugarcult
Suggs
Sum 41
Donna Summer
The Supremes
Sweet
Matthew Sweet
Matthew Sweet & Susanna Hoffs
The Swinging Blue Jeans
The Swingle Singers
June Tabor
Yukihiro Takahashi
Take That
Tally Hall
John Tams
Serj Tankian
Ben Taylor
James Taylor
Martin Taylor
Roger Taylor
Tea Leaf Green
Teenage Fanclub
Hans Teeuwen
The Temptations
Tenacious D
Bobby Tench
Tesla
Texas
Texas Lightning
They Might Be Giants
Nicky Thomas
Richard Thompson
Thompson Twins
Three Good Reasons
Thrice
Tiffany
Andy Timmons
Tiny Tim
Titãs
Toadies
Toad the Wet Sprocket
Tok Tok Tok
Tongo
Peter Tosh
Toto
Ralph Towner
Transatlantic
Translator
Trashcan Sinatras
Travis
Randy Travis
The Tremeloes
Trouble
The Tubes
Tanya Tucker
Mike Herrera's Tumbledown
Ike & Tina Turner
Joe Lynn Turner
Tina Turner
Twenty 4 Seven
Bonnie Tyler
Steven Tyler
McCoy Tyner
Type O Negative
Judie Tzuke
U2
UB40
Umphrey's McGee
The Undead
Underground Sunshine
Usher
Frankie Valli
Vampiri
Vanilla Fudge
Sarah Vaughan
Stevie Ray Vaughan & Double Trouble
Eddie Vedder
Caetano Veloso
The Ventures
Carl Verheyen
The Verve Pipe
The View
The Vines
Anne Sofie von Otter
Cornelis Vreeswijk
Voodoo Glow Skulls
Vow Wow
The Wailers
Rufus Wainwright
Rick Wakeman
The Wallflowers
Steve Wariner
Jennifer Warnes (as Jennifer Warren)
Dionne Warwick
The Waterboys
Roger Waters
Stan Webb
The Wedding Present with Amelia Fletcher

Ween
"Weird Al" Yankovic
Paul Weller
Mae West
Paul Westerberg
Wet Wet Wet
Chris While
Brooke White
Jack White
Whitesnake
White Zombie
The Who
Widespread Panic
Dar Williams
John Williams
Robin Williams with Bobby McFerrin
Brian Wilson
Cassandra Wilson
Amy Winehouse
Bill Withers
Stevie Wonder
Evan Rachel Wood
Roy Wood
Carol Woods with Timothy T. Mitchum
Victor Wooten
World Party
Link Wray and His Ray Men
Wu-Tang Clan
Bill Wyman
XTC
Yanni
Yeah Yeah Yeahs
Yellow Magic Orchestra
Yellow Matter Custard
Yes
Dwight Yoakam
Yonder Mountain String Band
Neil Young
Youssou N'Dour
Dweezil Zappa
Frank Zappa
Zoot
The Zutons
Zwan

. . . and more
every day!

261

Fab Four Memorabilia Sales

Due to the worldwide appeal of The Beatles, some of the more scarce memorabilia commands huge sums. Here are some of the most expensive Beatles items ever sold at auction:

Single baseballs signed by members of The Beatles have sold for as much as **$68,000.**

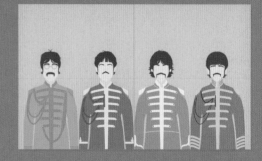

Sgt. Pepper UK gatefold cover signed by all four members $290,500 (Heritage Auctions 2013).

Bass drum skin used on the *Sgt. Pepper* cover, almost **$720,000** (Christie's 2008).

John Lennon's leather necklace, worn in 1967–68 **$209,000+** (Christie's 2004).

Handwritten lyrics by John Lennon for "All You Need Is Love" **$1,250,000** (Cooper Owen 2005).

Autographed gnome prop from *Sgt. Pepper* album cover shoot **$42,500** (Heritage Auctions 2015).

John Lennon's 1953 Austin Princess hearse, driven in the "Imagine" video **Est. $245,000+** (RM Sotheby 2016).

John Lennon's white suit worn for the *Abbey Road* cover **$46,000** (Braswell Galleries 2011).

But the record goes to John Lennon's psychedelic painted Rolls Royce Phantom V, selling for **$2.23 MILLION** in 1985 to Canadian businessman Jim Pattison, making it the most expensive piece of music memorabilia ever!

The Beatles 1

1 is a compilation album featuring number 1 singles the band released in the United Kingdom and the United States from 1962 to 1970. Released on November 13, 2000, the album coincided with the 30th anniversary of the breakup of The Beatles. *1* was a commercial and critical success all over the world and has sold approximately 40 million copies. Interestingly, it was the first Beatles compilation to be available on a single disc, and has inspired numerous "number 1" compilation albums since its release.

#1 Bestselling album of the decade (2000–2009) in the United States

#1 Bestselling album of the decade (2000–2009) worldwide

#1 In over 30 countries when released

#1 Bestselling album of the year in 2000

#1 Bestselling album of the 21st century in the United States

#1 Bestselling non-German language album in Germany

Track Listing (original release)

Love Me Do
From Me to You
She Loves You
I Want to Hold Your Hand
Can't Buy Me Love
A Hard Day's Night
I Feel Fine
Eight Days a Week
Ticket to Ride
Help!
Yesterday
Day Tripper
We Can Work It Out
Paperback Writer

Yellow Submarine
Eleanor Rigby
Penny Lane
All You Need Is Love
Hello, Goodbye
Lady Madonna
Hey Jude
Get Back
The Ballad of John and Yoko
Something
Come Together
Let It Be
The Long and Winding Road

Hello, Goodbye:
Life After the Beatles

Despite the breakup of the group, John, Paul, George, and Ringo continued to make music. Whether it was solo projects, new bands, collaborations, or the immense influence they've had on the generations of musicians who've come after them, The Beatles' musical legacy continues to this day. Below is a list (to date) of the music the Fab Four made post-Beatles.

- 💿 *John Lennon / Plastic Ono Band* (1970)
- 💿 *Imagine* (1971)
- 📱 "Happy Xmas (War Is Over)" (1971)
- 💿 *Some Time in New York City* (1972)
- 💿 *Mind Games* (1973)
- 💿 *Walls and Bridges* (1974)
- 🔗 "Fame" (cowritten with David Bowie), single (1975)
- 💿 *Rock 'n' Roll*, cover album (1975)
- 💿 *Shaved Fish* (1975)
- 📱 "(Just Like) Starting Over," single (1980)
- 💿 *Double Fantasy* (1980)

- 🪦 December 8, 1980
 Lennon was shot in the back four times in New York by Mark David Chapman in the archway of his apartment building. Ono scattered his ashes in New York's Central Park, where the Strawberry Fields memorial was later created. Chapman was sentenced to 20 years to life for Lennon's murder.

- 💿 *Milk and Honey*
 (1984, posthumous release)

- 💿 *Wonderwall Music* (1968)
- 💿 *Electronic Sound* (1969)
- 💿 *All Things Must Pass* (1970)
- 🎤 The Concert for Bangladesh (multiple acts) (1971)
- 💿 *Living in the Material World* (1973)
- 💿 *Dark Horse* (1974)
- 💿 *Extra Texture (Read All About It)* (1975)
- 💿 *Thirty Three & 1/3* (1976)
- 💿 *George Harrison* (1979)
- 💿 *Somewhere in England* (1981)
- 💿 *Gone Troppo* (1982)
- 💿 *Cloud Nine* (1987)
- 🔗 Formed the Traveling Wilburys with Jeff Lynne, Roy Orbison, Bob Dylan, and Tom Petty (1988)
- 🔗 *Traveling Wilburys Vol. 1* (1988)
- 🔗 *Traveling Wilburys Vol. 3* (1990)
- 🔗 Harrison began a collaboration with McCartney, Starr, Martin, and Lynne (1994)

- 🪦 In 1999 Harrison and his wife survived an attack at their home in which Harrison suffered more than 40 stab wounds and a punctured lung.
 However, in 2001, Harrison was treated for a brain tumor and lung cancer and died in November of that year, aged 58.

- 💿 *Brainwashed* (2002, posthumous release)

KEY

💿 Album	🔗 Collaboration	🎤 Live event
📱 Single	🪦 Death	🎼 Score/Orchestral

- *McCartney* (1970)
- *Ram* (1971)

 McCartney formed the band Wings (1971)
- *Wild Life* (1971)
- *Red Rose Speedway* (1973)
- *Band on the Run* (1973)
- *Venus and Mars* (1975)
- *Wings at the Speed of Sound* (1976)
- *London Town* (1978)
- *Back to the Egg* (1979)
- *McCartney II*, Solo Album (1980)

 (Wings disbanded in 1981)
- "Ebony and Ivory" (collaboration with Stevie Wonder) (1982)
- "The Girl Is Mine" (collaboration with Michael Jackson) (1982)
- "Say Say Say" (collaboration with Michael Jackson) (1983)
- *Give My Regards to Broad Street* (film musical) (1984)
- Performed at Live Aid (1985)
- *Press to Play* (1986)
- *Choba B CCCP* (1988) Released only in the Soviet Union
- "Ferry Cross the Mersey," charity single (1989)
- *Flowers in the Dirt* (collaboration with Elvis Costello) (1989)
- *Tripping the Live Fantastic* (1990)
- *Liverpool Oratorio* (1991) (orchestral music)

- *Unplugged* (The Official Bootleg) (1991)
- *Strawberries Oceans Ships Forest* (The Fireman) (1993)
- *Off the Ground* (1993)
- *Paul Is Live* (1993)
- *Flaming Pie* (1997)
- *Standing Stone* (1997) (classical music)
- *Rushes* (The Fireman) (1998)
- *Run Devil Run* (1999)
- *Working Classical* (1999) (orchestral music)
- *Liverpool Sound Collage* (with Super Furry Animals and Youth)
- *Driving Rain* (2001)
- *Back in the US / Back in the World* (2002)
- *Chaos and Creation in the Backyard* (2005)
- *Ecce Cor Muem* (2006) (classical music)
- *Memory Almost Full* (2007)
- *Electric Arguments* (The Fireman) (2008)
- *Good Evening New York City* (2009)
- *Ocean's Kingdom* (score for ballet) (2011)
- *Kisses on the Bottom* (2011)
- *New* (2013)
- "Hope for the Future" (ending song for the video game Destiny) (2014)
- "Only One," single (collaboration with Kanye West) (2014)
- "FourFiveSeconds," single (collaboration with Kanye West and Rihanna) (2015)
- *Pure McCartney* (2016)
- "Nineteen Hundred and Eighty-Five" (McCartney & Wings vs. Timo Maas & James Teej) (2016)

- *Sentimental Journey* (1970)
- *Beaucoups of Blues* (1970)
- *Ringo* (1973)
- *Goodnight Vienna* (1974)
- *Blast from Your Past* (1975)
- *Ringo's Rotogravure* (1976)
- *Ringo the 4th* (1977)
- *Scouse the Mouse* (1977)
- *Bad Boy* (1978)
- *Stop and Smell the Roses* (1981)
- *Old Wave* (1983)
- *Starr Struck: Best of Ringo Starr, Vol. 2* (1989)
- *Ringo Starr and His All-Starr Band* (1990) (All Starr Band)
- *Time Takes Time* (1992)
- *Ringo Starr and His All Starr Band Vol. 2: Live from Montreux* (1993) (All Starr Band)
- *4-Starr Collection* (1995) (All Starr Band)
- *Ringo Starr and His Third All Starr Band, Vol. 1* (1997) (All Starr Band)
- *Vertical Man* (1998)
- *VH1 Storytellers* (1998)
- *I Wanna Be Santa Claus* (1999)

- *The Anthology . . . So Far* (2001)
- *King Biscuit Flower Hour Presents Ringo & His New All Starr Band* (2002)
- *Extended Versions* (2003) (All Starr Band)
- *Ringo Rama* (2003)
- *Tour 2003* (2004) (All Starr Band)
- *Choose Love* (2005)
- *Ringo Starr and Friends* (2006) (All Starr Band)
- *Ringo Starr: Live at Soundstage* (2007)
- *Photograph: The Very Best of Ringo Starr* (2007)
- *Ringo Starr & His All Starr Band Live 2006* (2008) (All Starr Band)
- *Liverpool 8* (2008)
- *Ringo 5.1: The Surround Sound Collection* (2008)
- *Y Not* (2010)
- *Live at the Greek Theatre 2008* (2010) (All Starr Band)
- *Ringo 2012* (2012)
- *Icon* (2014)
- *Postcards from Paradise* (2015)
- *Give More Love* (2017)

Songs for Other Artists

The Beatles were prolific songwriters, and many would argue among the very best in the world. As well as penning songs for themselves, they regularly wrote for other artists of the time.

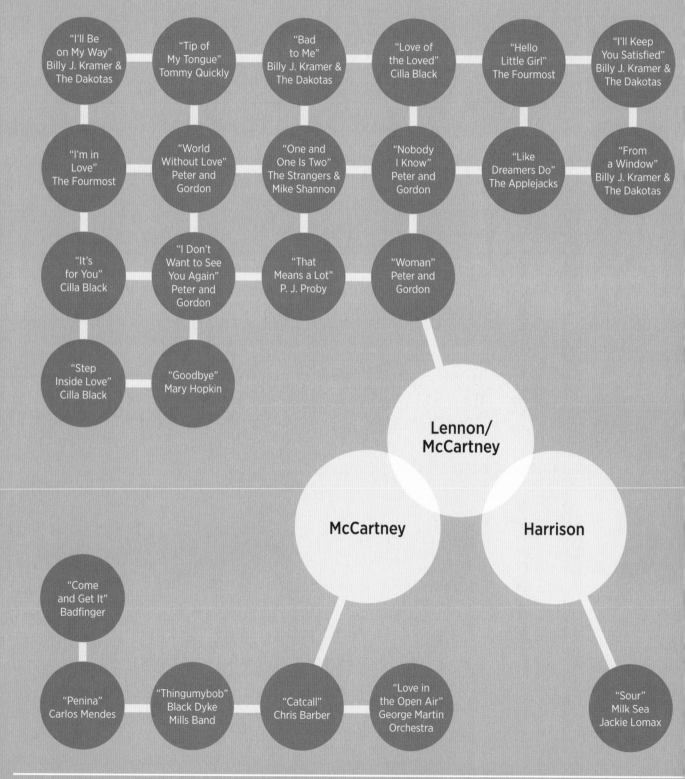

"I'll Be on My Way"
Billy J. Kramer & The Dakotas

"Tip of My Tongue"
Tommy Quickly

"Bad to Me"
Billy J. Kramer & The Dakotas

"Love of the Loved"
Cilla Black

"Hello Little Girl"
The Fourmost

"I'll Keep You Satisfied"
Billy J. Kramer & The Dakotas

"I'm in Love"
The Fourmost

"World Without Love"
Peter and Gordon

"One and One Is Two"
The Strangers & Mike Shannon

"Nobody I Know"
Peter and Gordon

"Like Dreamers Do"
The Applejacks

"From a Window"
Billy J. Kramer & The Dakotas

"It's for You"
Cilla Black

"I Don't Want to See You Again"
Peter and Gordon

"That Means a Lot"
P. J. Proby

"Woman"
Peter and Gordon

"Step Inside Love"
Cilla Black

"Goodbye"
Mary Hopkin

Lennon/ McCartney

McCartney

Harrison

"Come and Get It"
Badfinger

"Penina"
Carlos Mendes

"Thingumybob"
Black Dyke Mills Band

"Catcall"
Chris Barber

"Love in the Open Air"
George Martin Orchestra

"Sour"
Milk Sea
Jackie Lomax

Spotlight: The Fifth Beatle

No telling of The Beatles' story would be complete without a mention of the so-called "fifth Beatle"—their much-loved manager Brian Epstein (1934–1967).

Brian Samuel Epstein was an English music entrepreneur and became manager of The Beatles after discovering them at the Cavern Club, Liverpool, in November 1961. Impressed with the potential of the band, Epstein began to contact major record labels, suffering numerous rejections before securing a meeting with the head of Parlophone, George Martin. After their meeting in May 1962, Martin agreed to sign the band, in no small part due to Epstein's enthusiasm and insistence that they would become famous all over the world.

Epstein was hugely respected and trusted by John, Paul, George, and Ringo, and their early success is attributed to his management, both personally and professionally. As well as handling all of the band's business and financial affairs, Brian would often settle disputes within the band.

Brian Epstein died in 1967 from an accidental drug overdose, and the band took his passing hard. To many, the death of Brian Epstein marked the beginning of the end for The Beatles as a group.

If anyone was the fifth Beatle, it was Brian

Paul McCartney, 1997

The Beatles Worldwide

The Beatles' live performances tended to focus on the United Kingdom, Ireland, and the United States. However, they did play in a handful of other countries. Here are the countries lucky enough to have had at least one live Beatles show.

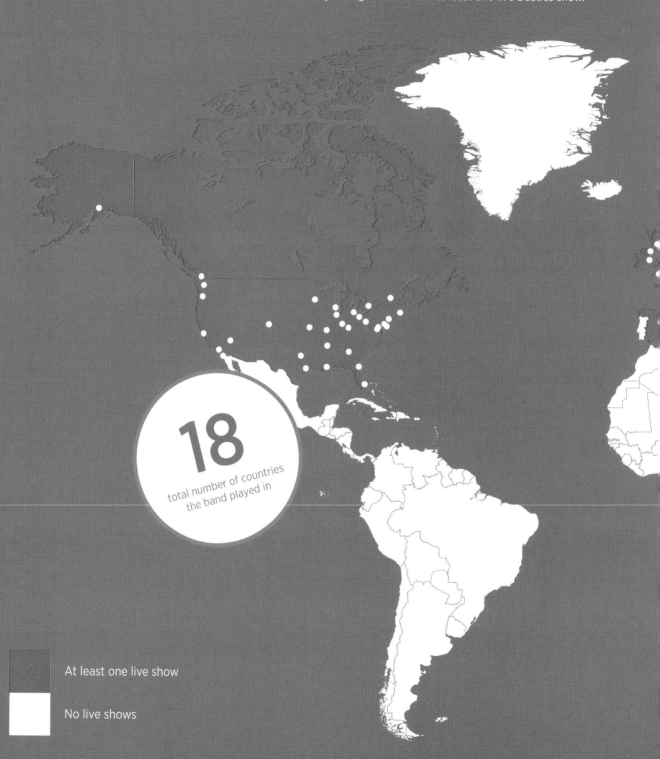

18 total number of countries the band played in

At least one live show

No live shows

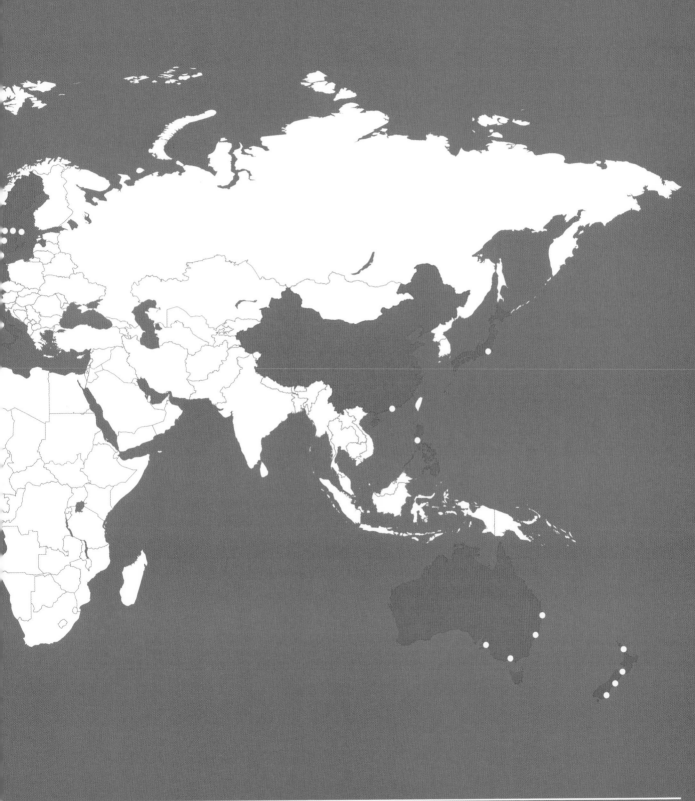

Spotlight: The Other Fifth Beatle

Like Epstein, producer and head of Parlophone George Martin is a crucial part of the story of The Beatles, and is considered to be one of the most important elements in their success.

Sir George Martin CBE was The Beatles' producer, arranger, and mentor, who signed them to EMI (Parlophone) and worked closely with the band through their entire career. He worked on a significant majority of their songs, playing piano and writing scores for numerous tracks. He was a consistent inspiration to John, Paul, George, and Ringo and always encouraged them to experiment and push boundaries in the studio. These collaborations led them to discard conventional studio techniques and produce innovations that are still used today.

Martin played piano on a huge number of songs from the release of *Please Please Me* onward, as well as scoring the likes of "Eleanor Rigby" and "Penny Lane" and producing the musical score to the *Yellow Submarine* soundtrack. It was also his suggestion to add the now iconic string quartet to McCartney's "Yesterday."

George Martin died on March 8, 2016. Writing about George's life and death on his blog, Paul McCartney referred to George in the same way he did Brian Epstein, calling him the "fifth Beatle."

If anyone earned the title of the fifth Beatle, it was George.

Paul McCartney, 2016

Hairstyles Over the Years

The Fab Four were always seen as fashion icons, and their hairstyles were as imitated and scrutinized as their outfits. Let's have a look at how their hair changed over the years...

	Lennon	McCartney	Harrison	Starr
1963				
1964				
1965				
1966				
1967				
1968				
1969				
1970				

ACKNOWLEDGMENTS

John would like to thank: Claire, Ian and Sharran, Damian, Harley and Alohna, Danny, and my coauthor, Rob.

Rob would like to thank: Cara, Levison, Andy and Jacky, my coauthor, John, and everyone else who has supported this project.

Both authors would like to thank: Claire, Simon, and everyone who backed the Limited Edition chapter on Kickstarter. Matthew, Carrie, and their teams for tracking us down and making this happen.

CREDITS

Additional research by Claire Shannan

Additional research on *Please Please Me* by Simon Whitwell

Additional design elements by Matthew Brown

Additional images from:

National Numismatic Collection at the National Museum of American History

Public Domain images John Darch

Public Domain images Lothar Spurzem

Public Domain images Derzsi Elekes Andor

Public Domain images Los Almos

Additional timeline images via Public Domain on http://commons.wikimedia.org

Additional vector elements and images via www.shutterstock.com

SOURCES

- Allan W. Pollack's Notes On: http://www.icce.rug .nl/~soundscapes/DATABASES/AWP/awp-notes_on.shtml
- https://www.beatlesbible.com/
- Davies, Hunter (2016). *The Beatles Book.* London: Ebury Press
- Davies, Hunter (2009). *The Beatles: The Authorised Biography.* London: Ebury Press
- http://www.beatlesinterviews.org/
- Official Charts Company: http://www.officialcharts.com
- http://www.thebeatles.com/
- http://whatkeyisitin.com
- Ingham, Chris (2015). *The Dead Straight Guide to the Beatles.* Clarksdale
- http://www.wikipedia.org
- http://www.wikimedia.org
- http://www.thebeatlesthroughtheyears.com
- http://www.beatlesstory.com
- http://www.bbc.co.uk
- http://www.rollingstone.com
- http://www.songfacts.com/
- http://www.beatlesebooks.com/
- http://www.theguardian.com
- http://www.ha.com
- http://www.letssingit.com/
- http://mentalfloss.com
- http://www.imdb.com
- Erlewine, Stephen Thomas (2007). *Please Please Me* Review. Allmusic
- Calkin, Graham (2001). *Please Please Me*
- *Rolling Stone* (2012). "500 Greatest Albums of All Time"
- Lewisohn, Mark (1988). *The Beatles Recording Sessions.* New York: Harmony Books
- Carlin, Peter Ames (2009). *Paul McCartney: A Life.* New York: Simon and Schuster
- Klosterman, Chuck (2009). "Chuck Klosterman Repeats The Beatles." The AV Club
- McCormick, Neil (2009). *The Beatles—Please Please Me* Review. *The Telegraph*
- Harry, Bill (1992). *The Ultimate Beatles Encyclopedia.* London: Virgin Books
- Lewisohn, Mark. *The Beatles: Tune In.* Little, Brown Book Group
- MacDonald, Ian (1994). *Revolution in the Head: The Beatles' Records and the Sixties.* New York: Henry Holt and Company
- Martin, George; William Pearson (1994). *With a Little Help from My Friends: The Making of Sgt. Pepper.* Boston: Little, Brown
- Norman, Philip (1993). *Shout!* London: Penguin Books
- *Rolling Stone* (2007). *The Beatles Biography*
- Badman, Keith (1999). *The Beatles After the Breakup 1970–2000: A Day-by-Day Diary.* London: Omnibus
- BBC News (2001). "George Harrison Dies"
- BBC News (2004). "Faces of the Week: Brian Wilson"
- BBC Radio 2 (2009). "60's Season—Documentaries"
- The Beatles (2000). *The Beatles Anthology.* San Francisco: Chronicle Books
- Benson, Bruce Ellis (2003). *The Improvisation of Musical Dialogue: A Phenomenology of Music.* Cambridge and New York: Cambridge University Press
- Martin, George (1979). *All You Need Is Ears.* New York: St. Martin's Press.
- NME (2006). "Beatles to Release New Album"

NOTES

This book has not been endorsed by any member of The Beatles, their friends, families, or estates as of November 2017. No direct connection, support, or advocacy is implied.

This work is a piece of entertainment and not a complete history of The Beatles. We have chosen to leave some elements of the band's history out and have focused on elements that lend themselves to illustration or visualization. Every attempt has been made to ensure accuracy throughout.

Performance Pages: The number of total live shows is based on the period from the release of the corresponding album to the day before the release of the subsequent album. There is one date on the Spring 1963 UK tour that is debated between sources (the performance in the Azena Ballroom in Sheffield). It is noted as taking place on both February 12, 1963, and April 2, 1963. We determined on February 12, 1963, so it is not included in the *Please Please Me* performance graphic.

Success Pages: The album chart positions from around the world only include countries where the album charted within the top ten.

Instrument Pages: These relate only to Paul McCartney, John Lennon, George Harrison, and Ringo Starr. They do not cover additional musicians.

Album track lengths relate only to original UK releases.

Most-used lyrics graphics are an approximation and may not include all words used on the album. Word sizes are relative and approximate.

Song authorship is split into 25% sections, in order to represent "entirely written," "mostly written," or "cowritten."

All conspiracy theories quoted in "Turn Me On, Dead Man" are speculation and hearsay. The authors in no way support or give credence to these rumors.

All illustrations of real people, real places, or real items are visual representations and approximate.